WHAT is Now KNOWN
was ONCE oNLy iMaGiNed

What Is Now Known Was Once Only Imagined

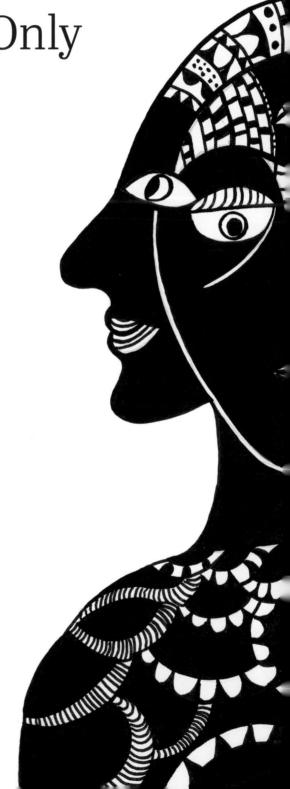

An (Auto)biography of

by Nicole Rudick

siglio New York 2022

When I was quite young,
I saw a film
called Rashomon.
A Japenese film which
showed the Rape and
murder of a young woman..
Three witnesses tell the story
of what they saw
Each version is totally
different.
Which version was true?
All of them?
None of them?

Is perceiving
on ly personal?
Does that mean my version
is only mine?
Where does that put Reality?
Does it exist?

Do I exist?
Is life a dream?
My dream that I can
choose to make into a
Nightmare or a song?
These are the questions I
asked myself after seeing

Rashomon in 1950.
It made a lasting impression
on me.
It taught me that each
Reality is unique, and the
only one who can see
all the pieces of the puzzle
is GOD,
 Not me!

Foreword

"What could he set down in orderly sequence on schedules, when so much exceeded this?" The "he" of this sentence is W. E. B. Du Bois, though the voice belongs to Saidiya Hartman in *Wayward Lives, Beautiful Experiments* (2019), a book that hangs with a dozen others like lanterns on a dark street as I think about the ways written lives are constructed. Hartman is writing about how Du Bois, then a young sociologist studying Philadelphia's Seventh Ward at the close of the nineteenth century, found that his organized information and prepared ideas could neither account for nor encompass the richness of the lives he observed, the raw material of everyday living and dreaming. It reminds me of Jeanette Winterson's observation, "The truth of fiction is not the truth of railway timetables." In other words, the accounting of a life is not the simple accounting of facts. Neither biography nor autobiography is, as Winterson recognized, "a rigid mould into which facts must be poured."

Nathalie Sarraute was interested in the things—sensations, feelings, thoughts—that exist on what she called the "frontiers of consciousness." They are there, but only just, and must be teased into view, "evoked," she writes, like a conjuring. Considering the critical response to the *nouveau roman* in France, Sarraute wrote in 1963 that many of the form's "supporters" seemed to "imagine that these theorizing novelists are cool calculators who began by constructing their theories, which they then decided to put into practice in their books." But novels don't exist to illustrate theories; sometimes they begin nowhere, with almost nothing, and proceed from there. In her own writing, Sarraute relied on fragments, both in her first book, *Tropisms* (1939), and in her memoir, *Childhood* (1983), written forty-four years later. Together, these fragments form a sense of their subject—not a visual one; it's not "painting a portrait," as we like to say. By "sense" I mean "sensorial": being within a person's mind, feeling what they feel, seeing what they see, loving what they love, and never knowing what they have forgotten.

Lisa Cohen titled her triple biography *All We Know* (2012) after a phrase used by one of her subjects, Esther Murphy. Murphy would utter the phrase and then follow it with reams of what she did know about the question at hand. The phrase, Cohen writes, represents "at once 'everything we know' and 'the very little we know,' a declaration of comprehensiveness and incompletion." I could say that we never really know each other and we never fully know ourselves, and that would be true. We must be satisfied, at some point, with what we do know, no matter how meager the parcel.

Bernadette Mayer's *Memory* (made in 1971, published in 2020) is a memoir. It's right there in the title. Though what do we make of the word in singular? Is a life simply one giant memory made up of a million little fragmented parts? Are we each walking, breathing memory sticks, with only so many bytes of storage? *Memory* incorporates six hours of transcribed journal narration ("Observation honk observation bleep there's always more there") and voluminous images to represent a single month of Mayer's life, like a time capsule. The book is comprehensive but incomplete: "emotions, thoughts, sex, the relationship between poetry and light, storytelling, walking, and voyaging to name a few," she writes, naming the missing elements. So many views of such a small amount of time and yet it's never enough. I think of Joe Brainard's refrain "I remember" as a warding off of forgetting as much as a charm of evocation.

Where do the borders of a person's life lie? Where is the hard stop, the point at which the (auto)biographer can say with assurance, this has no bearing? In *Gene Smith's Sink*, Sam Stephenson wandered off the path of the biography he was writing, about the photographer W. Eugene Smith, only to find that the path had been of his own making. He discovered instead an open landscape, life as a vast plain. In that wide space, he met people he wasn't expecting. They are people whose lives are important if not to the world at large, then at least to themselves. They became important to Stephenson, too, emblems of intimate significances. In writing Smith's life, he realized that he couldn't leave them behind and didn't want to. And so his biography became more than the story of one man's life; it is also the story of writing that life and of the deep, often invisible connectedness of one life to many others. The negative space around a subject teems with life, too. What do we see of the subject when we look away?

♣

I first discovered Niki de Saint Phalle (1930–2002) in someone else's story. Her name—my nickname—leapt out at me. She was a woman artist who celebrated women, rendering them in buoyant colors, and she was French, which was catnip for me in my youth. (Much later, I came to understand that, having been raised in the United States, she was as American as she was French, if not more so—in her independence and in the monumentality and energy of her work.) After that, whenever I saw her again, she was always one facet of a larger history or a passing mention in another artist's life. (I can't recall the identities of these others; their names are lost, and hers has persevered.) An uncategorizable artist, Saint Phalle fits in at odd angles to any tidy story of art, and I feel the necessity not simply of focusing on her work, which has already been the subject of at least a half dozen monographs, thick with images, but of asserting her voice—that is, her feelings about herself, her art, and the world.

Saint Phalle watched Akira Kurosawa's film *Rashomon* when it was released in the United States. She had just entered her twenties. Decades later, she thought of it as

she wrote her first memoir, *Traces* (1999), which covers the years from her birth (she was born Catherine Marie-Agnès Fal de Saint Phalle) to when she married Harry Mathews at age nineteen and finally felt "free to be myself." The full title of the book is *Traces: An Autobiography, Remembering 1930–1949*. I'm intrigued by the combination of the words *traces*, *autobiography*, and *remembering*: a story of oneself built from vestiges of memories, like a net with holes. But in that fragmentation, Saint Phalle finds the freedom to tell her story:

> Is perceiving only personal?
> Does that mean my version is only mine?
> Where does that put reality?
> Does it exist?
> Do I exist?
> Is life a dream?
> My dream that I can choose to make into a nightmare or a song?

In her second memoir, *Harry and Me: The Family Years* (published posthumously in 2006), she invited Mathews to write remembrances alongside hers, as occasional annotations. Some of his notes elaborate on her memories, others gently contradict, to correct what he sees as an error or to give her more credit than she gives herself. "Harry remarks…" she writes by way of introduction to one of his notes. "Harry recalls…" "Harry remembers it differently…" His is never the last word—the book is hers, and the reader can feel it—yet she has made room for his voice. (Isn't that what art does—clears a space, makes room?) The act radiates generosity and love as well as self-assuredness, not in her rightness but in her right to her version of the story.

Saint Phalle was a visual artist. From around 1953 to her death, in 2002, she made paintings, sculptures, performative works, drawings, prints, books, films, and large-scale public and private works. The word *traces* also has a visual meaning: a mark made in the past, or simply something drawn, like a tracing or a recording, or an echo. Art and writing are traces in this sense—marks made that reverberate forward (and backward) in time. "Everything starts with drawing for me," Saint Phalle writes on a sketch. On the left half of an undated work (quite possibly my favorite in this book), she drew a handful of animals and plants in her flat, two-dimensional style—a lizard, a bird, snakes, an elephant, a spider, the sun, a trio of wilting flowers in a vase, a cactus, a tree, a crescent moon and stars. On the right half, she drew several versions of the alphabet, a miscellany of ornament: lacy, curving, scalloped, blooming, spiky, striped. The letters resemble the animals; the animals recall the letters. Together, they read like a primer for a language that was hers and hers alone. And in that language, she could say what she needed to.

In writing a life of Saint Phalle, I imagined combing her papers and then setting out to speak with those who knew her best in order to form a rounded sense of my subject. At her archive in Southern California, where she spent the last eight years of her life, I discovered that some of that work had already been done. I paged through a binder full of interviews with her friends, collaborators, assistants, contemporaries, and other categories of people who had cause to know her. The interviews were conducted after Saint Phalle's death and are intended to be records of both the better-known and the more intimate moments of her life. "What comes to mind when you hear the name Niki?" each interview subject is asked. "Do you remember your first encounter with her?" "Tell me about your memory of…" I thought about that phrasing for some time—tell me about a memory of a memory. Each interview contains a different Niki; each interview subject recalls her in a different way. I was suspicious and felt that, too often, these remembrances sought to lay claim to Saint Phalle. Which of these memories is closer to the truth? What is the truth of a person anyway? I do know that there are numerous memories in this binder, but none are Saint Phalle's. "We are all a product of someone else's dream," Hilton Als observes, writing in the voice of the silent-film star Louise Brooks. It's an argument for liberating ourselves from what others may think of us (or, more precisely, from what we imagine they think of us), for heeding the interior monologue, for finding clarity in recognizing the unknown. As a prospective biographer, I also took it as an argument for listening intently to the individual who dreams her own dream.

Ruth Scurr set out to write a biography of the seventeenth-century biographer John Aubrey but found only fragments of memoiristic material. "When I was searching for a biographical form that would suit the remnants of his life," Scurr writes, "I realised that he would all but vanish inside a conventional biography, crowded out by his friends, acquaintances and their multitudinous interests." She constructed her biography as a diary, composed only of Aubrey's own words, gleaned from manuscripts, letters, and books. Where she could not fill gaps with his writings, she let the emptiness stand. "When he is silent," she explains, "I do not speculate about where he was or what he was doing or thinking." (Isn't it more true to life to omit the things you do not know than to lay down assumptions and speculations as though they are sturdy bricks?) That is a neglected truth: the unknowability of another's mind. I took Scurr's lesson to heart, as well as her directive that the biographer's aim should be "to get as close to her subject and his sensibility as possible; to produce a portrait that captures at least something of what that person was like."

What could be closer to the artist's voice than the artist's own voice, closer to her sensibility than that produced by her own hand? Saint Phalle left behind two memoirs of her early life and a vast trove of drawings, prints, writings, letters, poems, books, and sketches that respond to or comment upon her life and thoughts. An artwork, for Saint Phalle, was not an object but an act—ritual, performance, public, revelatory of her personal life. Art gave her wholeness. It gave her the ability to talk about loss and pain, mistakes and successes, collaboration and creativity. It gave her the ability to talk about joy. "I bring to LIFE my desires my feelings my contradictions longing forgotten memories

shadows—visions from some other place," she writes on a sketch. The duality of this state-ment, of "bringing to life," is an apt summation of the overlap of Saint Phalle's life and art: both a bringing into existence and a bringing to bear. These are visions from the frontiers of consciousness. In living, she gave these sensations form. In her art, she gave them life.

In her archive, I paged through a scrapbook containing newspaper clippings and exhibition announcements put together by the artist Jean Tinguely, Saint Phalle's collaborator, supporter, confidante, and lover. On one page, a wallet-size, black-and-white photograph of Saint Phalle is pinned between the book's spiral binding and a pink program from the Festival of New Realism, at Galerie Muratore, Nice, in 1961. Her hair looks newly shorn, in a cropped pageboy that perhaps grew out to the unruly bob she sports in many of the photographs of her earliest Tirs (shooting paintings), begun that same year. She is youthful and unadorned. It could be a passport photo, but in any case, it shows her at the start of her long career. Tinguely has drawn lines in blue marker radiating out from the photo like vivid starlight. She shines brightest on the page because she is the only star in the sky.

In the mid-1980s, Saint Phalle composed a short autobiographical essay titled "Niki by Niki." She muses on the themes, myths, and symbols that recur in her work, then traces the path of her career, from medium to medium, in pursuit of the question, "What is the essential period of my work?" I found two variants of the essay. In a typed draft, she writes in the first person. The published version appears in the third person, with Saint Phalle examining herself as a critic might. Though the sentences in both versions are largely the same, the change in voice disrupts the intimacy of the writing. In the draft, the author and subject are one, fused by the authorial "I," and we, the readers, have Saint Phalle to ourselves on this small voyage. In the published text, they are divided—"I" and "she"—the boat crowded with the artist and the evaluative voice. She finally concedes this in the published version's third postscript: "All of this is just Niki trying to do art criticism. The essential is not here: the mystery remains." The draft doesn't bear this third postscript. Did the first person feel more authentic and so did not require the caveat? If the self as third-person subject was counterfeit, why did she publish that version? I don't know the answer, but I feel certain that the "essential" of her work is the "I."

Saint Phalle did not intend the art and writings here to form a book, though cer-tain pieces of text are taken from books she herself wrote, memoirs that describe her life until she dedicated it to being an artist. She did not write books about her life once she became an artist. She put her story in the work. The work is the site of her discourse—on love, desire, artmaking, women, artistic collaboration, family, doubt. The draft version of "Niki by Niki" has only one postscript: "P.S. I forgot about my graphic work. All of my ideas come from my drawings. Lousy little scribbles on generally bad paper for essential ideas.

Drawing, drawing, as soon as I have a pen in hand, the anxiety goes." This book comprises selections from Saint Phalle's graphic material—lousy little scribbles as well as finished art—that trace the underpinnings of her creative life. The forceful self that drives the draft of "Niki by Niki" suffuses her graphic work above all, which makes it a natural conduit for (auto)biographical storytelling.

I have presented Saint Phalle's writings and drawings free of commentary and interpretation. "Not yet subjected to any treatment. The originals," as Svetlana Alexievich writes of the first-person accounts she gathers into the oral history *The Unwomanly Face of War* (1985). ("I build temples out of our feelings… Out of our desires, our disappointments. Dreams. Out of that which was, but might slip away." This is Alexievich, but it's Saint Phalle, too.) The selection is subject to my own interpretations and feel for her life, much as I might have tried to leave myself out of it, so it is a typical biography in that regard. But all the words are hers—all the thoughts and feelings, changes and distortions—so that the story, though perhaps only one possible version, is all hers as well.

Put together, the distinct works in this book make a non-narrative story. I intend them to be read in sequence, cover to cover. Subjects recur and vibrate against and contradict one another. They make meaning through their contiguity, their role in a syntactic construction (each work a word in a sentence, a sentence in a paragraph, and so on). Certain emblematic images reappear, too—trees, monsters, snakes, birds—but shift in meaning, from iteration to iteration, as words do. Each work can be read and understood on its own, but when they come together, we get a bigger picture of Saint Phalle's inner world. It is a picture I have put together, but who's to say it wasn't already there and just needed a different way of reading and looking? This book is an act of cooperation or participation between Saint Phalle and me, and the reader, too. A cooperative, to borrow from Roland Barthes: "To the United Readers and Lovers." It contains gaps and breaths, an abiding and uncertain openness that characterizes not only the progress of a conversation but the progress of living.

—N.R.

I was a Depression baby. While Mother was expecting me, she discovered Father's infidelity. Once, Mother told me it was all my fault. She cried all through her pregnancy. I felt those tears.

where are you?
why did you leave me?
what did I do wrong?
Will you ever come back?
Every woman became you.
MAMA!
EVERYthing is my FAULt.

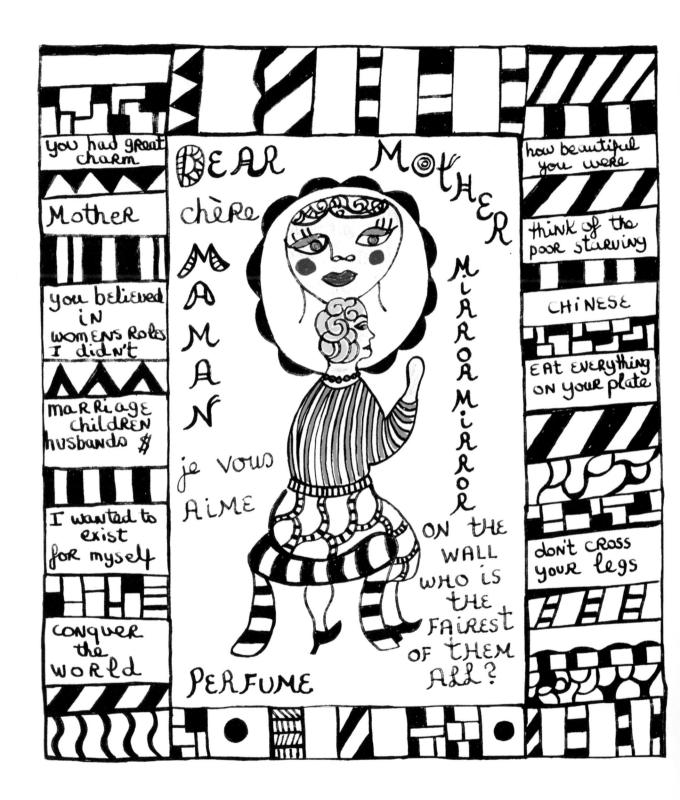

DEAR MOTHER

chère

how beautiful you were

you had great charm

Mother

MAMAN

je vous AIME

think of the poor starving

CHINESE

EAT EVERYTHING ON YOUR PLATE

you believed IN WOMENS ROLES I didn't

marriage children husbands $

I wanted to exist for myself

MiRROR MiRROR

don't cross your legs

ON THE WALL WHO IS THE FAIREST OF THEM ALL?

conquer the WORLD

PERFUME

Dear MOTHER,

When I was born in Paris on October 29, 1930, the umbilical cord was tied twice around my neck. You told me the doctor saved my life by slipping his hand between the cord and my neck.

Otherwise, I would have been born strangled.

Danger was present from the first moment. I would learn to love DANGER, RISK, ACTION. I would also be plagued all my life by asthma and respiratory problems.

My astrological sign is double Scorpio. A chart to overcome all obstacles—to love obstacles.

You told me that when I was born, you lost all your money in the crash. It was when you were expecting me that you found out about my father's first infidelity. I BROUGHT trouble.

After the first three months, we were separated. You sent me to my grandparents in the Nievre, and you went to New York. I spent my first three years there. Mother, Mother, where are you? Why did you leave me?

Will you ever come back?

Everything is my fault.

Every woman became you. Maman. Maman.

I don't need you. I will manage without you. Your bad opinion of me, Mother, was extremely painful and useful to me.

I learned to rely on myself. Other people's opinions of me wouldn't matter. That gave me a tremendous LIBERTY. The liberty to be myself.

I would REJECT your system of values and invent my own.

I decided early to become a heroine. Who would I be? George Sand? Joan of Arc? Napoléon in drag?

At fifteen I won a poetry prize. Maybe I would write?

Whatever I decided to do, I wanted it to be difficult, exciting, grand.

I WASN'T GOING TO BE LIKE YOU, MOTHER. You accepted what had been handed down to you by your parents. Your religion, masculine and feminine roles—your ideas about society and security.

I would spend my life questioning. I would fall in love with the question mark.

This booklet
was written for the
best Mother and Daddy
in the whole world.
by Agnes.
Christmas 1933

I like the daisy when it is little
do you? I like to see the pretty

petals of the daisy. In the morning
They are opening their petals.
It is a lot of fun to watch them.
Don't you think so?

Father enjoyed going out in rough weather. He liked risks. Maybe that's where I developed a taste for them, or is it in the genes?

John, when Father was there, you were on your best behavior with me, and I loved it. You even put the worms on my hooks, which you refused to do when we were alone. How I hated cutting up those worms!

We both vividly remember fishing in a sailboat when a squall came up. The skies were ominous, dark, and then it began raining very hard. Father had an awfully hard time pulling the sails against the wind, while you and I were using the worm cans to bail out the water that was filling the boat.

With great difficulty, Father got to an island where we were helped to shore by some priests. They covered us with blankets, as we were drenched, and they gave us hot tea and cookies. It was an island where Catholic priests went for retreats. No female before me is said to have ever stepped ashore there.

You weren't there, John, the day Father convinced Mother to go out fishing in an outboard motor boat with me, and our sisters, Claire and Elizabeth. As usual, a storm appeared. The motor went dead, and Father had to row the boat to shore with Mother standing at the prow screaming dramatically, "Save my children! Save my children!"

As a young girl, I rejected Mother and Father as models for future behavior.

I was faced with the enormous problem of reinventing and re-creating myself. I had no clear national identity. I felt half French, half American. I also wanted to be half man and half woman.

Men's roles seemed to give them a great deal more freedom. Achievement as a possible choice for me was denied.

I felt that my virginity, looks, charm, and a certain social veneer were important to Mother and Father. Their desire for me was that I should marry a rich and socially acceptable man.

I would spend my life proving I had the right to exist. I would one day make [Mother] proud of me by becoming famous and rich. It was my capacity to ACHIEVE that was important to me.

Yes, I would prove MOTHER WRONG. I would also prove MOTHER RIGHT. One day I would do something unpardonable, the very worst thing a woman could do. I would abandon my children for my work, the way men often do. I would give myself a good reason to feel guilty.

As a child, I could not identify with Mother, our grandmothers, our aunts, or Mother's friends. Their territory seemed too restrictive for my taste. Our home was a space with little liberty or privacy. I didn't want to become like them, guardians of the hearth. I wanted the world which then belonged to men.

When Father left the apartment, after breakfast at 8:30 every morning, he was free (or so I thought). He had the right to two lives, one inside, the other outside the home. I wanted the outside world also to be mine.

Very early, I got the message that men had power, and I wanted it. Yes, I would steal their fire from them. I would not accept the boundaries that Mother tried to impose on my life because I was a woman. No, I would trespass into the world of men, which seemed to me adventurous, mysterious, exciting.

Now that I am bigger, I have my own room, my own bathroom, just the way my brother has his own room. My room is not too big, not too small. There's one great advantage: it's MY room, no one else's! I wish I could leave it the way I want. I cannot. I must make my room the way Mother wants, neat. I cannot spread out my toys, make my little messes. It has to look the way she wants... but I forget! That's why I'm always in trouble... but it's worth it! My room then becomes alive, becomes mine... my space. Important to me my whole life, a space all my own which can be invaded by no one. I will make imaginary spaces, fairy-tale spaces, one day, one day, when I escape from the golden zoo. My room at night... it can be scary. When I open it up to go to bed, my heart throbs.

Alone at Night

Alone in my bed in my white cotton
dress. The one with the lace collar.
I saw a shadowy figure behind
the window.
He shattered the window pane with his
disfigured hands, half animal half man.
He threw hundreds of black disgusting
beetles, small spiders and other
un-nameable revolting little crawlers
into the room
My eyes followed these hideous little
creatures as they paraded up the walls.
and covered all the surfaces of my room.
I held my favorite monkey doll to my
breast for protection. Now these
fiendish little beasts began to cover
the floor near my bed. HELP.
under the sheets I fled away from
this hideous vision. I began shrinking,
hoping that way they would not notice me.
After much difficulty I disapeared.

Sleepless
moments,
difficulty,
abandoned
inner peace...
scared by the darkness
SCARED.
scared of everything.
The man in black,
black mask,
black cape,
black gloves.
Will he come?
Will he kill me?
Where will he stab me with his knife?
My eyes?
Will he take out my eyes?
Will there be two sockets?
Will he plunge his knife
in my heart? Will he open
my chest and out will come,
my soul,
a bird;
a free bird,
that'll fly away,
fly away into the sun?

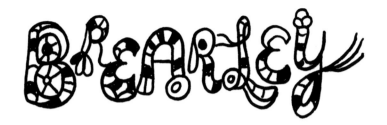

I loved Brearley* where I went for two years after being expelled from the convent. Brearley encouraged me to write and act. My first play was about the Witches of Endor. It was there that we read Shakespeare out loud. I remember playing queen Clytemnestra in *Agamemnon* by Aeschylus. It was there that I wrote my first poems.

Our classroom was a corner room that looked out on the East River. There were green, dusty-looking plants next to the teacher. I remember looking out the window at tugboats whenever I could. That's when I got my love for them. They seemed mysterious, and I wondered what secret treasures they were carrying.

Nature, dragons, monsters, and animals have kept me in touch with the feelings I had about these things as a child. I feel that the part of me that stayed a child is the artist in me.

At BREARLEY I became a feminist. We were indoctrinated with the idea that women could and should ACHIEVE.

When I was eleven, I started drawing trees. Around that time, Mother started taking us to the Metropolitan Museum of Art once a month on Sundays. I remember searching for the trees in all of the paintings.

I remember in art class, my friend Jackie Matisse always drew horses, and I kept drawing the same tree on the right side of my page. Another friend, Sylvia Obolensky, kept drawing maps, which she would then take home and cook in the oven to make them look old.

I remember my report card said I had no imagination. As the three of us became artists, maybe art is more about OBSESSION and less about talent than people think.

The Brearley School, an all-female private school in New York City.

Will you [crossed out] to the ancient world
an eighth wonder unfurl!

Perphaps you shall dwell
amid the pyramids of Egypt
and your fame
shall make the rosetta
clad in shame.
Or will you search
in eager haste
for the chaste Diana
of the temple.
Who knows but that
Jupiters statue in Greece
will cease
to be immortal besides
your own.
Or shall you be a wonderer
amid the hanging gardens
of Babylon
Perphaps you will claim
the mausoleum of Halicar Aussus
your own
and maybe the Pharos lighthouse
of Alexandria shall loose
its brilliant rays
[crossed out] when accossed by your new discoveries.
Who knows but that the
collossus of Rhodes will
be dust when affronted by
your triumps.

I was never popular in school. Most of the girls didn't like me. However, I managed to have some great and passionate friendships. At Oldfields,* Claudie, Babe, and I became a trio. I remember drinking alcohol from little perfume bottles and smoking in the toilets and kissing each other. All the things we shouldn't do.

My senses had been inflamed by my cousin Jacques, and I sat down and wrote six or seven wild pornographic pages. Years later, when I read the Marquis de Sade, it sounded similar. It was an orgy of love and gore. Where I got those ideas from I have no idea. I was innocent. It occurred to be that maybe the Marquis de Sade had never had any sexual experiences!

The headmaster called me in. He told me he was profoundly shocked. He asked how I could think of writing something like that. I told him I really didn't know, that it

*Oldfields School, an all-female private boarding school in Maryland.

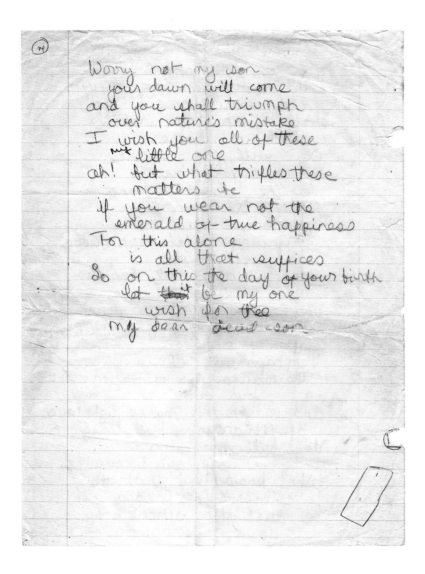

Worry not my son
 your dawn will come
and you shall triumph
 over nature's mistake
I wish you all of these
 ~~my~~ little one
ah! but what trifles these
 matters be
if you wear not the
 emerald of true happiness
For this alone
 is all that suffices
So on this the day of your birth
 ~~let~~ ~~that~~ it be my one
 wish for thee
 my dear dear son

just came like that. He said he would give me one more chance, but next time I would be expelled. I was warned I could never, ever, circulate or write something like that again.

The headmaster told my roommate that he preferred having three hundred students than one like me. I was very hurt. I wanted to be liked, but my wild side was stronger.

Truly, what I had done began to scare me. I didn't want to become like Father. This was a BIG FEAR, to become like Daddy, a libertine. I was scared of the rising sexual feelings inside of me, really scared that I might be wild, and I wanted to be in control.

HARRY

I remember meeting Harry Mathews for the first time in Lenox, in the Berkshires, when I was eleven and he was twelve. He had come to spend a few weeks there with his mother to attend the Berkshire Music Festival. Mother made catty comments about his mother, and I gathered that Father was paying too much attention to her.

I found Harry extremely good-looking and was very impressed by his knowledge of music. I went once a week with Mother to the concerts and saw Harry there regularly. He did not pay the slightest attention to me. He admired some fifteen- and sixteen-year-old girls. I ended up having a big crush on him. I remember one afternoon I sang "Carmen" when he came over to impress him. It didn't work.

I saw him a few years later at a few dances, and he seemed terribly stuck-up to me. He never danced with me. Nor did he say hello. I decided I didn't like him and started counting the pimples which had begun to appear on his face.

When I was seventeen, I met Harry again, on a train going to Princeton. He came towards me saying, "Niki, you look beautiful." When his eyes met mine, there was that magic flash… that moment of communion. The others after Jacques had been little crushes. Harry was tall, dark, and ruggedly handsome.

His physique was in contrast to his structured intellect. I admired Harry's intellectual capacities. I thought he was smarter than me. I liked that he could read Greek and Latin. Admiration triggered my love for Harry. His intellect put him on a higher plane from the other boys I met.

A few days later, he called, and we saw each other, again and again… almost right away. He wrote me wonderful letters… Where are they now? He used to call me "little eye." Our courtship went very quickly. We laughed and liked the same things. We both did not want to grow up having a life resembling that of our parents and their friends. To become rich was not our goal. We found another altar to worship: ART.

THE EYE 👁

The eye is always there.
Your eye, my eye.
The look, our look.
The Registered moment
Your eye, my eye,
DO YOUR EYES SEE WHAT I SEE?
You liked the strange cacti
 in my garden.
The gray green, the green, SURPRISE
an ORANGE blossom at the top
OUR eyes felt the same emotion.
I LIKE WATCHING YOU LOOK

WHERE CAN WE DO it?

I want to do it. You want to do it. We want to do it. Where? We don't have a car. We don't have any money for a hotel. We are seventeen. It's not like today. You can't screw with your parents in the next room. Love is forbidden. It's very hard to know where to do it. If we go to Central Park, we'll be arrested. Our friends live with their parents. We have to connive, be smart, wait til we know one of our parents' apartments is free.

Luckily, Harry's mother often went out in the afternoon, but it was always a risk, a gamble. Lovemaking was forbidden, exciting, nearly impossible.

Impossibility enhances desire. Love was terribly exciting for our generation. People got married young so they could make love. Men aren't as eager to get married as they used to be. Everything has changed.

Where shall we make love? On top of the trees? Shall we fly into a cloud? Should we take a magic carpet? Shall we have a fairy godmother transform us into two squirrels in Central Park and go at it and at it?

Love was forbidden, so it was love we put all our thoughts to. Impossibility breeds passion. We nearly got caught many, many times.

When I told Father I had eloped, he took it very calmly. He was probably relieved. He offered to tell Mother, as he knew she would take the news badly. A few days later, when I saw Mother in our rented summer house, she was lying on the divan. She was pale with no makeup on. Her hand was held to her heart. Beside her was a doctor who said, "You've nearly killed your mother."

Mother cried, and I felt awful. Mother, amongst other things, was a brilliant dramatic actress. She seized the opportunity to make me promise that I would have a proper Catholic wedding, even though she knew I was a nonbeliever. I felt trapped and agreed. Harry's mother wore black to the wedding. For her it was a day of mourning. I refused to wear a long white dress and wore a short blue satin one.

I felt at last free. Free to be myself. I believed in fairy tales and that "they lived happily ever after... " I had forgotten that quests and overcoming difficulties are the key to most fairy tales. It was an exciting moment to be accompanied by the man (or rather the boy) I loved.

HARRY

He was better than an encyclopedia. He collected an amazing amount of information inside that big head of his. Harry was an impassioned accumulator of words, facts, languages, poetry, music, and puns, and later, alas, women.

How could I not fall for him? We were meant to meet. We complemented each other. He was neat. I was messy. He couldn't stand how I threw everything in a suitcase, so he always packed my clothes for me. Great! Sometimes I forgot to bathe the children. Harry would stick them in a tub with a detergent when he found them smelly. I cooked. He cleaned.

I remember our impassioned chanterelle pickings in the woods. I remember making jams together and starting a vegetable garden. Listening to music, reading poetry out loud. So many things. Reading in bed at night. I loved beating him at rummy. I liked it less when he creamed me at ping-pong.

Harry was fun. He read a lot, and he was interesting. He introduced me to T.S. Eliot, Nathaniel West, and all kinds of other writers that I devoured. Art, literature, and music were our gods. We wanted to burn candles for them.

I made quite a few drawings that resemble the fancifully embellished, perfectly formed letters I had done in my favorite class of penmanship as a child. I spent hours in rapt fascination scrawling out those complex yet primitive images with my quill pen... as they made me feel good.

Some months later I found myself pregnant, which was not in our plans. My mother-in-law was adamant that I should have an abortion. She even brought the abortionist into her house. He was a weasel of a man and the last person I wanted to have touch me. I revolted at seeing him and said I would keep the child. Harry backed me up in this, and I felt very good about my decision.

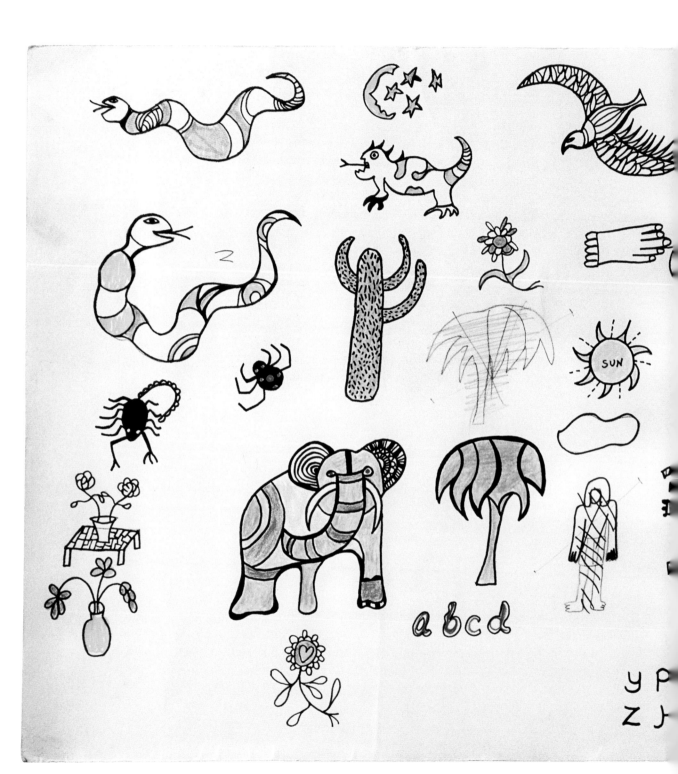

abcd

y p
z f

32

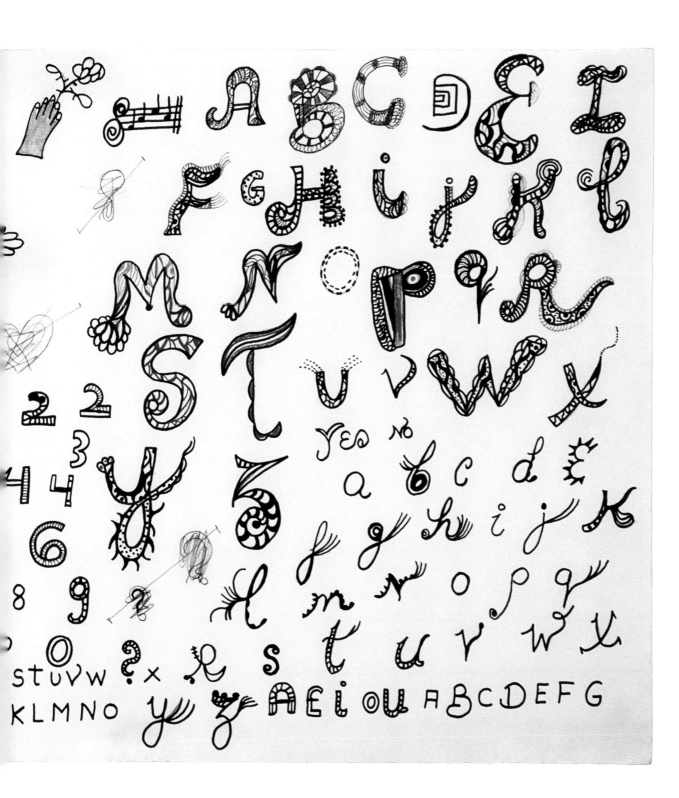

When Harry and I arrived at the maternity ward, I was taken to a room with about ten other women in it. Some of the hospital staff immediately started to tie me down on a bed. I found this situation unbearable and started screaming. The doctor entered and gave me a shot of something that was then in fashion, called "twilight sleep." It was supposed to completely block out my memory of the delivery process, but it didn't quite work on me. I remember screaming in protest, flailing my arms around, and kicking my legs as much as possible while the attendants finished tying me down.

My body was black and blue from struggling to be free from the humiliation of being tied down. The baby was brought in to us within a few minutes and I remember undressing her in front of Harry. Then I carefully tallied up her fingers and toes, confirming they were all there, to assure myself nothing was wrong with her. Harry wanted to name her Laura... after Petrarch's love. I agreed to this because we had recently seen the film *Laura*... and I found Gene Tierney terribly seductive and exciting in it.

Harry bought me a very cheap secondhand washing machine shortly after Laura's birth. Now I gladly used the machine to launder Laura's numerous sleepers... but this was not at all what I thought marriage should be like. I was in no way the perfect wife. Little by little, I took our dirty clothes and hid them under our bed, where they slowly accumulated... and waited until Harry declared he had no more clothes to wear. Then I led him to our room and lifted the corner of the bedspread to reveal the secret pile that had amassed beneath the bed. I sighed, "I just can't do this, Harry... it's just too boring." He did not seem at all surprised by my revelation.

Somewhere around four or five months after Laura was born, I developed a hyperthyroid condition and suffered from a state of great nervousness. Although I didn't know it at the time, this was when Harry started having an affair with a woman who was considerably older than me. This was also the beginning of what would become a long series of infidelities.

As a woman, I was not really sure of myself, even though I had no trouble attracting men. Underneath there was a very real problem with my sexuality. I found it thrilling and scary. My worst fear was to be like my father. I had conflicting feelings of wanting to be both sexually free and wanting to maintain a strict control over my desire.

After our first few months of joy with Laura, I began to resent that Harry had the freedom to attend his courses... while I was the one obliged to stay at home and look after the baby. I was frustrated and felt that I could not develop myself under these conditions. When I was struck with the desire to take up painting, I knew nothing about how to start. So I asked Harry if he would stay home and babysit while I attended an evening class in Boston. He readily agreed to this arrangement. Well, I went to that class twice... and that was enough for me! I decided it would be much more interesting to experiment on my own, rather than listening to some didactic professor on the subject, so I went out immediately and bought my own paints and an easel.

Harry and I began to worry about America. McCarthy was starting to spit his venom, mounting his witch hunt. We were also fascinated by Ralph Ellison's *Invisible Man*, which had just been published. We found the racism described in it utterly unbearable. Both Harry and I had long been aware of the social inequalities in America, but reading Ellison's book had served to make us hyper aware of them... and so this too played a big role in our growing unease. With all this in mind, Harry and I arrived at the resolute decision: when he was finished with his studies at Harvard, we would leave America to live in France for a couple of years.

A little after our first year in Paris, Harry and I rented a small house in Menton in the South of France, about an hour away from Nice. Friends of ours who were directing the musical festival there had suggested we come down. I would spend most of the day with an English lord. He was a wreck from the Second World War who was totally depressive and talked obsessively of suicide. He also used to play music for me on a rickety old piano that was very out of tune. Nonetheless, he played rather well, and the character of the dilapidated piano gave his serenades a special charm.

It was while I was with this English lord that I imagined committing suicide for the first time. I didn't want to hurt anyone's feelings, so I thought about how I could accomplish this without anyone knowing mine was an intentional death. And a diabolical idea came to mind: ride a rubber swimming-pool mattress out into the ocean with a large safety pin in hand. When I got far enough out not to be seen, I would poke holes in the float. I knew I would have to go very far out because my desire to survive would force me to attempt a swim back in. So I decided it was essential to go beyond a distance that was humanly possible to swim. I told my English lord about this, and he thought it a brilliant idea.

I would spend a lot of time walking alone by the water, looking down on the sea and wishing that each wave would swallow me up. I had wanted to make something of my life, and I now felt doomed. I felt my mind slipping from me bit by bit. This feeling of my mind slipping away from me was the most frightening and painful experience of my life. As a very young child, I had learned to hide my pain, and over time, I developed a great command of my appearance in the company of others: cool and composed while I was burning inside. I also harbored a type of pride that prevented me from revealing my inner torment. Many years later, the physical pain of rheumatoid arthritis would wake me screaming in the middle of the night, but this (and every other physical pain I have endured) has never equaled the pain and fear I felt during the experience of losing my mind. My psychic pain was like a giant rat trap. It was much worse than depression. There was a horrible feeling in my chest that I was unable to get rid of coupled with an inner scream that would not stop. The moment became all-important, and I could not see the end. Would I ever recover from this nightmare?

Harry noticed a gleam of triumph in my eye which disturbed him terribly. When I went to our room after leaving the table, he followed. Stopping just outside our door in the hall, Harry watched in silence as I swiftly lifted the edge of our mattress, bed linens and all... to hastily stash a knife. It was at that moment that Harry spied the bevy of sharp instruments I had accumulated there: an assortment of knives, scissors, razors, screwdrivers, and such. This arsenal provided me with such a keen sense of protection that I assembled an alternative collection of similar objects in my handbag, which Harry was not yet aware of.

When the clinic finally had room for me, Harry took me there. I noticed there was a barbed-wire fence all around the facility, and when I got to the room assigned to me, I noticed there were bars on the window. I pointed to them, asking Harry, "What's that for?" And he responded solemnly, "To catch butterflies." Somehow his remark reassured me.

An urge to paint overcame me yet again, and because I had no crayons or paints, I gathered twigs and leaves from the garden. When I had finally managed to obtain some glue, I sat down and made some collages with my collected debris. The next time I saw Harry, I asked him for some crayons, which he brought me along with some paper. To Harry's and the doctors' great surprise, I responded so quickly (not to the clinic's therapy but to mine: painting) that, at the end of six weeks, they told Harry I was ready to leave, and I did. The result of my mental breakdown was good in the long run, because I left the clinic a painter.

A week or two after I had been released from the psychiatric clinic, I found amongst the mail a letter from my father. I opened it and read a long confession. It started off with, "I'm sure you remember when you were eleven and I tried to make you my mistress… " I remembered nothing but continued. The shock of reading this letter was too much for me. I put it back in its envelope, and a violent migraine immediately began to overtake me. Then a severe migraine accompanied by vomiting would occur every Friday. The migraine would begin to dissipate only after I had disgorged everything in my system down to the bile, and I would feel much better. Then finally, after a full year of these "Good Fridays," the ill effects seemed to disappear altogether.

Later on during that day, I got up the courage to share the arrival of my father's letter with Harry. He read it silently and with great care. It was a big shock for him as well. Wanting to handle our outrage rationally, he suggested I show the letter to Dr. Cossa, the Jungian psychiatrist who was treating me. Dr. Cossa read the letter and summarily took a match to it in his fireplace. He was apparently shocked and categorically refused to believe its contents. (This was, after all, 1953.) He then emphatically stated that none of what my father had written was true… that my father was obviously mentally unstable and suffering from melancholia. He declared that a man such as my father, who was raised in a pious Catholic home with strict moral principles, could never have committed any of the transgressions he confessed to.

I listened to Dr. Cossa but I was skeptical. I had struck from my mind any memory of the incident that had occurred between my father and me, but too many memories of my father seducing my mother's friends (or our maids) were still very present. Because of these vivid memories, I was not at all convinced by Dr. Cossa that my father's pious upbringing had any positive influence on controlling his adult behavior.

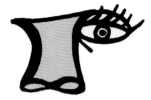

Through painting, I could explore the magical and the mystical which kept the chaos from possessing me. Painting put my soul-stirring chaos at ease and provided an organic structure to my life, which I was ultimately in control of. It was a way of taming those dragons that have appeared throughout my life's work, and it helped me feel that I was in charge of my destiny. Without it, I'd rather not think about what might have happened to me.

A painting I made during this period would have great relevance to what I would do later. It was a woman sitting. She had a tiny head like my future Nanas, and she held a small child in her arms. It was very abstract yet concrete. One could see that it was a woman and a child because of the contour lines. There was only one other image in the painting. It was a window.

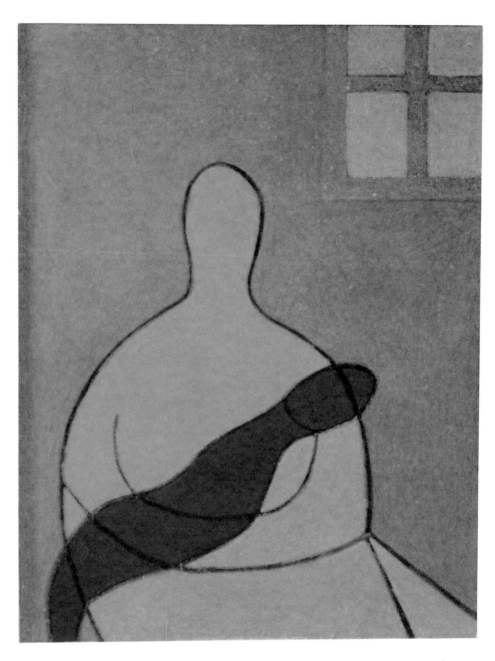

Is the Mother wishing for the big wild world?

After a few months in Paris, Harry and I began feeling restless for a change of pace. We had first heard of Deià in Menton, when a friend had shown us some photos and told us of the simple and authentic life there. So Harry and I packed up and headed to Deià with Laura, where we lived quite happily for two years.

In the south of Spain, I fell in love with the rounded white houses with their gentle curves. The fireplaces were like those in Mallorca. They were rounded and inviting and always a central part of the room. Stone benches were incorporated around the exterior of the fireplace so people could easily warm their cold bones by the fire in winter.

Discovering the Prado was a great shock. It is there that I really discovered Goya and his different periods. I love the humor in his gorgeous and wicked portraits of the monarchy… and his later paintings of war and disaster. I think I identified with his black humor… and his horror of poverty, war, and the sometimes miserable human condition. I saw some incredible Brueghels and El Grecos… and discovered the extraordinary Bosch painting, *The Garden of Earthly Delights*.

Being an only child himself, Harry felt strongly about having a second child, and it was in Mallorca I found myself pregnant again. The doctor told me I would have to spend three months in bed if I wanted to have this pregnancy go to term. I suspected being bed-ridden might prove quite an ordeal for me, so I decided to give myself the challenge of reading Proust's *Remembrance of Things Past* from A to Z, and I loved it.

Harry and I could not for the life of us agree on a boy's name. I wanted to call him Amadeus, after Mozart, but Harry disagreed terribly with this, as he felt a boy with such an old-fashioned name would be teased horribly while growing up. I can't remember Harry's preferred name… but we just couldn't come to an agreement with each other on the matter. So when Robert Graves came for a visit at the hospital shortly after the baby's birth, Harry and I asked if he could possibly settle our argument by naming our son. Robert promptly suggested that we give him the name from the appropriate saint's day listing for our son's birth date, May 1. He then quickly referenced the source to inform us: our child's name was to be Philip. (Thank God it wasn't Saint Hildegund's day!) Since we had invited Robert to name our son, Harry and I both agreed to this resolution.

Philip looked like a skinned rabbit when he was born. He was the smallest thing I'd ever seen, and I fed him with an eye dropper. He had a wonderful grin on his face, a few curls right in the middle of his head, and a winning personality. The doctor had examined Philip's umbilical cord at birth and said it would not have sustained him in the womb for another two months.

We were in Italy on the island of Elba, living in the portion of a house we had rented for the summer. For some time I had been growing ill from Graves' disease, which had apparently been activated by Philip's birth. It caused my thyroid gland to go on acting as though I were still pregnant by working much too quickly. By the middle of summer, I had become very thin, suffered from insomnia constantly, and a rapid heartbeat prevailed… along with exaggerated reactions to everything. It was as though my adrenaline system was working ten times faster than the normal rate.

Knowing my mother had developed this same condition after I was born, and having suffered from hyperthyroidism myself a few months after Laura's birth, I went to see an Italian thyroid doctor by summer's end. During our consultation, I made the grave mistake of reporting my previous nervous breakdown. Hearing this, the doctor dismissed me, telling me I was suffering from a mild depression and there was no thyroid trouble. Young and foolish, Harry and I didn't think to get another opinion. The result of this would be that my weakened state continued, and I caught tuberculosis, which went untreated. However, I wasn't the only one in the family with health problems.

One morning Harry and I woke up to find Philip unconscious with his eyes rolled back in his head. Harry drove to the nearest reputable hospital while I held Philip in my arms and Laura slept in the back seat. When I entered the hospital room with Harry, a nun was holding Philip in her arms, diligently feeding him sugar from a spoon. She told me, "Give him lots of sugar… he needs it." When we returned to Paris in the fall, we took Philip to L'Hôpital des enfants malades, where they found that he was suffering from hypoglycemia, which can make one faint and comatose. Poor Philip, he really had a rough few years in and out of hospitals.

In midwinter I was hospitalized. As a result of the unchecked Graves' disease and the attendant complication of tuberculosis, my heart nearly gave out from fatigue, and I had to be rushed into emergency surgery for a thyroid operation. Afterwards my heart was pounding at about 200 beats per minute, and I really didn't think I'd make it. I asked Harry to bring me Bach's *Art of Fugue*, which I played over and over again, as it seemed to have some calming effect on my heart and mind.

These unrelenting physical disasters were hard and took their toll on all of us. I actually believe some of the seeds of Harry's and my breakup were sown during this turbulent time. Somehow it seemed as though the fun had gone out of life, and our house of cards would soon come tumbling down.

POEM

When I awake in the morning
Next to your body long brown and thin,
The horrors of the night passed slowly fade
As the monsters that rage from my unhappy youth
Are extinguished between your lips.
My eternal swarm of sinuous snakes
And those dark bottomless pits
Evaporate in your warm embrace.
You who love me
You who have torn me away from the
incestuous hell of my youth:
Rock me my poet
Rock me in your glistening arms
Your child your muse.

2.

After dinner the other night
you said she played with her feet
against yours

And all through the night I couldn't sleep
An eternal thirst constricted me
It scorched my throat with it's torturing

What trump can I pull on this red headed symbol?
This woman of velvet and perfume
Who promises everything asking for nothing
I who ask for everything
and promise nothing to you,

She promises soft fields
of fragrant sleep without sadness
and the kiss of all women
so what can I do to defeat this ruse,
the play of her feet against yours?

I who ask you of you
I who ask you for me

3.

Oh my poet
when I look back
on the hells which we tumbled through
at the lies, the vice, the beastial and crude
which we lost ourselves to
I am struck by the luck we have had
when I think of how
we have now begun anew

when I think
there were nights we did not dare look each other in the eye
nights you cursed my name while making love to another
nights when my incestuous desire inflamed again
in the arms of another man

when I think
there were weeks we chose to sleep in separate rooms
to keep our hearts apart
there were scissors, knives, tears and drugs
when I think of how you wanted to run from your muse
and me from my poet

and in spite of all this
we could not lose sight of each other
in our hearts and minds
while I plagued you with my eternal sadness
as you made your apprenticeship

oh my poet
and you are a poet
now that we are restored
I think of the luck we have had
and ask myself now
how long will it last?

Deyá 1954

I felt a certain restlessness in myself and started to sense a certain restlessness in Harry as well. Harry told me he had dreams of extensive travels he wanted to undertake alone. He felt doing this with a family would be far too difficult. We both had inevitable dreams we needed to fulfill. I also sensed that this was the beginning of our end… because I did not see myself staying in our idyllic mountain home, alone with two kids, while Harry roamed the earth freely.

I needed a confrontation with the outside world, and I wanted to be taken seriously in my communications with it. I was quite aware that this was the beginning of a long journey, but to be recognized as someone who had embarked on that journey was most important of all to me. Then all those adolescent dreams which had been sleeping quietly inside of me… dreams of conquering the world… of doing something meaningful within it… of being someone… emerged full force in me again.

I suggested to Harry we should separate for a year… to allow me the time to totally immerse myself in my work… I didn't want to worry about him… the children… or any other responsibilities except my art.

I felt that I had done such a terrible thing in leaving my family that I buried myself 100% in my work for the rest of my life to make up for it. I needed to prove that what I had done had not been in vain and had been worthwhile.

It was difficult… I certainly never had another family as Harry was able to find.

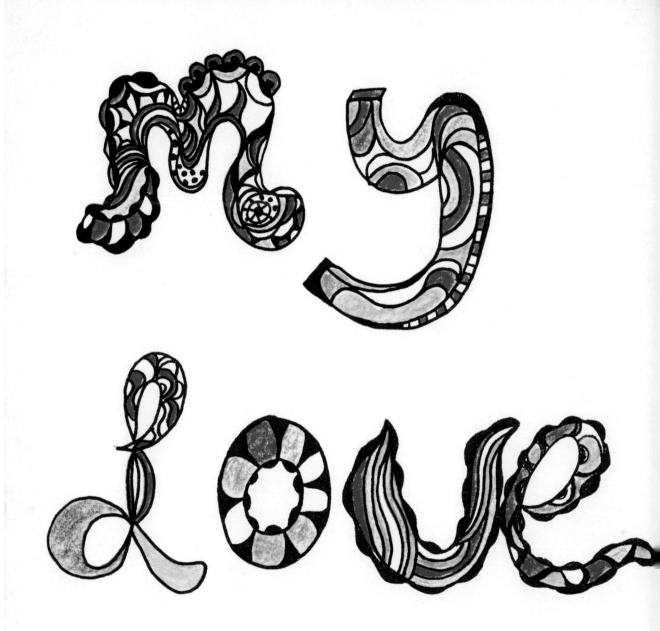

where shall we make love?

IN a bed?

on top of the sun?

in a field of flowers?

where shall we make Love?

in a bathtub?

under the stars

in the jungle with
lions and crocodiles?

What do you like the most about me?

my lips?

my breasts?

my funny nose?

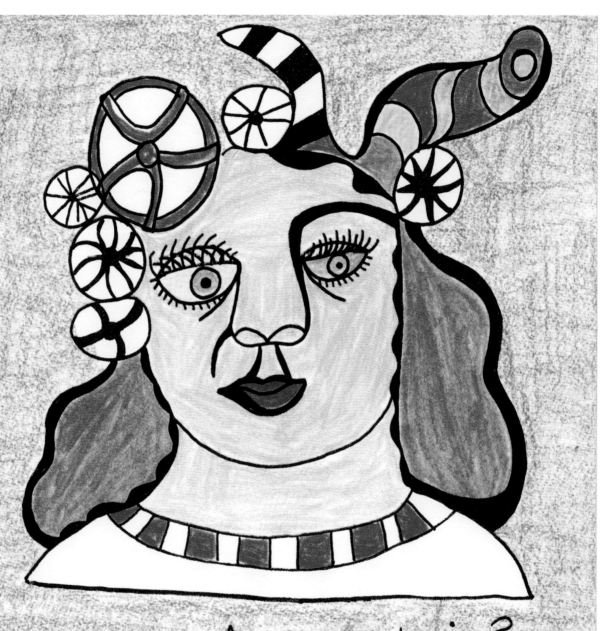

Do you like my brain?

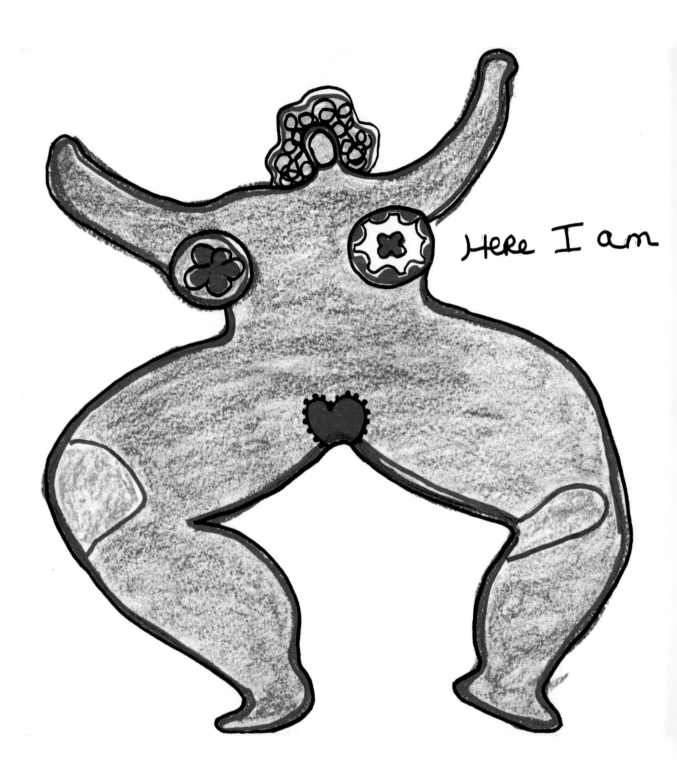

Here I am

I would like to give you
EVERYTHING

my mouth

← my heart

$1000 ← my money

my breasts

← my imagination

my time

my terrific cooking

my everything ← canned purple mushrooms

every morning you brought
me breakfast in bed

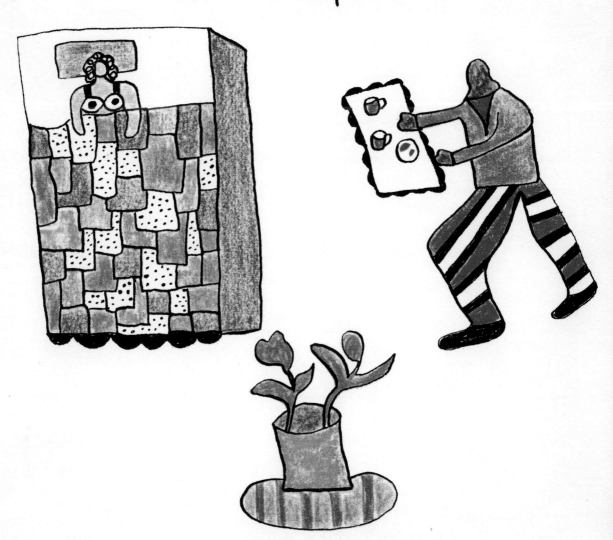

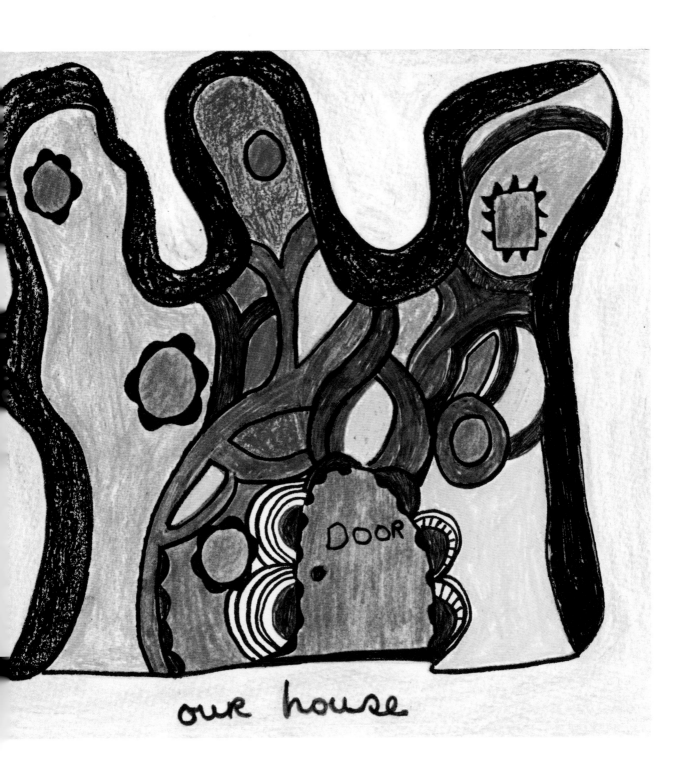

our house

The trips we took

camel

AFRICA

* CAPE OF HOPE

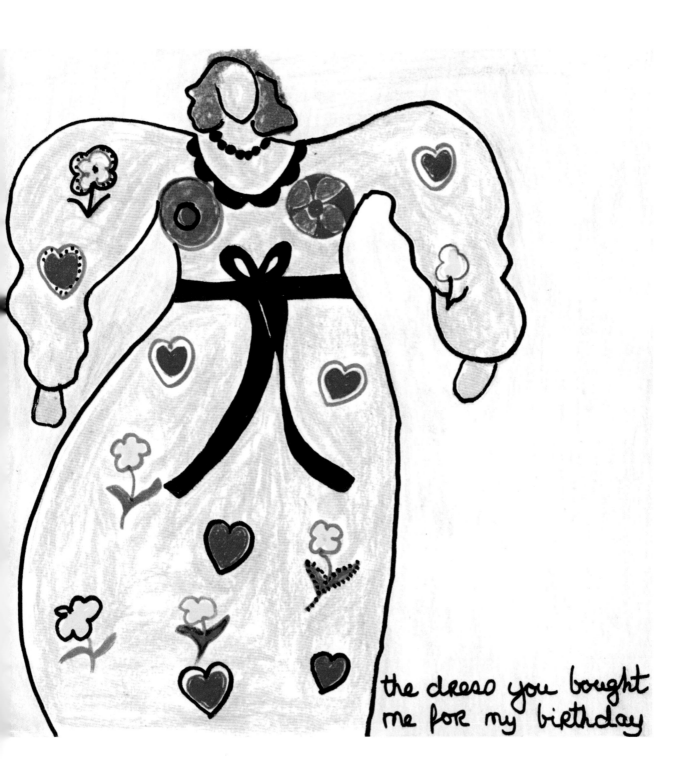

the dress you bought
me for my birthday

What shall I do now that you've left me?

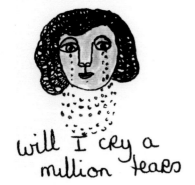

will I cry a million tears

COFFIN

will I die?

will I take to drink?

INDiA
GURU

take a trip?

will I consult the star and a crystal ba on how to win you back?

will we stay friends?

YES

will I fall in love again?

NEW SEX snake

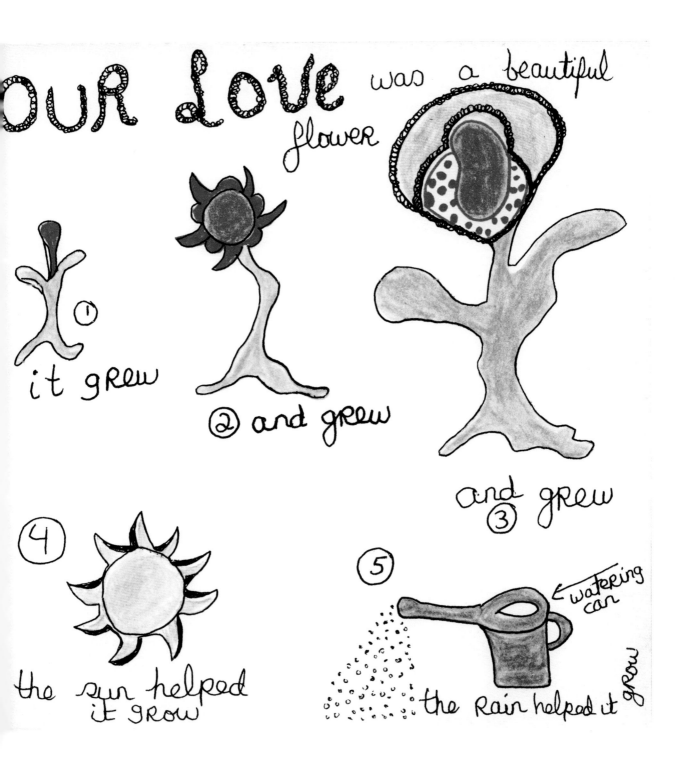

OUR LOVE was a beautiful flower

① it grew

② and grew

and grew ③

④ the sun helped it grow

⑤ ←watering can

the Rain helped it grow

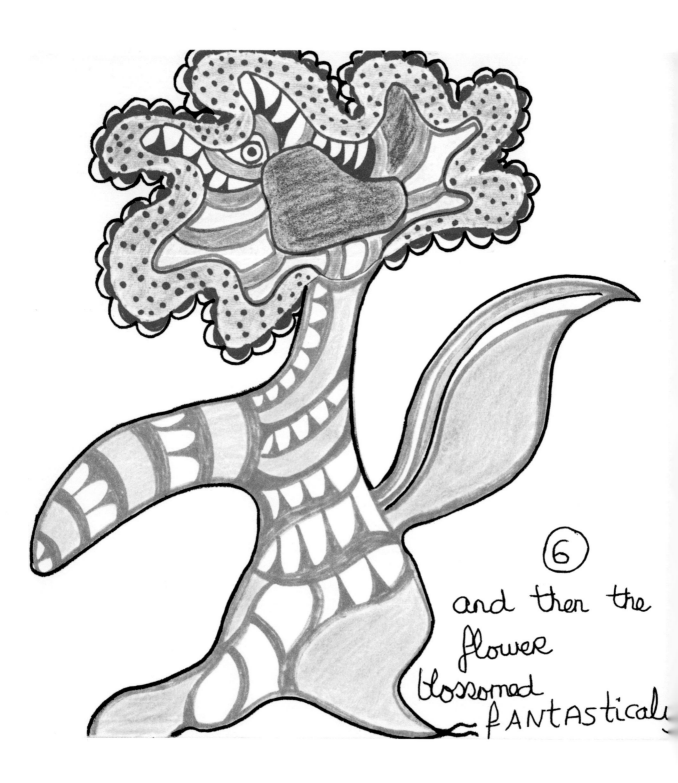

⑥

and then the
flower
blossomed
-fANTAStically

(7) 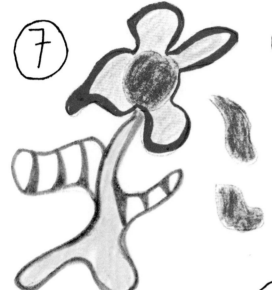 winter came and the
petals started to
fall

(8) and then the
flower died

⑨ I took the petals and put them in a box

⑩ and I locked the box in my heart

THE END

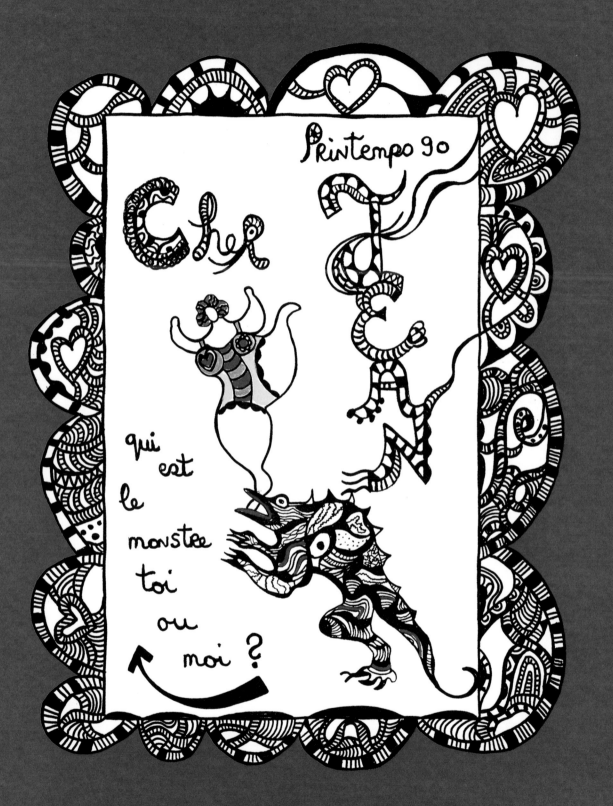

Dear Jean,*

I remember very well meeting you and Eva for the first time in 1955. I was twenty-five years old. I immediately fell in love with your work. Your studio looked like a huge pile of iron garbage hiding wonderful treasures.

A long, black-and-white moving relief was hanging on the back wall of your studio. It had a little hammer hitting a bottle and numerous little wheels with wires which were trembling and turning. I had never seen anything like it, and I was crazy about it.

Harry and I didn't have much money, but we decided to buy it. You were very pleased: you and Eva had just enough to eat and work. You used to steal the coal to heat your studio in winter from the piles behind the hospital adjacent to l'Impasse Ronsin, where you lived.

Your dealer at the time used to buy your entire production. For this she gave you less than $100 a month, starvation wages.

In your studio, there was a ladder which one climbed up and there received a fantastic surprise. Eva had installed in her space perched near the skylight a wonderful world of her own. She had made her first big sculpture in cloth with extraordinary embroidery. She would soon make my portrait.

You liked my paintings, which you took seriously, and also my badly drawn projects on little bits of paper. I drew projects of my future architecture, which I showed you. One of them was a chapel, and you said you would put in motion all the sculptures of the Stations of the Cross.

I talked to you about Gaudí and about the Facteur Cheval, whom I had just discovered and who were my heroes, and the beauty of man alone in his folly without any intermediaries, without museums, without galleries. You were against this idea, you thought art ought to be in society, not outside of it. Then I provoked you by saying that the Facteur Cheval was a much greater sculptor than you.

"I never heard of that idiot," you said.

"Let's go and see him right away," you persisted.

We did, and you felt a tremendous satisfaction with this creative outsider, and you told me, "You're right. He's a greater sculptor than me."

You were seduced by the poetry and the fanaticism of this little postman who realized his insane, immense dream.

Jean, you were very good-looking. You walked like a panther, and you had those magnetic eyes which you knew very well how to use. A very handsome, dangerous-looking man.

*Jean Tinguely, Swiss artist.

I was in love with my husband, Harry Mathews, and I was amused to see you with other women. For me, you were a great seducer. You told me all your techniques about how to seduce women. If you didn't have money, often you'd go to one in a café and say, "Please buy me a cup of coffee." Women enjoyed helping a starving artist.

We had formed a real friendship based on our mutual passion for art.

Eva and you formed a unique couple. Each one as original as the other. Eva had a young lover who lived with you, and your favorite girlfriend liked Eva very much. There was a great complicity between you and Eva and a great love which you lived in your own way.

In 1955, I wanted to make my first sculpture. It was natural that I asked you to weld a structure in iron on which I would put plaster. You borrowed some oxygen bottles—you weren't welding yet.

The sculpture looked like a tree gone crazy. In its branches were stuck all kinds of objects, including multicolored, feathered bait for fish, colored papers, and paint. I had used the fireplace in the bedroom of my two small children, Laura and Philip, as a base. My first sculpture would be for them. Unfortunately, a sculptor friend who later rented the apartment saw fit to destroy it.

It was around 1959 that you spoke to me about Yves Klein, Marcel Duchamp, and Daniel Spoerri. Until then, Hugh Weiss had been my mentor. He encouraged me not to go to art school. I trusted him; the many museums and cathedrals I visited became my art school.

At the same time, there was a huge show of American art in Paris. For the first time, I saw Jackson Pollock, de Kooning, etc…

I was completely bowled over. My paintings suddenly seemed very little in comparison. This was to be my first big artistic crisis. I'd resolve this in the same way I always would in the future: metamorphosis.

I started making reliefs of imaginary landscapes with objects, stopped painting in oils and used gouache and lacquer paints, bought toys in stores and found objects at the flea market. These were mainly objects of violence, like a hatchet, knives, and guns. Sometimes I would put in other things, such as a shoe. It was fun, exciting. I liked this new, immediate way of expressing myself instead of the months of slow, patient work on my oil paints.

I showed you my new works, Jean; you liked them very much. You took me to see Daniel Spoerri's work, which fascinated me. He captured life by gluing tables that had been eaten on. This attitude towards art, which was new to me, was stimulating. You then introduced me to Arman and Yves Klein.

One day I got into a fight with Daniel Spoerri. When he saw one of my reliefs, on which I put nails to represent a rocket, he said, "Why didn't you use a real rocket?" It was part of the New Realists' philosophy to use only found objects. This annoyed me.

Why make rules? I slapped him. Obviously it hit home.

It was also at this time I met the painters Joan Mitchell and Jean-Paul Riopelle. I was mortified because Joan didn't take me seriously as an artist. For her I was a married woman who was painting. I didn't have a gallery so I wasn't a professional. Joan fired my ambition and my desire to prove myself to the world by treating me like the wife of a writer. I thought my paintings were just as good as hers and her painter friends', and I also wanted to prove to them that I existed.

Meeting this group of artists fueled my desire to live the artistic adventure to the hilt without the marvelous equilibrium which I'd found between my work, Harry, and my children. I owe a lot to Joan Mitchell.

I was never bored with Harry for one moment in the eleven years we lived together. I loved my children and my work, my life was filled. A refrain, however, kept coming through my head from time to time: Paradise… How I'd like to descend into HELL and you know HELL! Maybe intense painful reminiscences from the past were creeping up. I didn't want to stay in HELL, but I wanted to go down into the DEPTHS.

There were times when I used to dream about leaving this almost perfect life that I had made such an effort to build with Harry.

I started to talk to Harry about departing and living alone for a year or two, to go to the end of my potential as an artist. I felt I needed solitude.

Harry wasn't happy, but he never did anything to hold me back. He had many weapons he could have used, like the children. Perhaps he had too much respect for me and my art to use them.

I had a brief love affair with a well-known artist at the time who was running after me. He was married, or at any rate, he was living with someone, and his specialty was to break up couples and seduce the wives of friends. I wasn't in love with him, but he held me in a certain way. I didn't like this dependence, so I bought a gun to kill him symbolically. There were no bullets in the gun. The revolver was in my handbag, and it made me feel better.

One day I had the idea to do his portrait. I bought a target in a toy shop, a target to throw darts at, and I asked him if he would give me one of his shirts. Then I put a tie on it. All of this was glued on wood. I called it *Portrait of My Lover*. I started to have fun by throwing darts at his head. It was successful therapy because I began to detach myself from him.

You came to my studio one day with Daniel Spoerri. You both saw this relief and were crazy about it and decided immediately to use it in a new exhibition where the New Realists were shown. I was delighted.

There was a lot of aggression in me that was starting to come out at this time; one night at La Coupôle, which was still only a café-brasserie where artists used to

hang out in Paris, I was with Jean-Paul Riopelle and Joan Mitchell. Giacometti was at the table; later Saul Steinberg arrived. It was quite late at night. [Steinberg] started coming on too obviously. I didn't like it, and I felt humiliated by his exaggerated attention. But I liked his great mustache.

He was carefully and extravagantly dressed. He had on a beautiful gray cape. A great uncontrolled violence suddenly surged up in me. So I took a glass of beer that was on the table and threw it at his head. Giacometti was so thrilled by my doing this that he kissed me on the mouth and spent four or five hours talking to me.

Giacometti talked about art and about his hatred for Picasso. I've always been a great admirer of Picasso and was amazed by the hatred he aroused in many important artists. Picasso was very important to me. I liked his immense freedom with materials and his continual research. His changing of styles stimulated me. For everyone else, at the time, it was Duchamp YES, Picasso NO. I always liked both, and Matisse too.

I started putting my violence into my work. I made reliefs of death and desolation. One of them had the revolver which I had bought to symbolically kill my lover. The moon in these reliefs was always black, with images of violence. Yes, I was starting to descend into HELL.

I started living alone. Harry generously bought my paintings, which permitted me to live very modestly. I was able to work on my art all day long without getting a job. It seemed logical for the children to stay with Harry, as I didn't have enough money to look after them. I went to see the three of them often.

Daniel Spoerri started to court me. I wasn't indifferent to his charm. He looked like Louis Jouvet, whom I found attractive. You were Daniel's best friend, and I noticed that you didn't like this very much.

You and Eva had separated. Eva was going to New York City to join a brilliant and rather crazy scientist, Billy Klüver. Two days before she was to leave, I presented her to a great friend of mine, Sam Mercer, who was a lawyer and painter, full of charm, originality, and surprises. It was love at first sight for them. She decided to remain in France and live with Sam. She moved into Sam's apartment a week later. I was very happy because I didn't like the idea of Eva being so far away. I was also proud of my matchmaking.

Jean, I used to see you often at this time. You would come by, and I would accompany you to the iron yard and choose pieces that excited you. We continued our interminable discussions on art. You talked to me a lot about the Dadaists. You and Yves Klein saw the Abstract Expressionists as the enemy to be defeated. You wanted your vision of the universe to replace theirs.

The day of my thirtieth birthday, October 29, 1960, Harry bought me a gorgeous white curly lamb wool jacket. I looked very spectacular, and Jean and Daniel were

enthusiastic. I was very proud of my new jacket. Daniel invited me to have dinner with him. I accepted with pleasure, and I asked myself, "Would he be my next lover?" When Daniel turned his back, Jean, you came to me and said, "I forbid you to go out with him."

I was very surprised and replied, "Why?"

"I want you to have dinner with me," you said. I didn't want to break the friendship between you and Daniel nor mine with you. I responded, "OK, but what do I tell him?"

"Just lie, invent anything."

I saw in your eyes that something had changed. You looked at me differently. I asked you, "What is it? What's going on?"

You continued, "I can't bear the idea of his going out with you in that beautiful coat. I like it even less than the idea of his touching you."

Two days later I didn't resist your eyes anymore. You were looking at me in this new way I found very disturbing. We didn't leave each other anymore. (It's sometimes dangerous to buy too beautiful clothes for your wife.)

I wanted to be independent, FREE. I had no intention of becoming a couple. I saw myself rather as a Mata Hari of art having plenty of adventures and eventually returning to Harry a year or two later.

Life, however, is never the way one imagines it. It surprises you, it amazes you, and it makes you laugh or cry when you don't expect it.

Collaboration doesn't just happen because you want it to. It is a magical gift and it was inscribed in our Destinies.

We were helped by our love of Play and by the very opposition of our two artistic worlds and by the fact that we loved and were stimulated by each others work.

The encounter between Jean and me is the meeting of two energies which ~~fertilized~~ exploded and gave birth to new creations multiplied

PING PONG. We were always
playing - Ideas back and forth.
When Jean and I started
living together in 1960 he
introduced me to Marcel
Duchamp - Daniel Spoerri -
~~the Resists~~ ~~and the~~ Rauschenberg
Yves Klein ~~and~~ and I
introduced him to the world
of the Facteur Cheval,
Gaudi and the watts towers.
 I met Jean when I
was 25 years old - my pockets
full of little pieces of paper

with drawings on them of
mad gigantic castles and chapels.
He didn't laugh at me like
most everyone else at that
time. He ~~took~~ my visions
seriously. When I told
him that my dreams were
much greater than my
technical abilities he
~~told~~ me this ~~phrase~~ ~~was~~
~~phrase~~ which was ~~so~~ to be so
important for me. "Niki,
the dream is everything,
technique is nothing - you
can learn it."

answer to question no. 6.

I shot AGAINST

Daddy
all men
small men
tall men
Big men
fat men
Men
my brother
society
The church
the convent
school
my family
my mother
AIL MEN
Daddy
myself
MEN

I shot BECAUSE
it was fun and
it made me feel
great.
I shot because
I was fascinated
watching the painting
bleed and die.
I shot for that
moment of magic.
ESCTASY.
It was a moment
of scorpianic truth.
WHITE PORITY SACRIFICE
READy AiM FIRE!
red blue yellow the
painting is crying
The painting is dead.
I have killed the
painting. It is Reborn.
WAR with NO victims
I shot because it
prevented me from
going mad.

74

1961 I SHOT AGAINST

DADDY
ALL MEN
small men
TALL MEN
BiG MEN
FAT MEN
MEN
My BRother
society
the church
the convent
School
my family
my mother
ALL MEN
DADDY
Myself
MEN

I SHOT BECAUSE
it was fun and
made me feel great.
I shot because
I was fascinated
watching the painting
bleed and die.
I shot for that
moment of MAGIC.
ECSTASY
It was a moment
of Scorpianic truth
WHITE PURITY
SACRiFICE
READY AIM FIRE!
RED yellow blue
the painting is
CRYing
the painting is DEAD.
I have killed the
painting. It is Reborn
WAR WITH NO VICTIMS

DEAR MR. IOLAS,
 HERE IS A FIRST STUDY
FOR the SHOOTING gallery
for my show. I hope
you think it is O.K.
 amitiés _ Niki _

the moon and a little bird

AT

BOUM

CATHEDRALE
WITH A GARGOYLES
Nouveaux
etc.
ART
Statues
COWBOYS

HEIGHT 3 x 36 inches plus 15 inches

WIDth 5 x 36 inch

IDEA OF MOVING PLASTIC BAGS
 PONTUS HULTEN
MECHANICAL REALIZATION
 JEAN TINGUELY

MOUNTAIN
OF OBJECTS.
REMAINS OF
OUR CIVILIZATION
UMBRELLAS. CLOCKS
FRYING PAN, TOYS. RADIO
ROCKETS ETC.

BOMB
XPLODING

Airplanes attacking
jet airplanes

scenic BIRD
Metal behind
wood

Sachets animé

NO. 1
MOVING PLASTIC BAGS
OF PAINT

Try and get
bones from zoo?

PLASTIC
BAGS PAINT
OF

SNAKE

the dead—
arms legs feet
cadavers of
rules reptiles etc.
animals

DON'T WORRY
I DON'T THINK ANYONE
WILL GET SPATTERED WITH
PAINT.

4 x 36 inches away
FROM MONSTERS
STANDS SPECTATOR
SHOOTER

REMEMBER 1960-61-62?

Dear Cher

Rostu

PERFORMANCE

PARTiCiPATiON

BANG

darts

target

cible

VIOLENCE

MANS SHiRT

ACTION

RAGE

Mis a MORT

PORTRAIT OF MY LOVER

DEATH

↓

REBIRTH

GUN

ROUGE

SMOKE

TABLEAUX TiR

SURPRISE

SHOOTING PAINTINGS

Dear Pontus,*

You asked me about the shooting paintings.

One spring day in 1961 I was visiting the Salon Comparaisons exhibition in Paris. A relief of mine was hanging in the show. It was called *Portrait of My Lover*.

There were darts on the table for spectators to throw at the man's head. I was thrilled to see people throw the darts and become part of my sculpture. Near my work, there hung a completely white plaster relief by an artist named Bram Bogart. Looking at it—FLASH! I imagined the painting bleeding—wounded; the way people can be wounded. For me, the painting became a person with feelings and sensations.

What if there were paint behind the plaster? I told Jean Tinguely about my vision and my desire to make a painting bleed by shooting at it. Jean was crazy about the idea; he suggested I start right away.

There was some plaster at l'Impasse Ronsin. We found an old board, then bought some paint at the nearest store. We hammered nails into the wood to give the plaster something to hold onto, then I went wild and not only put in paint but anything else that was lying around, including spaghetti and eggs.

When five or six reliefs had been finished, Jean thought it was time to find a gun. We didn't have enough money to buy one, so we went to a fairground in the boulevard Pasteur and convinced the man at the shooting stand to rent us his gun. It was a .22 long rifle with real bullets, which would pierce the plaster, hit the paint in little plastic bags embedded inside the relief, causing the paint to trickle down through the hole made by the bullet and color the outside surface. The man from the shooting stand insisted on coming along. Maybe he was afraid we wouldn't return his gun.

We had to wait a couple of days before he came, which, of course, added to the excitement and gave us time to invite a few friends, including Shunk and Kender, photographer friends who documented the first shoot-out. Jean also invited Pierre Restany, who then and there decided, while watching red, blue, green, rice, spaghetti, and eggs (where was the yellow?), to include me among the New Realists. I was getting a great kick out of provoking society through ART. No victims.

We took turns shooting. It was an amazing feeling shooting at a painting and watching it transform itself into a new being. It was not only EXCITING and SEXY, but TRAGIC—as though one were witnessing birth and a death at the same moment. It was a MYSTERIOUS event that completely captivated anyone who shot.

We nailed the reliefs to a back wall of l'Impasse Ronsin. There was a long, grassy field in front of the wall, which gave us plenty of room to shoot.

Pontus Hultén, Swedish museum director.

L'Impasse Ronsin was situated near the L'Hôpital des enfants malades in the middle of Paris, just off the rue Vaugirard. Brancusi still lived there, and Max Ernst had previously lived in these little ramshackle studios. They were a poetic group of little shacks with no water or bathrooms.

Today it seems quite incredible that one was able to shoot freely in the middle of Paris. A retired cop who lived nearby came and watched the shoot-outs as soon as he heard the shooting begin! He liked these events and never asked about a gun permit—this was in the middle of the Algerian War!

For the next six months, I experimented by mixing rubbish and objects with colors. I forgot about the spaghetti and rice and started concentrating on making the shooting paintings more spectacular. I started to use cans of spray paint, which when hit by a bullet made extraordinary effects. These were very much like the Abstract Expressionist paintings that were being done at that time. I discovered that when paint fell on objects, the result could be dramatic. I used tear gas for the grand finale. Performance art did not yet exist, but this was a performance.

The smoke gave the impression of war. The painting was the victim. WHO was the painting? Daddy? All Men? Small Men? Tall Men? Big Men? Fat Men? Men? My brother JOHN? Or was the painting ME? Did I shoot at myself during a RITUAL which enabled me to die by my own hand and be reborn? I was immortal!

The new bloodbath of red, yellow, and blue splattered over the pure white relief metamorphized the painting into a tabernacle for DEATH and RESURRECTION. I was shooting at MYSELF, society with its INJUSTICES. I was shooting at my own violence and the VIOLENCE of the times. By shooting at my own violence, I no longer had to carry it inside of me like a burden. During the two years I spent shooting, I was not sick one day. It was great therapy for me. The ritual of painting a relief over and over again in immaculate virginal white was very important. The theatricality of the whole performance appealed to me immensely.

It was late spring 1961 that I met Jasper Johns and Robert Rauschenberg. They had already met Jean Tinguely at the time of his *Homage to New York* at the MoMA. We soon became friends. I found both of them gorgeous and was fascinated by their being a couple. They had a grace that comes with beauty allied with exceptional talent and intelligence. It was electrifying being with them.

I made an homage to Jasper. It was a relief with a target and a light bulb painted in his colors. I asked him to finish it by shooting. He took hours deciding where to shoot the few shots he finally fired at the target. Bob Rauschenberg, however, shot his piece in a few minutes and screamed, "Red! Red! I want more red!"

Bob had a particular way of talking about art and its relationship to life that was expressed with such clarity and passion that it would linger inside of me for many years and become a part of me.

Jasper and Bob invited Jean and me to participate with them in a David Tudor concert which was to be given at the American embassy. The music was by John Cage. I was very excited and proud to be involved in a project with artists that I admired so much. Jasper decided, after much thought, that he would have a target made of flowers. Bob worked onstage during the entire performance creating a painting the audience never saw; when it was finished he wrapped it up in a sheet and carried it away. David Tudor spent most of the time under the piano.

Jean made a sexy machine called *Striptease*. Over the course of the musical evening, the machine shed various parts until all that was left was the motor. I prepared a shooting painting which was shot at by a professional shooter—David was afraid I might kill him by mistake!

The audience, except for Leo Castelli and a few fans, was not nearly as enthusiastic about the concert as we were. As a matter of fact, they hissed and booed and a lot of people left before the end. We found the hostility and the anger stimulating.

I think it was around February or March of 1960 that I met you, Pontus. Jean had told me a great deal about you, and I also knew that you were the director of the Moderna Museet in Stockholm, so I was in awe of meeting you. You quickly put me at ease. Whenever there was something to twiddle or play with, like a piece of string lying on the table, it was irresistible to you, and you would pick it up and play with it for hours. I understood you were one of us.

Your enthusiasm for the shooting paintings was a great support to me. At the time, I was being attacked by the newspapers constantly.

The first time you visited my studio in rue Alfred Durand-Claye, you spent hours looking at my old paintings. I had disowned them, thinking they were no longer interesting. We argued about this, but I was secretly very pleased that you liked them. A few years later, you would buy one for the museum.

It was June 1961 that I had my first one-man show in Paris, at the Galerie J. I was finishing *The Shooting Stand* on the day of the show. Visitors would be allowed to shoot at a painting. Three reliefs would be prepared and shot at during the show. Jean had put a big sheet of rusty iron behind the reliefs to protect the wall and a contraption to catch the paint that ran down from the painting so that it wouldn't drip to the floor. Jeannine de Goldschmidt, the gallery owner and Pierre Restany's wife, stayed marvelously calm during the proceedings, and it did not seem to bother her at all that there would be shooting every day in her gallery with a .22 long rifle (by that time, we had found the money to buy a gun).

An hour before the show opened, an elderly man with a degenerate face came in and asked, "When can I shoot?" I explained he would have to wait a bit until we had finished hanging the show.

"Why don't you come back in a little while?"

"No, I'm not going to leave. I'm going to stay right here until I can shoot."

Every ten minutes he would ask, "Can I shoot now?" I finally got annoyed and went over quietly to Jeannine and implored, "Can't you find some nice way of getting rid of that guy. He's a nuisance."

Jeannine declared, "Are you kidding? That is Fautrier!" I was a fan of Fautrier's work even though his preoccupation with paint and space were very far from mine. I came back to him and said, "OK, you can start shooting." Later, when the crowd started arriving, he had difficulty giving up the gun. He kept shooting at the center and was trying to make one of his own paintings out of the shooting. When someone else was taking a shot, he would scream, "The center, the center! Shoot at the center!"

My other fellow artists were also fascinated by the fact that by shooting at a painting they could finish a work of art. They, too, were caught up in the spellbinding dynamics of the shooting paintings, a feeling as indescribable as making love. Bob Rauschenberg thrilled me by buying a sculpture of mine at the opening-night show.

Autumn 1961, Larry Rivers moved into one of the studios at l'Impasse. He was there with his new bride, Clarice. I would go and chat with them often. Jean was suspicious of these people he didn't know and refused to meet them. When Jean felt I had been chatting with them too long, he would take my gun and start shooting in the air. I knew it was time to come home. One day he could no longer resist the smell of Clarice's homemade soup, which won him over; after that we had lunch with them every day.

We almost lost their friendship, however, by forgetting to warn them that we were going to use the front of their house to shoot at my new relief with a small cannon Jean had just built. By mistake, Jean mixed in a little too much gunpowder with the paint in the cannon. When the cannon hit the relief, the entire house shook. Larry came out screaming, "What are you trying to do, kill us?" After much apologizing, our friendship was saved, and we continued to enjoy our great lunches together.

Why did I give up the shooting after only two years? I felt like a drug addict. After a shoot-out, I felt completely stoned. I became hooked on this macabre yet joyous ritual. It got to the point where I lost control. My heart was pounding during the shoot-out. I started trembling before and during the performance. I was in an ecstatic state.

I don't like losing control. It scares me, and I hate the idea of being addicted to something—so I gave it up. I was tempted to return to shooting when I suffered extreme depression and also while I had rheumatoid arthritis and could hardly walk.

I wanted to shoot my way out of the disease. I decided against it because I wasn't able to think of a new way to make the shooting paintings, and I didn't want to do the same thing I had already done. IT HAD TO BE NEW OR NOT BE, so I gave up the idea.

It was also hard to give up all the attention in newspapers and newsreels I was getting from the shooting. Here I was, an attractive girl (if I had been ugly, they would have said I had a complex and not paid any attention), screaming against men in my interviews, and shooting with a gun. This was before the women's liberation movement and was very scandalous.

It was not surprising that hardly anyone bought these works and they mainly belong to me today. Bill Seitz from the MoMA made a statement that my attitude was harmful to art and that I had set back modern art by thirty years!

From provocation, I moved into a more interior, feminine world. I started making brides, hearts, women giving birth, the whore—various roles women have in society.

A new adventure had started.

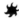

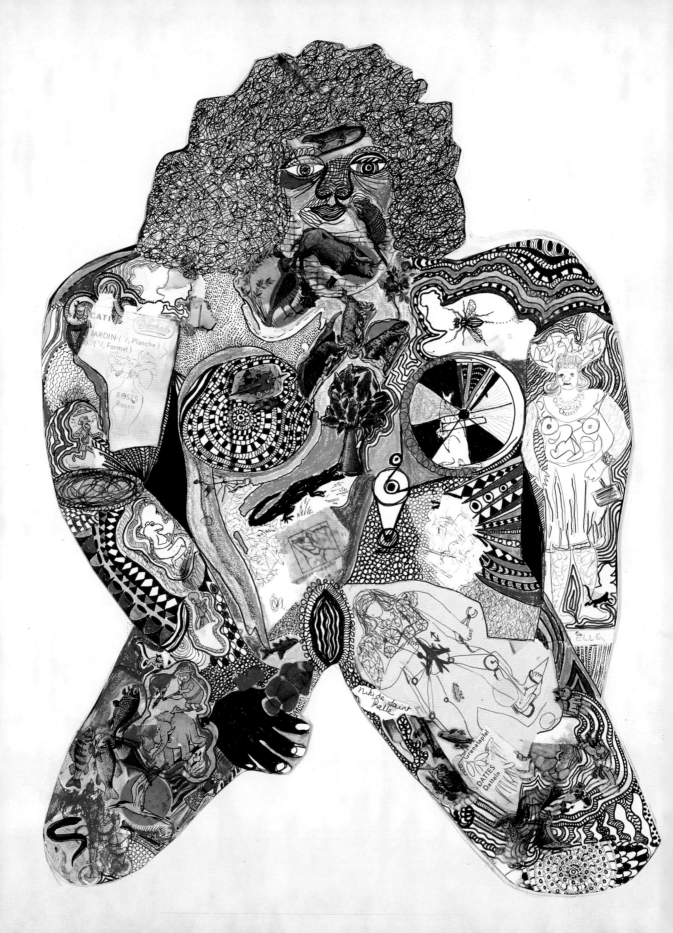

I don't think I belong to any society. I feel rootless. I was born French, I was brought up in America, and I've no spiritual or emotional tie with the family that raised me. People always rebel when they're not at ease, and I rebelled because I was born in what for me was the wrong milieu. Now I feel very much at ease. When it comes down to it, the milieu that suits me is one of people who have done something with themselves, no matter what. They might be artists, filmmakers, or butchers. The point is they're people who have put everything into it... and who have had the courage to pack up and move on. That's what I did.

We have about
300 cuts from the
wire / 500 bruises
- burns - glue -
all over our hair.
15 hours work a
day - aside from
Jean [?] and me
we have 6 helpers.
One of them went
on strike today!

Cathedral - factory - Noah's Arc
Jonas in the whale tomb spaceship
La Mama
elephant - plane
Submarine

long live the CUNT

7 months pregnant

the opening is May 31
 today is the 15th

What is John Ashbery up to these days?

look at the size of that tit
pretty terrific!

Is Frank coming over this summer?

Larry send us a polaroid shot of
the church next time you are out in
Southampton. We can't really remember
what it looks like not that it matters. Your
idea about a wall is necessary I think.

Tomorrow I start painting the outside
in color. She is driving me insane /
I am completely obsessed. I can't
sleep at night / Keep thinking about
her. When she is finished I'll go inside
with a machine gun and kill anyone
who tries to come in. I just can't bear
the idea of all those fucking people
walking inside her. If Larry has any
airplane pills left send me some in
an envelope. I only have 2 left. I have
taken the others to sleep at night.

Clarice when are you coming to Soisy? There is plenty of
room for all of you. A car and a babysitter.

how are you both? How is the book? Gwyn?
the carpet? Clarice your parents? the new sculpture bathtub neon
wood / the food? Clarice's [line drawing of a Nana]? the weather?
the drugs? Gaisseau's movie? the Oldenburgs? say hello for me.
Steve? Joe? Charlotte? Your spirits? up? or down? Southampton?
WRITE

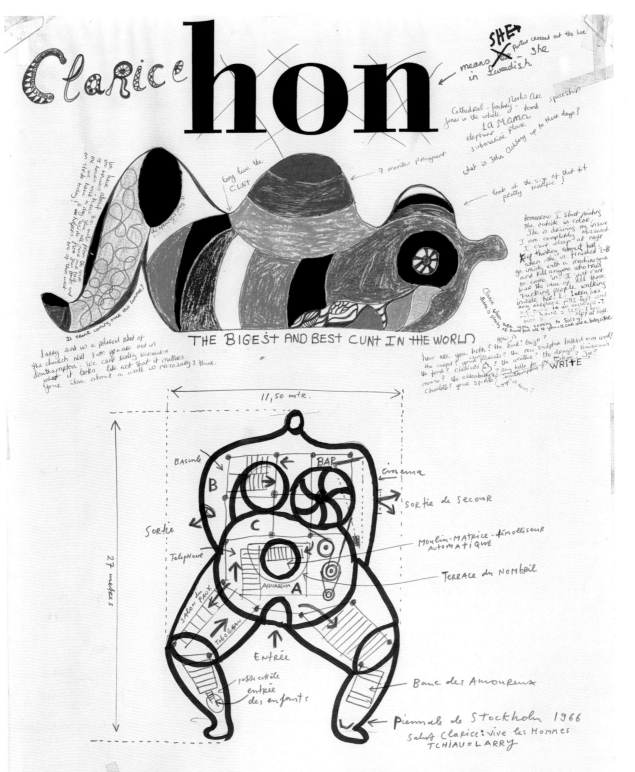

Moderna Museet

Alla dagar 12-17
Onsdagar 12-22
Efter 1/7 alla dagar 12-22

Niki de Saint Phalle
Jean Tinguely
Per Olof Ultvedt

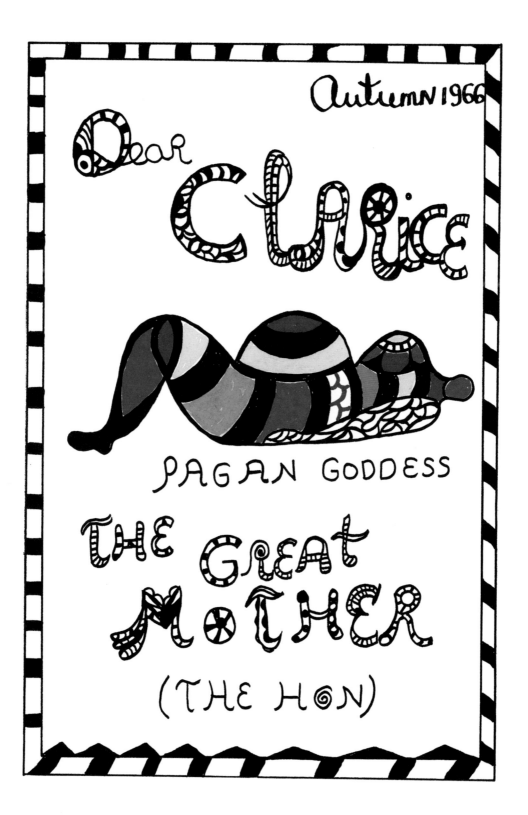

Dearest Clarice,*

You asked me what it was like working and making the HON, the BIGGEST NANA I ever made. She was ninety feet long, eighteen feet high, twenty-seven feet wide. Pontus Hultén, director of the Moderna Museet in Stockholm, asked me to go there in the spring of 1966 with Tinguely, Martial Raysse, and Claes Oldenburg to build a monumental sculpture in the big hall of the museums. Martial Raysse declined the invitation. Oldenburg couldn't come at the last moment, and Jean had just started some new work in Soisy and wasn't in the mood. It looked as though the whole project would fall through, but a secret voice kept telling me that I must go, that it was important. I listened.

The first few days we met in Stockholm were unsatisfactory. My enthusiasm convinced Jean to come also, and many ideas were tossed about by Jean, Pontus, myself, and the Swedish artist who joined us, Per Olof Ultvedt. Pontus suggested we all go to Moscow for a few days (Jean and I had never been there), and either the city or the vodka would inspire us. We were about to buy our tickets when Pontus had a brainstorm. EUREKA! He suggested we build a huge, penetrable Nana that would be so large she would take up the entire hall of the museum. We suddenly became very excited. We knew we were entering the sacred land of myth. We were about to build a goddess. A great PAGAN goddess.

As you, Clarice, were the original Nana, consider yourself the model for the GREAT GODDESS.

Jean assumed the technical direction of a team of volunteers that Pontus found for us. One of them was Rico Weber, a young Swiss artist who was to remain afterwards as assistant collaborator for Jean and me for many years. Rico was working as a cook at the snack bar of the museum. We had six weeks to produce our huge giantess and must have worked sixteen hours a day. We named our goddess HON, which means SHE in Swedish. I made the original small models that gave birth to the goddess. Jean, by measuring with eyes only, was able to enlarge the model in an iron frame and have it look exactly like the original. After the chassis had been welded, chicken wire was attached to the immense surface of the Goddess. I cooked, in huge pots, a mass of stinking rabbit-skin glue on small electric heaters. Yards of sheet material were mixed with the glue and then placed on the metal skeleton. Several layers were necessary to hide the frame. I often felt like a medieval witch brewing this glue. When the sheets dried and were stuck to the metal, we painted the body of the goddess white. I then made my design using the original model with some modifications. Later, with the help of Rico Weber, I painted the sculpture.

*Clarice Rivers, wife of artist Larry Rivers.

Pontus worked night and day, sawing and hammering and participating in every way he could with us. Meanwhile, Jean and Ultvedt were occupied with filling the inside of the body of the goddess with all kinds of entertainment. Jean made a planetarium in her left breast and a milk bar in the right breast. In one arm, we showed the first short movie starring Greta Garbo, and in a leg, a gallery of fake paintings (a fake Paul Klee, Jackson Pollock, etc.).

The reclining Nana was pregnant, and, by a series of stairs and steps, you could get to the terrace from her tummy, where you could have a panoramic view of the approaching visitors and her gaily painted legs. There was nothing pornographic about the HON, even though she was entered by her sex.

Pontus knew he had embarked on a perilous venture with this great lady and decided to keep the entire project secret. Otherwise, the authorities might hear distorted rumors and shut the show before it opened. We constructed a giant screen, behind which we worked; no one was allowed to see what we were doing.

I remember laughing with Pontus many times about enjoying his last moments at the museum before he was asked to leave by an outraged cultural minister. He was willing to take the risk as he always does when he believes in something. Pontus Hultén had already brought many innovative artists to Stockholm. He was the first to show Jasper Johns; he bought Rauschenberg's goat. He arranged for Jackson Pollock to be seen in Sweden and for John Cage to give his first concert, which everyone left horrified.

During this time, I was painting the HON like an Easter egg with the very bright, pure colors I have always used and loved. She was like a grand fertility goddess receiving comfortably in her immensity and generosity. She received, absorbed, and devoured thousands of visitors. It was an incredible experience creating her. This joyous, huge creature represented for many visitors and me the dream of the return to the Great Mother. Whole families flocked together with their babies to see her.

The HON had a short but full life. She existed for three months and then was destroyed. The HON took up all the space of the big hall of the museum and was never meant to stay. Wicked tongues said she was the biggest whore in the world because she had 100,00 visitors in three months.

A Stockholm psychiatrist wrote in the newspaper that the HON would change people's dreams for years to come. The birth rate in Stockholm went up that year. This was attributed to her.

The HON had something magical about her. She couldn't help but make you feel good. Everyone who saw her broke into a smile.

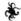

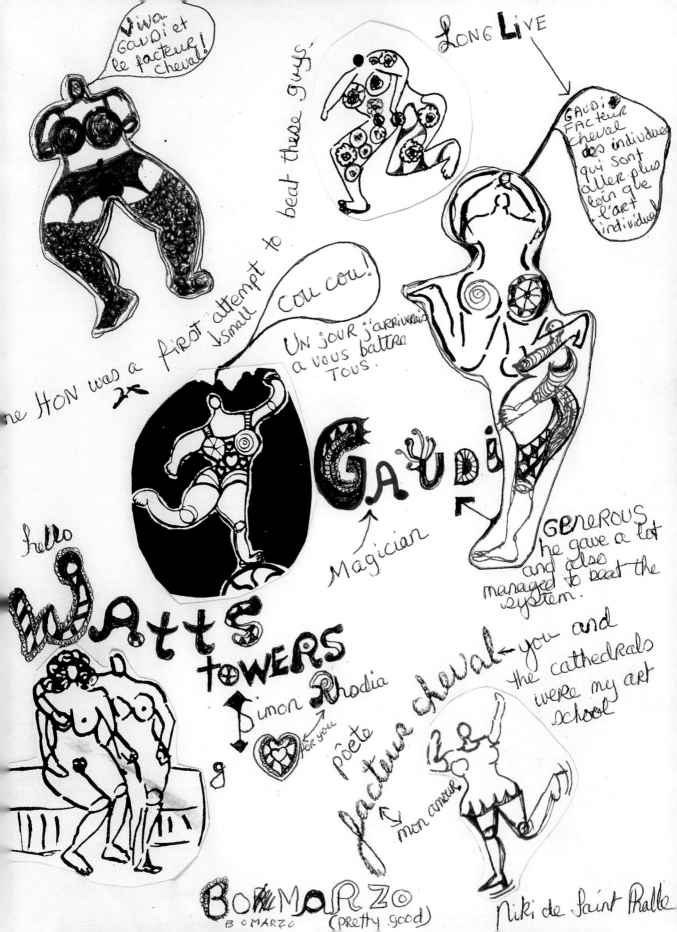

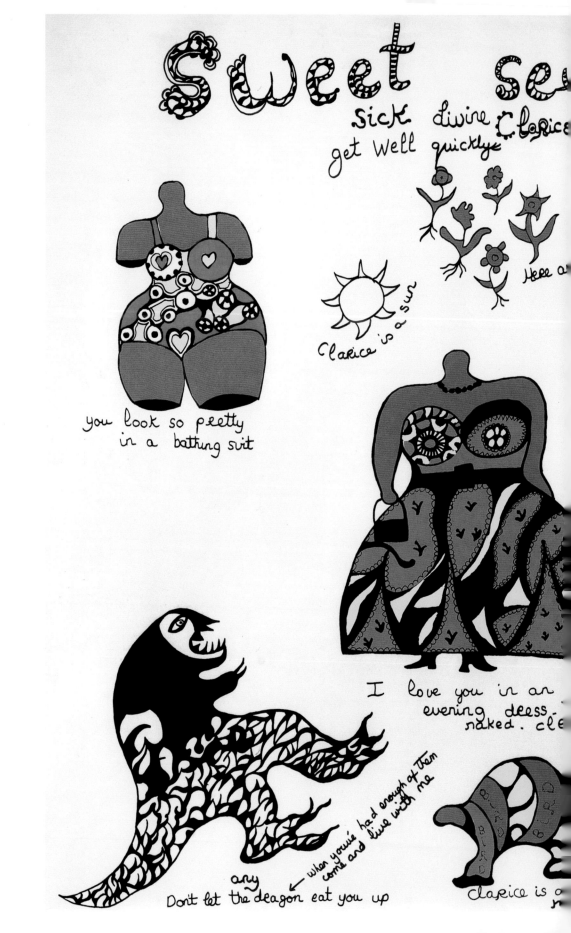

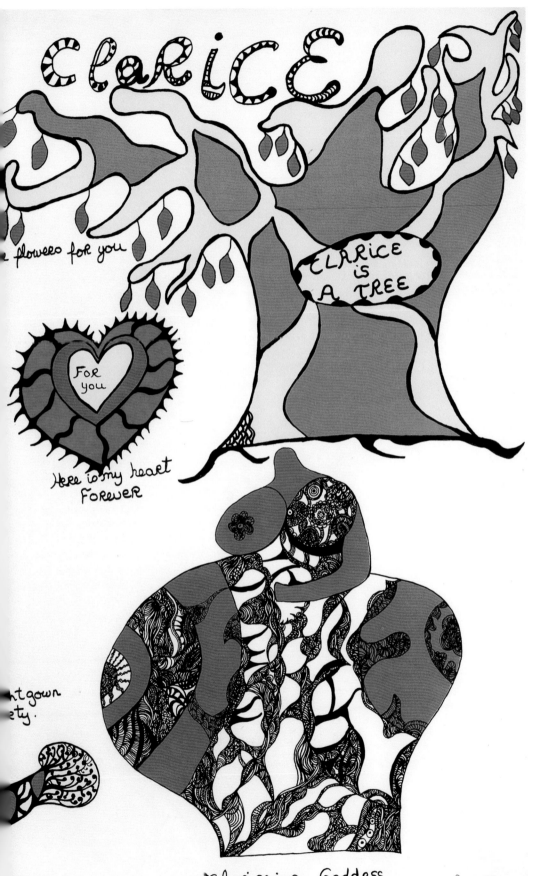

CLARICE

flowers for you

CLARICE
is
A TREE

FOR
you

Here is my heart
FOREVER

ntgown
ety.

Clarice is a Goddess
↑the

Niki de Saint Phalle

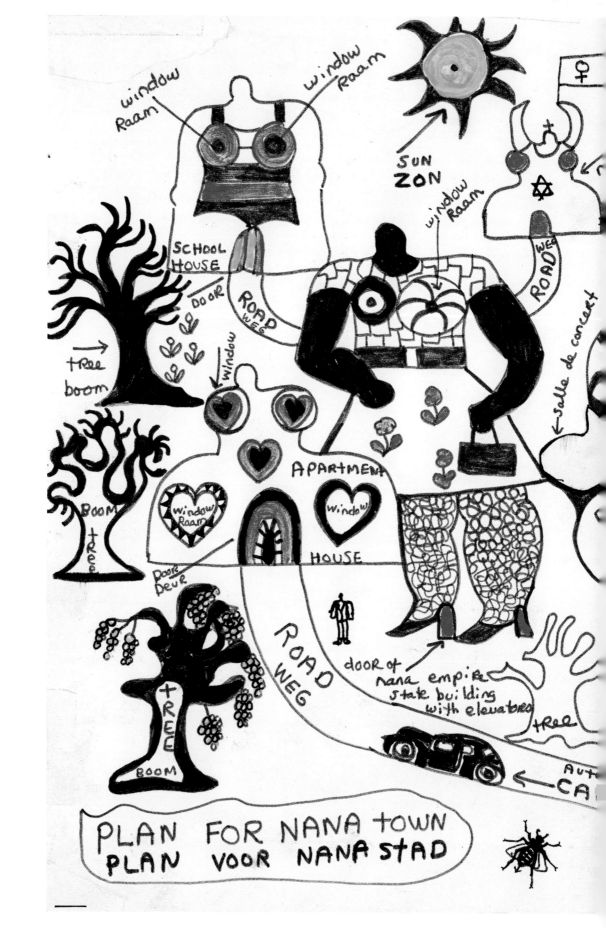

PLAN FOR NANA TOWN
PLAN VOOR NANA STAD

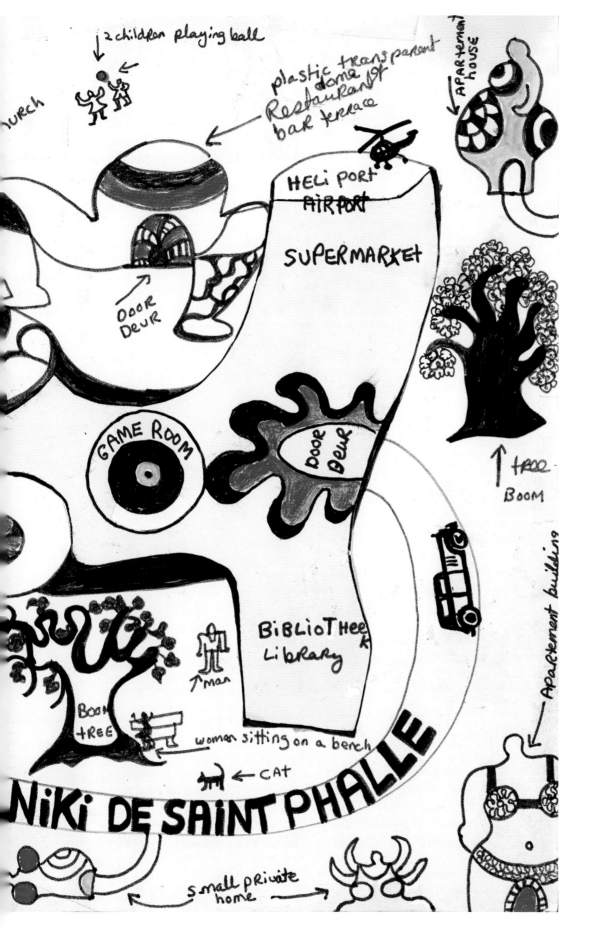

Love is my Achilles heel.
mon point faible. mon point méchant.
 My roles are forever
changing. Who am I today?
The Daughter, the Father, the
Brother, the Victim, the Mother,
the Tormentor? the ~~the~~ vampire?
 I want to Love you.
I want to give you everything.
Let me love you.
 Please please don't love
me too much. Don't get too
 don't devour me.
near ~~me~~ I will burn you. I
don't want to.
 I have sold everypart.
of me. My legs. my arms, my sex
my lips, my hair, my imagination

my breasts.

Every sigh every heartache every emotion I have rendered visible in some drawing some color and then I have sold them.

A woman crying a lake of tears. Lithograph numbered 1 to 75. That was 1969. I was heartbroken. ~~Who was it?~~ Who was it?

How much money did I make out of that?

There are those moments those Eternal moments when Love is a flower. When Love is Love. Love is the Sun. Love is me. Love is you. Love is Forever.

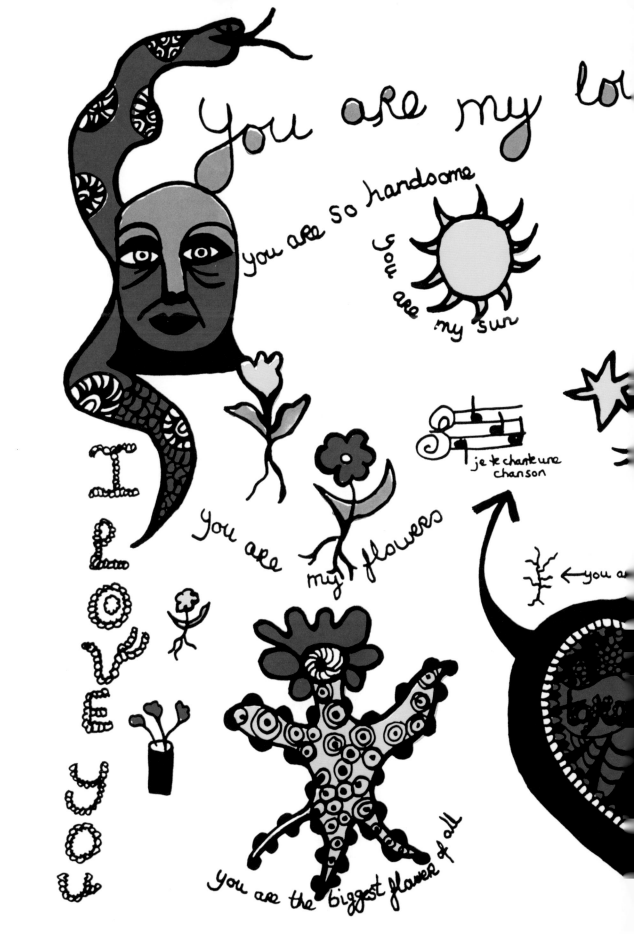

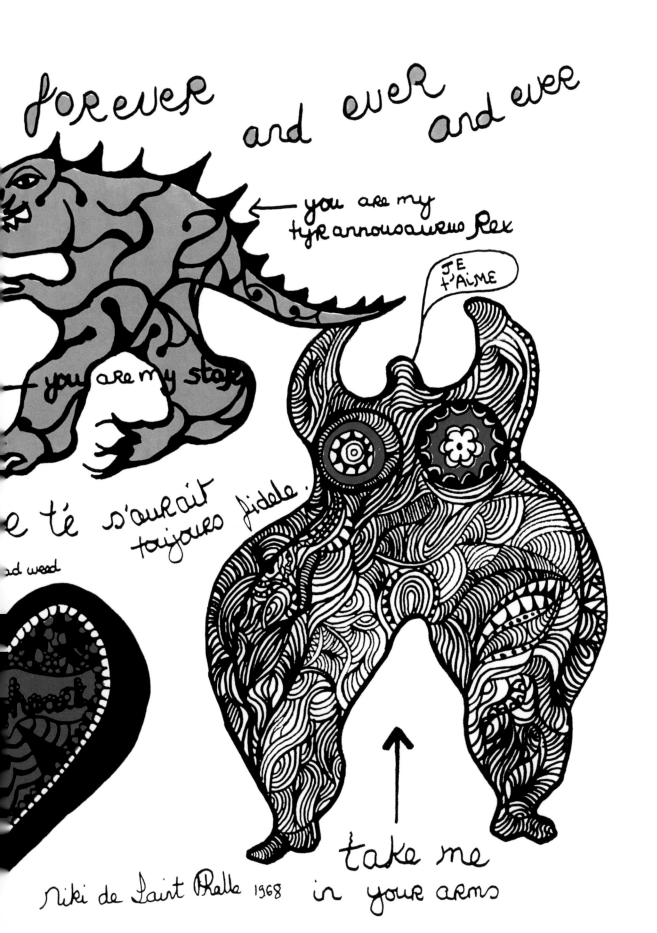

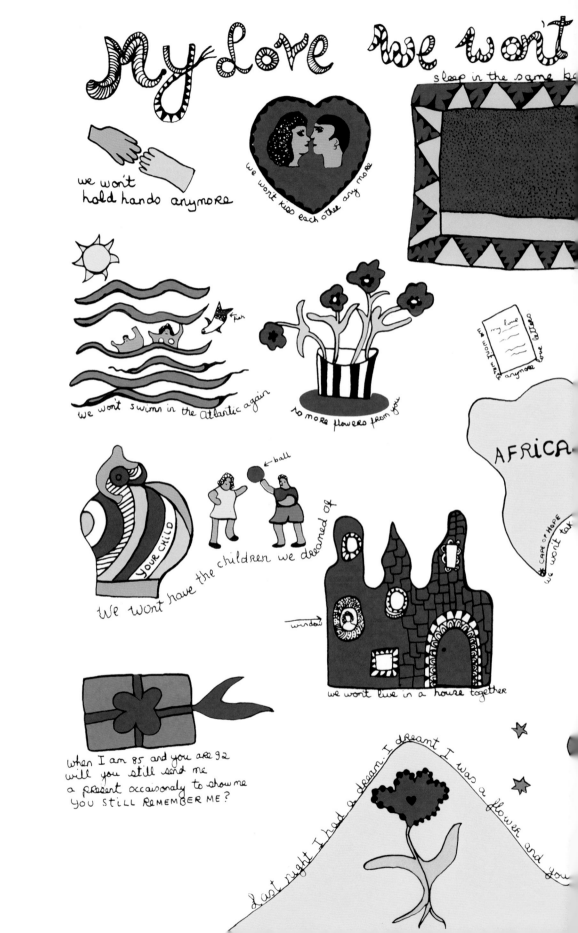

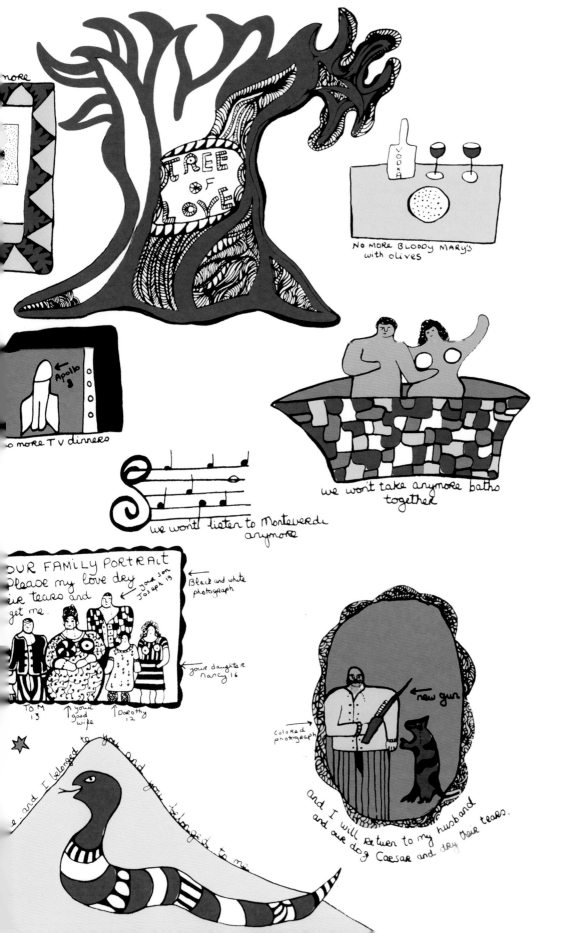

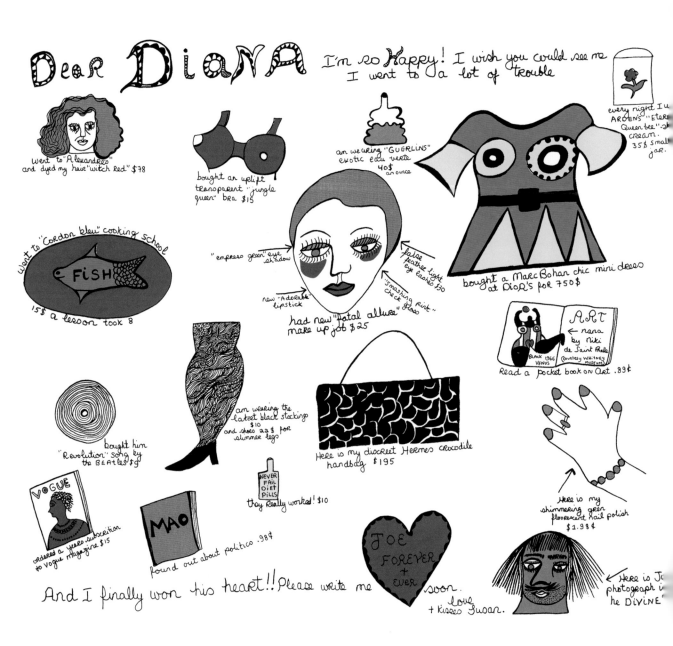

Dear DiaNa I'm so Happy! I wish you could see me I went to a lot of trouble

Went to "Alexandre's" and dyed my hair "witch red" $78

bought an uplift transparent "jungle queen" bra $15

an wearing "GUERLINS" exotic eau verte 40$ an ounce

every night I use ARDEN'S "Eterna Queen bee" skin cream. 35$ small jar.

Went to "Cordon bleu" cooking school

FISH

15$ a lesson took 8

"empress green" eye shadow

false light feather eye lashes $30

"smashing pink" cheek gloss

new "Adorabl" lipstick

had new "fatal allure" make up job $25

bought a Marc Bohan chic mini dress at DiOR'S for 750$

ART
← nana
by niki
de Saint Phalle
BLACK 1966 VENUS (Courtesy Whitney Museum)
Read a pocket book on Art .89$

bought him "Revolution" song by the BEATLES $9

am wearing the latest black stocking $10 and shoes 22$ for slimmer legs

Here is my discreet Hermes crocodile handbag $195

here is my shimmering green floorescent nail polish 1.98

VOGUE
ordered a years subcription to Vogue magazine $15

MAO
found out about politics .98$

NEVER FAIL DIET PILLS
they really worked! $10

JOE FOREVER + EVER

Here is Joe photograph he DiVINE

And I finally won his heart!! Please write me soon.
love + kisses Susan.

Mother was very young and beautiful. She had beautiful brown auburn curls piled high on her head. She looked sexy. She was petite and had a well-rounded figure. Her makeup was impeccable, and she smelled good. It was Chanel No. 5.

I liked Mother's looks; I liked the power it gave her. I liked her 1930s thick transparent glass dressing table covered with creams and powders and lipsticks. I loved her auburn curls and flawless white skin. I liked the way she elegantly spit into her mascara to make it thicker. She looked like the actress Merle Oberon. Even her name, Jacqueline, was quite sexy.

I did not reject Mother. I retained things from her that have given me a lot of pleasure—my love of clothes, fashion, hats, dressing up, and mirrors. These things I took from her, and they helped me to stay in touch with my femininity.

I saw this beautiful creature, Mother, whom I was a bit in love with (when I didn't feel like killing her), as a prisoner of an imposed role. A role handed down generation after generation by a long tradition which no one ever questioned.

So many things turn me on… a cat, stroking a cat… our little dachshund sausage dog named Vic and the way he would waddle around with his pointed nose and his silky ears… all kinds of colors, colors in the sky, colors in the trees, colors from the grass growing. There was always and there still is something to get excited about. If I get into a bad slump, my enthusiasm for something can always get me out. I know this and can use it. If something awful happens, that is the time to go and buy a new dress, go and eat caviar. What's the use celebrating when everything's going fine? It's much better to usher in new good waves by celebrating the bad times.

Learning to juggle a little helps a lot and believing and helping it to pass instead of caressing one's pain helps things to move along. I don't like stagnation; I prefer swimming with the river.

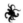

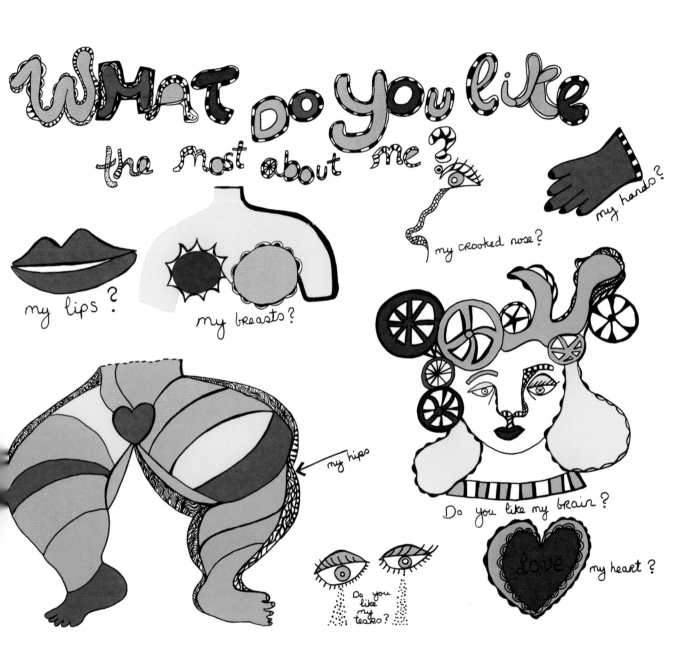

WHAT DO you like the most about me?

my lips?

my breasts?

my crooked nose?

my hands?

my hips

Do you like my brain?

Do you like my tears?

Love my heart?

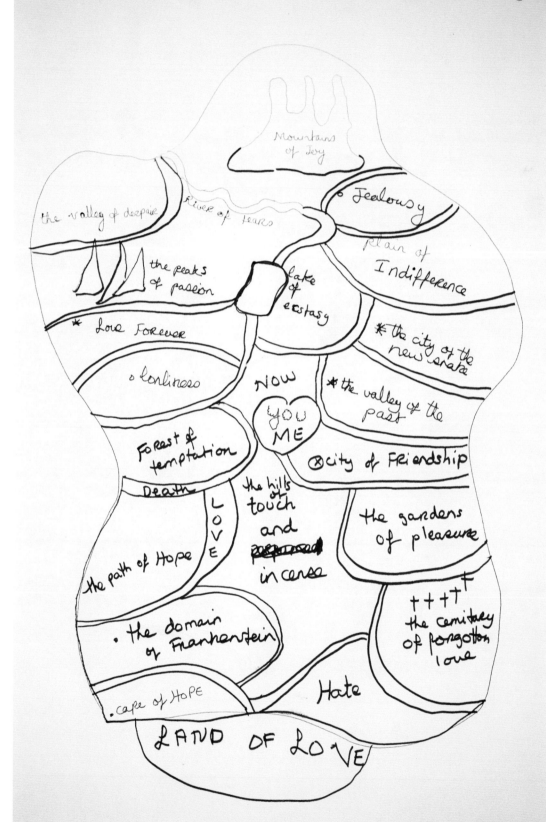

I like roundness.
I like roundness, curves,
wavy lines.
The world is round. The world
is a breast.
I don't like right angles
they scare me.
The right angle wants to
kill me.
The right angle is an assasin.
The point of the right angle
is ~~a~~ a knife
The right angle is pain.

I don't like symetry
I like imperfection.
My cercles are never
perfect.
This is my choice.
Perfection is cold.
Imperfection gives life.
I love the imaginary
the way a monk can love
God.
The imaginary is my refuge
my palace.

3.

Imagination leads me
inside what is square and
what is Round.
I am blind. My sculptures
are my eyes.
Imagination is the Rainbow.
Hapiness is imaginary,
what is imaginary is Real.

My mother would tell me about intercepting a letter that Dr. Cossa had sent to my father. Upon seeing this letter addressed to my father from my psychiatrist, she felt compelled to open it. My mother read the doctor's words in utter dismay. Dr. Cossa listed my father's alleged transgressions and informed him I would spend the rest of my life in psychiatric clinics if he went on writing such vile lies to me. He then strongly urged my father to see a psychiatrist... as he felt sure he was suffering from delusions. That night, my mother confronted my father with the content of Dr. Cossa's letter... which he admitted was true with great remorse. My mother in turn was overwhelmed with an immediate temptation to jump out the window.

Years later, as a form of exorcism, I would make a black-humor fantasy film called *Daddy*, in which I symbolically killed my father seventeen times. My entire family was extremely indignant and horrified by it, saying that I had vilified my father's memory. One person defended me... my mother.

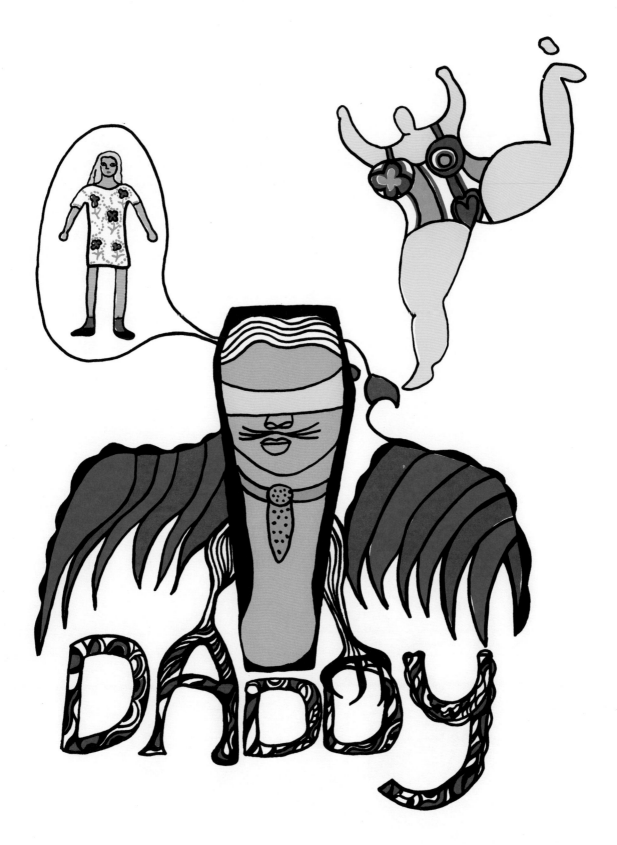

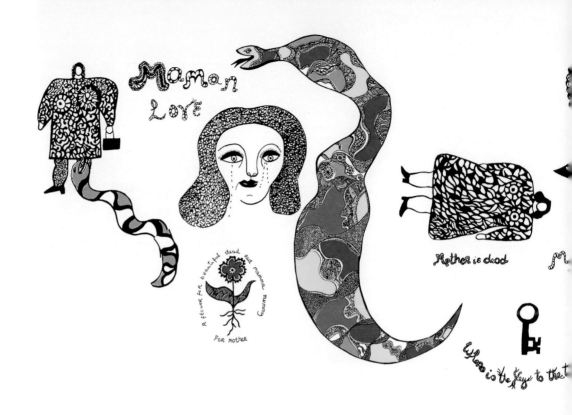

Maman Love

Mother is dead

A flower for beautiful dead, sad maman, mummy for mother

Where is the key to the t

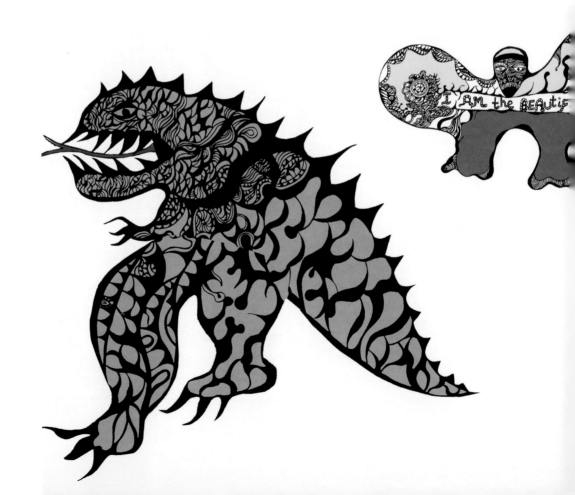

I AM the BEAUtif

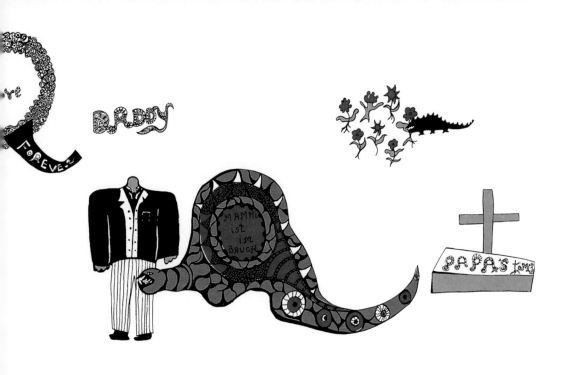

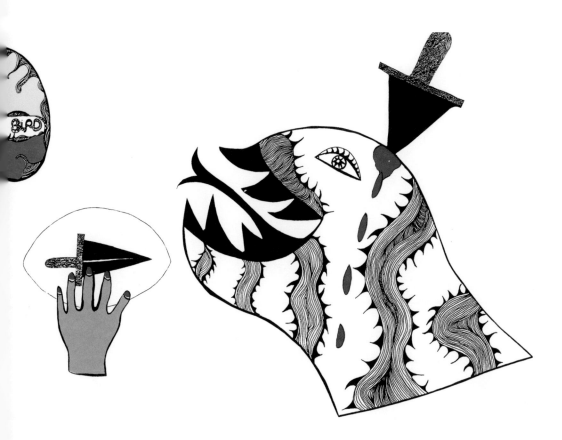

① I UNDERVALUE myself

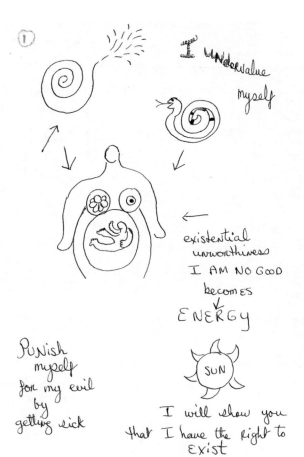

existential
unworthiness
I AM NO GOOD
becomes
ENERGY

PUNISH
myself
for my evil
by
getting sick

SUN

I will show you
that I have the right to
EXIST

② I OVERVALUE myself

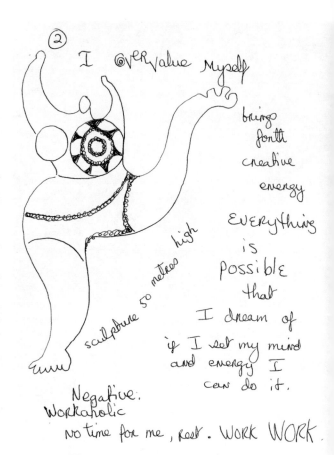

brings
forth
creative
energy

EVERYTHING
is
POSSIBLE
that
I dream of
if I set my mind
and energy I
can do it.

sculpture 50 metres high

Negative.
Workaholic
No time for me, rest. WORK WORK.

⑤

How people PERceive Me?

as a Maker of things images
Dreams.
for some I am a heroine
for others I am a Meglomaniacal
power trip woman.

For some it is important
that I have been associated
with humatarian causes.
~~my family would see~~

⑥

How people would like
me to BE.

I feel a lot of, young people
especialy young women want
me to go on my journey
and bring to the maturity
of my work and life
a deepening of, meaning, awareness
and life and Reavaluating
the possiblities open to a woman.
my family would say
Take it easy. Rest. travel.
enjoy yourself. (which would exhau

③

secret (very) FANTASY

having a bouquet

of
men
MEN

YOUNG middle
old

at my feet
counting me.
(life time
fantasy)

④

How I would like to appear
to Others?
(me)
As close to the original
as possible

not hide my
contradictions

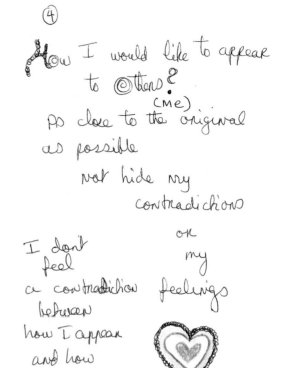

I don't
feel
a contradiction
between
how I appear
and how
I am

or
my
feelings

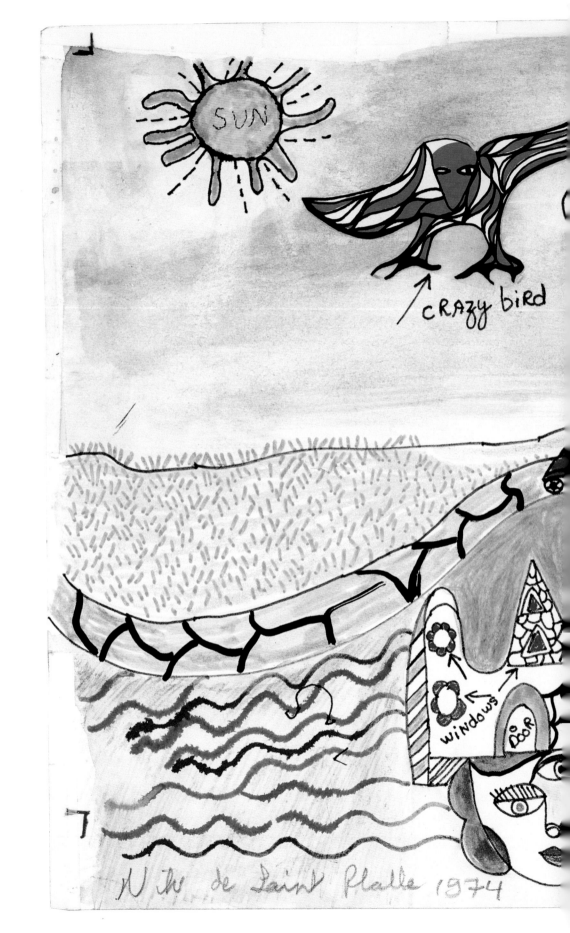

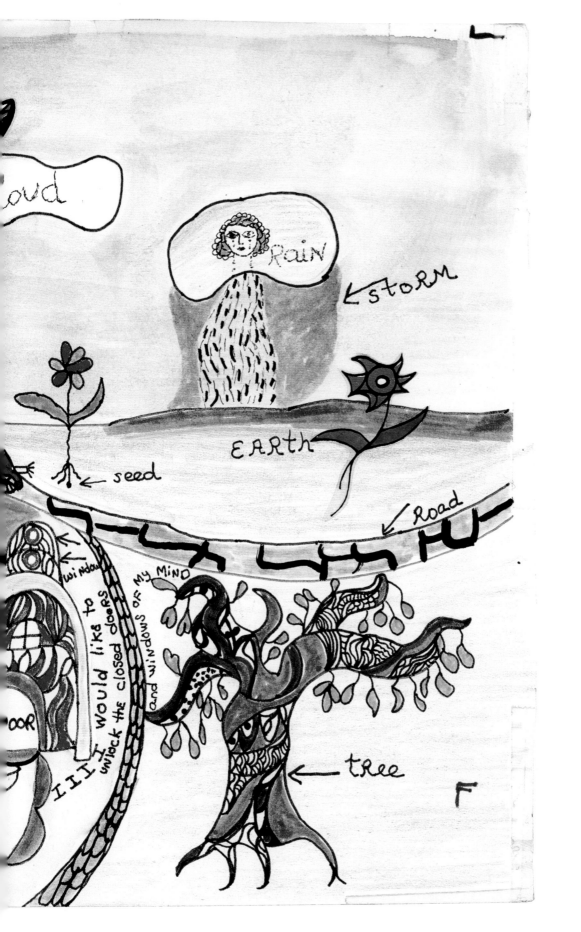

oud

Rain

← STORM

EARTH

← seed

→ Road

window

I I I would like to
unlock the closed doors
and windows of my mind

OOR

TREE ←

F

CARO PONTUS 2 3x

ca vas beaucoup mieux
je peut quitter l'hopital
dans 1 semaine. après
Arizona pour 2 mois pour
me redapper.
je t'embrasse très
fort et me Réjouit
de te Revoir
♡ Niki

Hello dear Pontus / I'm doing a lot better. I can leave the hospital in 1 week. Afterwards Arizona for 2 months to recover. / I send you big kisses and look forward to seeing you / Niki

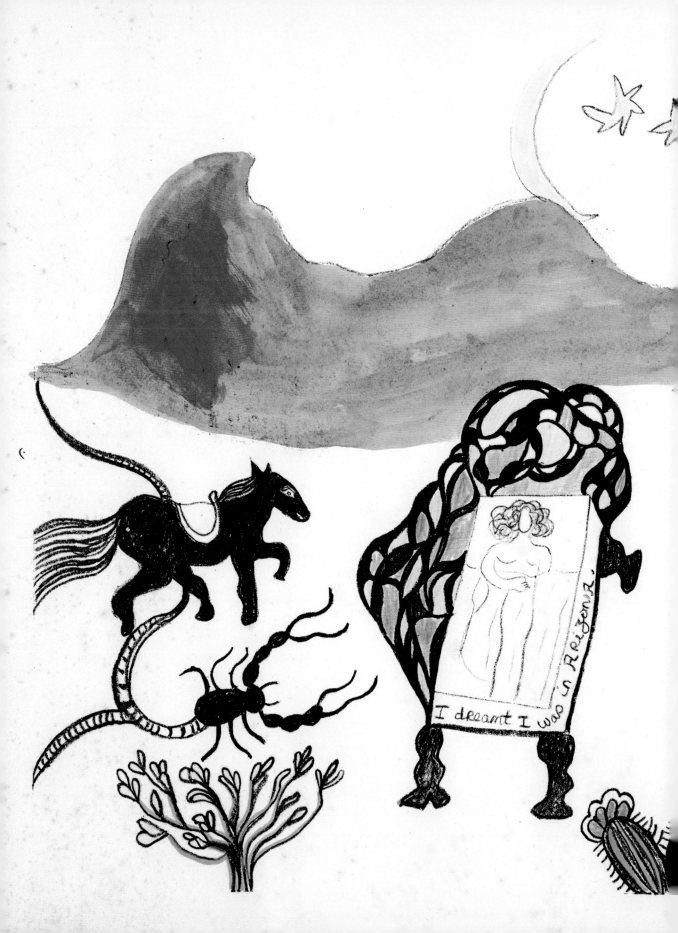

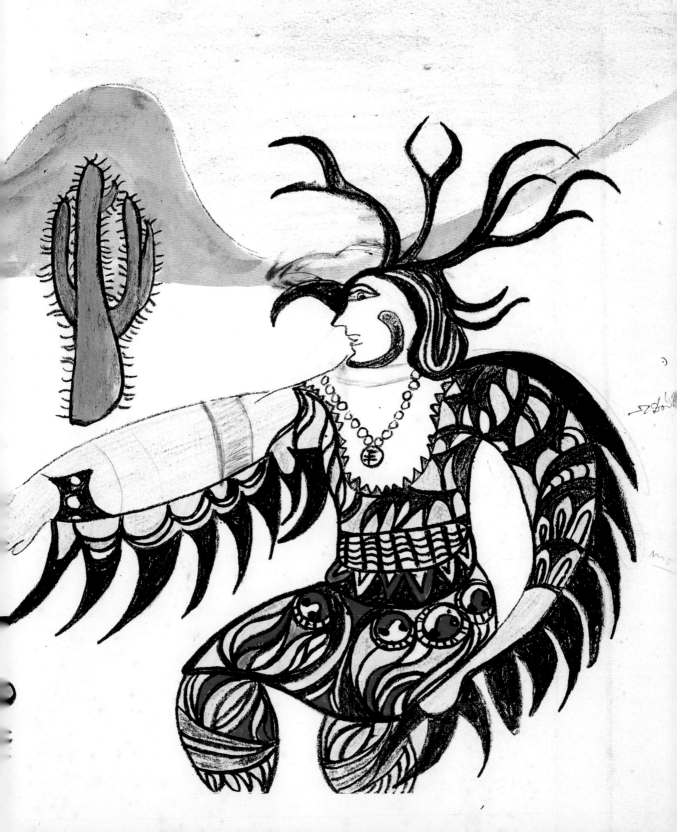

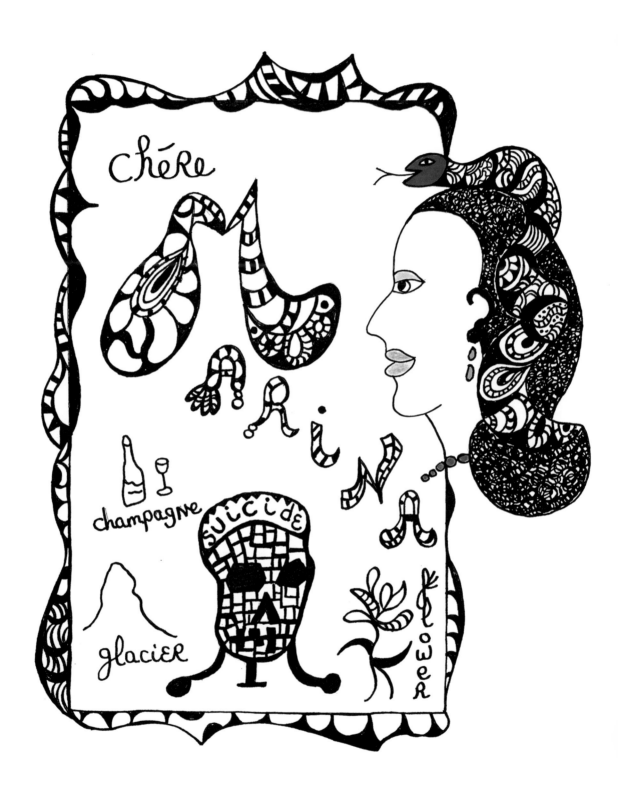

Dear Marina,*

During these years in St. Moritz, I fell in love with a glacier. I cannot remember the name of it anymore, but I remember exactly what it looked like. Maybe you remember there are many glaciers in Switzerland, and this particular one struck my fancy.

It took about an hour's walk to get to it. I must have walked there a hundred times. Then I wrote a film script about it. The subject was an artist and his preoccupation with time, accelerated time, metaphysical time, the merging of times.

In the end, the artist walks onto the glacier, knowing his youth there will be both captured and eternal.

I became fascinated with the idea of committing the perfect suicide, the way someone in an Agatha Christie novel would feel fascinated by committing the perfect crime. I would prepare a picnic. I went for days fantasizing about what would be my last meal. I would take great care to wear lots of very warm clothing, makeup, have my hair done in the afternoon. Bring a very pretty blanket, a flashlight, the *Duino Elegies* and no one would ever know (my plans had to be diabolically clever; otherwise, Eva or Jean or you might guess and feel awful).

It must be beautiful. A work of art.

So into my pocket I would slip in just a few sleeping pills. The glacier would do the rest. I would be found fast asleep and frozen in the morning. And I would look beautiful in the morning when they found me.

My plan was to go out to the glacier around midnight. Have a last meal (I had finally decided on caviar and Dom Perignon), pop the sleeping pills in my mouth, read with the help of my flashlight the "Fourth Elegy," and join the stars.

Those that loved me knowing how crazy I was about the glacier would just think Niki had gone there for a midnight snack and fallen asleep drinking champagne. They wouldn't be surprised.

Two days before THE FINAL DAY, I came down with pneumonia and was taken to hospital in Bern.

You came to see me. I couldn't talk for three days, I was so depressed. My search for infinity brought me to the edge of the precipice.

Living alone high in the Engadine mountains, I spent my time reading Nietzsche and Bachelard.

There was no reason to live alone. I chose this Spartan existence which went against my rather accessible, open, and gay nature, and I started to burn like a fire. My solitude gave me an ecstatic drunkenness. Passion was more than Existence.

*Marina Karella, Greek artist.

Like the phoenix that needs to go through the destructive fire with his body to be reborn, so I tormented myself with my will to go to the end of the experience.

Not only my mind, but my body took fire. Only through suffering and sacrifice did I feel free. I wanted to fly like a bird and discover infinity.

I have always chosen moments of great intensity instead of durability.

My art, as my love, will be sacrificed on the infernal burning altar. Remember? Your hair turned into snakes.

HHHHHHH I am afraid
I am angry
I am cold
I am driven
I am cruel
I am bad
I am a stone
I will burn in hell
HELP! I want
everything!
I hate
myself
I am the poison
I am
No good
I am the
mad bad
witch
BEWARE
DEATH

I am the star I am the child I am the worshipper
I am the fire I am the water I am the
I am the Resurrection I am the earth
I am the color I am the lover the
I am the mystery I am the poem I can the
I am the creator
I am the hidden serenity
I am the message

ETERNAL
LIFE

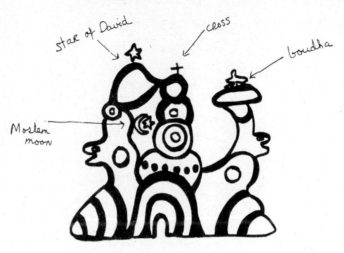

star of David
CROSS
boudha
Moslem moon

I would like to make a
CHURCH for all Religions

ALSO ON exhibit a study for a "court House" - A HOME BY the SEA - A SOUND RECORDING studio
A PLAY HOUSE FOR CHILDREN
A C
A

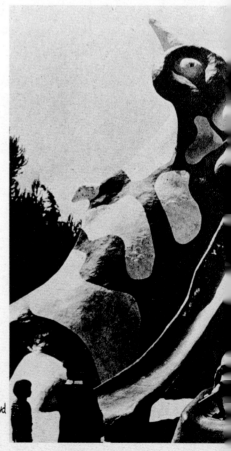

"THE TOWER" A Reminder of how ephemeral
life is.

"THE GOLEM" →
A CHILDRENS playground
already Realized
RABinovitch Park IN Jerusalem 1971

ONCE ONLY iMAGiNED" BLAKE

Phalle

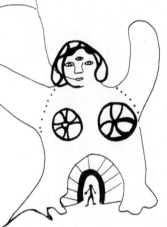

what was a servant yesterday an equal today and a ruler tomorrow? (turn page for answer to Sphinx's Riddle)

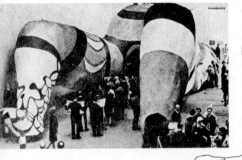

MADE iN COLLABORATION WITH TINGUELY AND ULTVEDT

↑ THE "HON" STOCKHOLM 1966

for the 21st Century.

g place for musicians. artists. writers.

"THE RiDDLE HOUSE"
A NURSERY school

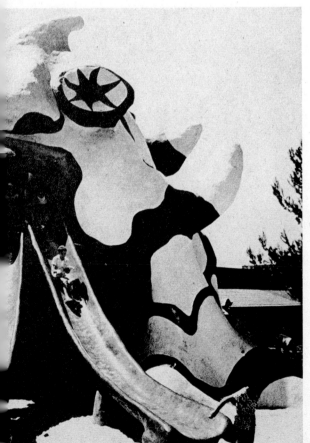

at the GIMPEL
GALLERY WEITZENHOFFER

1040 MADiSON AVE.
N. Y.C. 10021
tel.(212) 6281897

April 1979

FEMINISM

When I was twelve, I remember being in the linen closet with my mother.
She was counting the sheets and the towels, which had come back from
the laundry. I will never do that, I told her in a rather aggressive
way. Never will I spend my time doing things like that.
My mother slapped me. (Not an unusual event at that period of time
by a French mother. This was before Doctor Spock!)
She responded, "You will see, you will do exactly what I am doing;"
Very early I decided I would not play the traditional woman's role.
I saw my mother as a rather unhappy woman, trapped at home by her
five children. Her kingdom was her house and I wanted a larger kingdom.
My father's world - his freedom to go about where and when he pleased
seemed to me immensely more appealing.
I was extremely jealous of my parents interest in my elder brother
John's studies. I was a girl and it didn't matter whether or not I was a
good student. Most girls whose parents had any money at all at that
time, were brought up for the marriage market. You know, things were very
different forty years ago.
Meanwhile I was a rebellious teenager dreaming of being Joan of Arc
or Georges Sand and an exciting life.
At the convent I had continual fights with the nuns who told us that
Jesus always accomplished his mother's wishes. He could refuse her
nothing. My conclusion that she was more powerful than him put the
nuns into an uproar and they told me I needed a course in logic.
At the age of 18 I eloped with Harry Mathews who was among other things
an ardent feminist. This was 1948. It was extremely unusual for a
young man to think like that at that time. We shared the housework
and bringing up the children. My work was considered as important as his.
This caused great disturbances for my mother who thought Harry had stolen
my role and she used to hide her eyes from my paintings when she came
to visit us, as an expression of her disapproval of my artistic ventures.
Her disapproval was important ot me and pushed me to work even harder.
Later, I was asked by the Feminists, in the late 1960's to join their
movement. Even though I approved of their aims I could not decide to
join a group. I felt in my own way as a loner making monumental works
of art I was making a real contribution.

Feminism has always existed, and the feminist movement didn't
start in the sixties, it started centuries ago. Throughout history
there have been times when women have felt more strongly and fought
great battles for their liberty, and then they become quiet for
a period until they are forced to resume the battle once more.
I feel it very strongly and I feel it is one of the important things
that has really pushed me into proving that a woman can work on a
monumental scale.

Remember it zqs not long ago in the 18th century that the Church
forbade women to sculpt as it was supposed to give them bad ideas,
and that only yesterday Camille Claudol lost her liberty for having
more talent than Rodin.

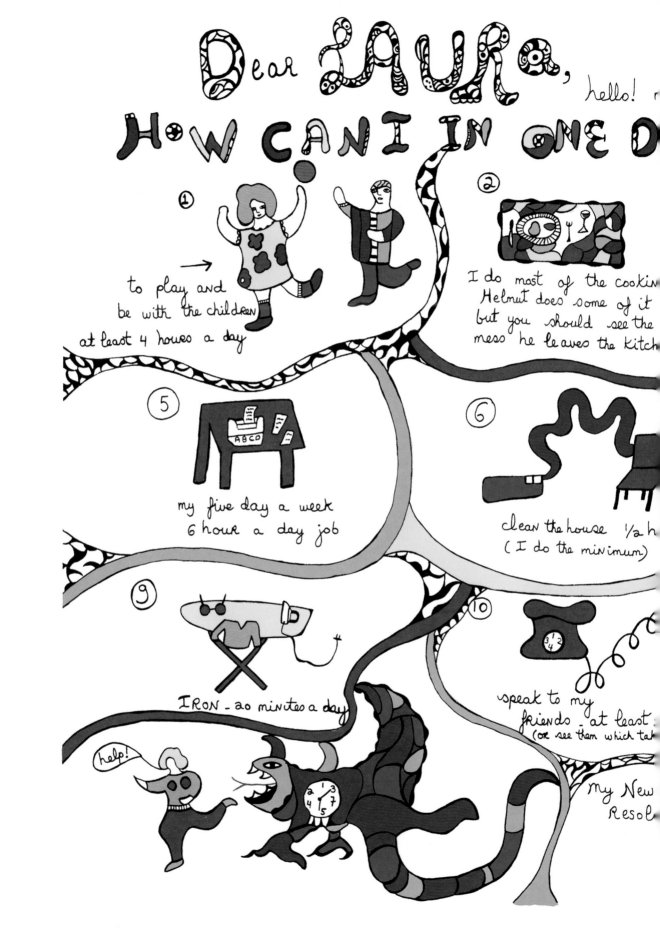

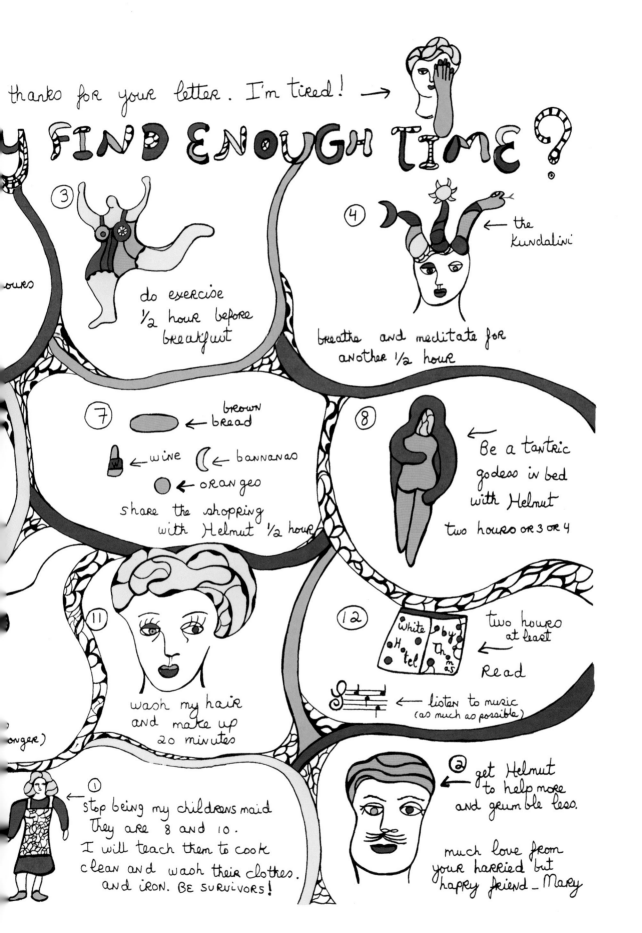

I identify with…
Fairy tales.
Finding a treasure.
I am the Fool.
The Fool hasn't done badly,
never knowing where he is
going, stumbling on his path,
finding mysterious treasures
and perilous adventures.

This is my right hand here is my wrist tears
I love it
with all its wrinkles sad
its thoughts its desires
I am proud of it
It made me make very beautiful
journeys into the strange
figures who came out of it

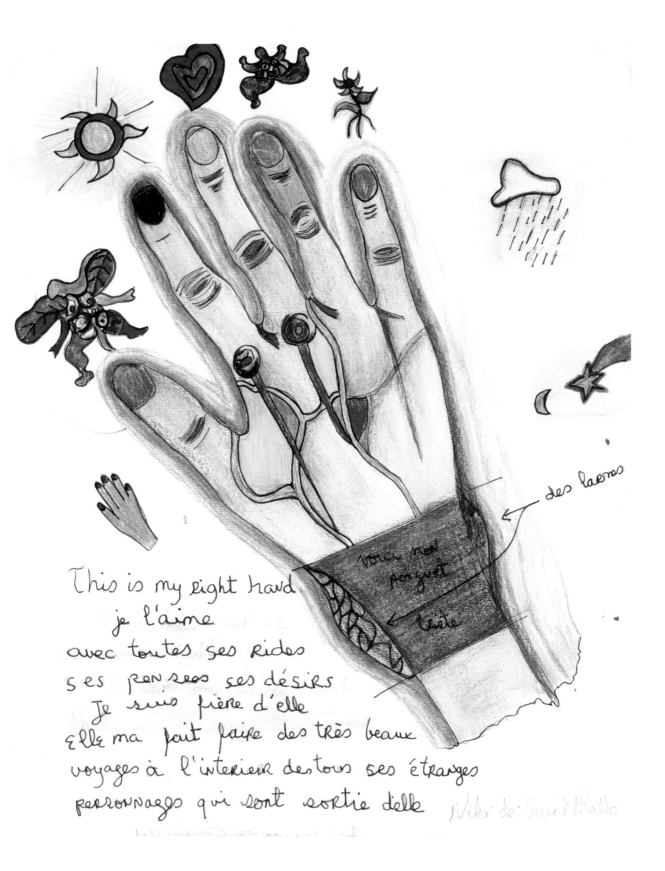

des larmes

voici mon poignet

texte

This is my right hand
 je l'aime
avec toutes ses rides
ses pensées ses désirs
 Je suis fière d'elle
Elle ma fait faire des très beaux
voyages à l'intérieur de tous ses étranges
personnages qui sont sortie d'elle Niki de Saint Phalle

Salute PoNT

this is my
version
of Uchello's
sAint George
and the
DRagon
at the B.M.

the time. Pontus, I have already ma
I don't like any of them. The anir
Do you have any photos or drawings
looking forward enormously to seeing y

S ANNA
BoNNe ANNée 1981

hello
the weather
here
on the
mountain
tops is
glorious.
Good
news! ~~Israel~~
Israel
has gotten
the finances.
Now it
is a
question
of finding

several versions of Noahs Arc.
are fine but the Arc look lousy.
ld boats that could inspire me?
both in California shortly. many greetings
and love Niki

DeAR CLARICE

how are you? This ha

Our house got washed away in the flood

just died of ~~homosexual cancer~~. AIDS

No one her

ME SAD

I bet romantic clothes come back now that fidelity is

ReAgan has deceded $10000000 money is more

Here at last is some

Contemporary Arts.

and our own

courtyard

FResh Po
a Ne

E.S.T. is still going strong and the HUNGAR Project is go

What is happening in

lots of love

April 23, 1983 - Malibu.

been the greatest year! It rained 🌧 all winter.

t was really scary! Then several [Steve → (poor thing)] dear gay friends

es make love here anymore because of herpes! UGH!

! Pollution will soon be hitting Malibu now that

ortant than health. → BLACK CLOUD OF DEATH

← CALIFORNIA JOGGER

News! L.A. is going to have its museum of

et company. →

SWAN LAKE

YOUPEE!

EVERYwhere here mmm

every day.

The SUN GOD →

University of California in San Diego ← has just put up a Niki de St. Phalle sculpture on the campus.

New York? Please write

Kisses from your friend - Agnes 🖤🖤 ← for you.

salute **FRAN!** samedi 2 Fev.

AUGURI !

bonjour

ta visite

éclair ma fait

une grande joie.

Je tiens

bien le coup en débit de chantage

a la bombe etc !

menace

Surtout parceque je me sens

tellement soutenu par toi

Ricardo Pepi Rico Venera

et toute l'equipe.

C'était vraiment important

I have always loved collaboration. I think that comes from the fact that I wanted to be in the theater, that I like working with people.

It is a very special feeling collaborating. Jean and I are like certain couples in history, like Adam and Eve, M. and Madame Curie, who have worked together and played together.

My work is really so different visually from his. That is why it works. It is because we are the two opposite poles, and we stimulate each other. That is why they look so good together. We discovered it one day—in the studio it is difficult to see things—but one day at the Iolas Gallery in New York, a show of mine was leaving, and a show of Jean's was arriving. It was just extraordinary. They looked so wonderful together. We each suddenly saw the absolutely opposite sides, and today we are still working and playing together.

Collaboration between Jean and me, the fusion of our work, is a gift from the gods. Our collaborations have brightly colored our love life, our friendship, and the rivalry we have always had.

It began in Stockholm in 1966 with the *Hon* and continued with the *Fantastic Paradise* on the roof of the French Pavilion at Expo 67 in Montreal. The *Fantastic Paradise* also spent a year in Central Park before finding its ultimate home at the Moderna Museet in Stockholm. It represented our lovers' battles together—his black menacing machines were attacking my colored, rounded world. The two poles met—masculine feminine, black and color, movement and stability. It was a war without victors or vanquished.

Other collaborations were the *Stravinsky Fountain* at the Centre Pompidou and the Tower of Babel in my *Tarot Garden* project in Italy. This is what happened: I was not satisfied with the Tower as it stood. I changed it and made it twice as big, but that didn't work either. It needed another dimension, so I called Jean—HELP! He came and put a sculpture on the top of the Tower which represented the lightning of divine destruction hitting the building. A new collaboration was born.

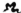

Happy 1985! Hello Jean / Your quick visit made me *very happy.* I am holding on despite the blackmail and bomb threat etc.! Mostly because I feel so supported by you, Ricardo, Seppi, Rico, Venera, and the whole team. It's really important

TAROT CARDS

in sculpture by
Niki de Saint Phalle

If life is a game of cards. We are born without knowing the rules. Yet we must play our hand. Throughout the ages people have liked playing with tarot cards. Poets philosophers alchemists artists have devoted themselves to discovering their meaning.

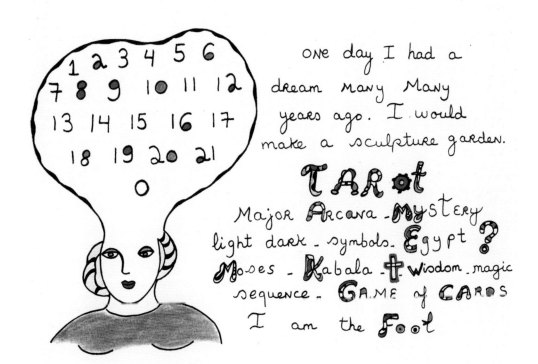

1 2 3 4 5 6
7 8 9 10 11 12
13 14 15 16 17
18 19 20 21
0

One day I had a
dream many many
years ago. I would
make a sculpture garden.

TARot
Major Arcana - MYSTERY
light dark - symbols. Egypt ?
Moses - Kabala ✝ Wisdom - magic
sequence - Game of Cards
I am the Fool

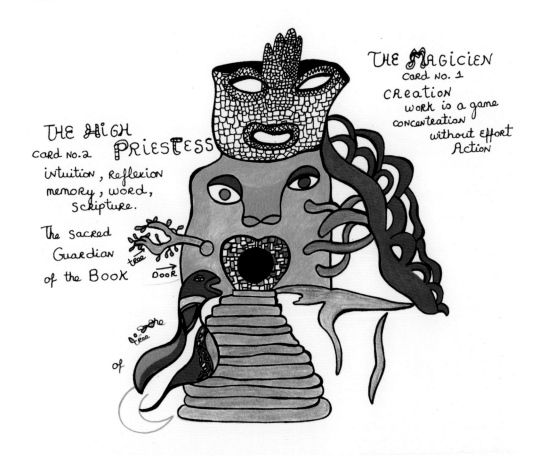

THE MAGICIEN
card no. 1
CREATION
work is a game
concentration
without effort
Action

THE HIGH
PRIESTESS
card no. 2
intuition, reflexion
memory, word,
scripture.

The sacred
Guardian
of the Book

tree

Door

of Tree

of

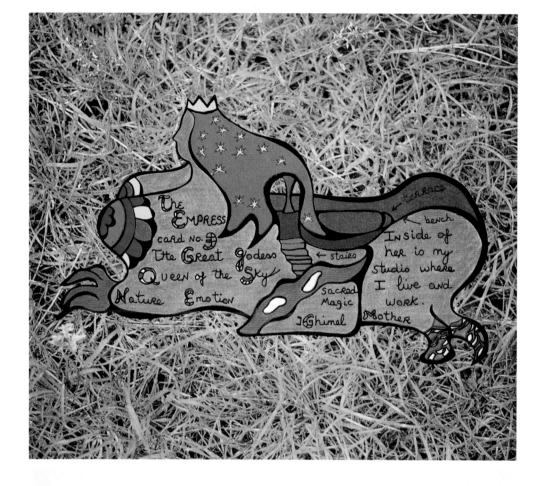

The Empress
card No. 3
The Great Godess
Queen of the Sky
Nature Emotion

← Terrace
← bench
Inside of her is my studio where I live and work. Mother
← staies
Sacred Magic
Ghimel

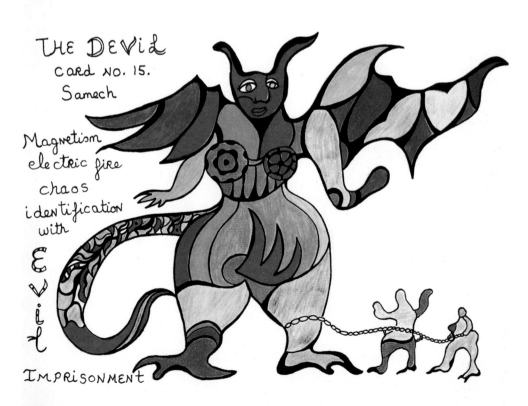

The Devil
card No. 15.
Samech

Magnetism
electric fire
chaos
identification
with

Evil

Imprisonment

DEATH card no. XIII MEM. there is no death - There is change - transformation. Our life is Eternal.

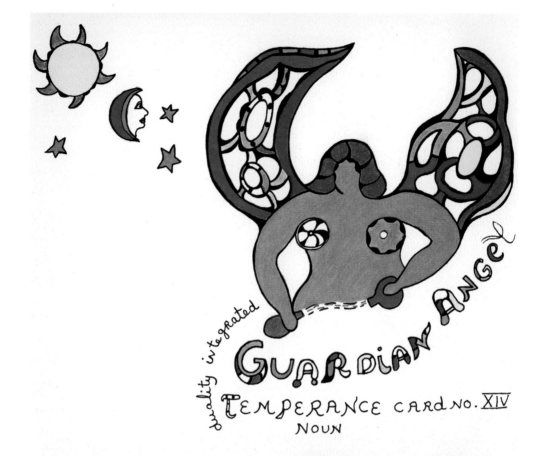

quality integrated

GUARDIAN ANGEL

TEMPERANCE CARD NO. XIV
NOUN

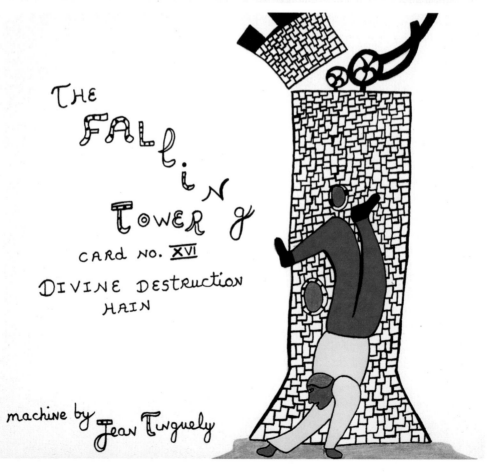

THE FALLING TOWER
CARD NO. XVI

DIVINE DESTRUCTION
HAIN

machine by Jean Tinguely

STRENGtH

card no. XI

Caph

Love is stronger
than lions and dragons
Only Love
conquers all.

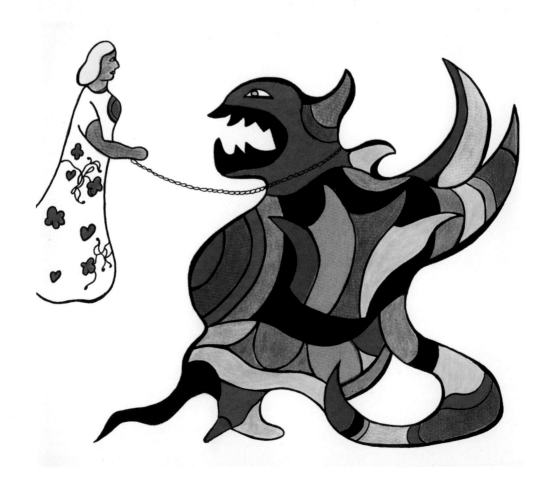

Egyptians Godess Mutter

Mesopotamia Druids

Mexican — African Religions

Hindu Greek Roman

Bondism German Edas

Polynesian American India

Tibet Confius Seik

Hebrew

Christian

At school we had a history class on Egypt which enthralled me. I spent as much time as possible in the Egyptian section of the Metropolitan Museum. I was Cleopatra with a fatal adder at my breast while Caesar and Alexander were at my feet. There is a mystery in those tombs that captivated me. I returned to them again and again.

I was also fascinated by monsters and prehistoric creatures, which I could buy at the five-and-dime store. I still collect them today. I saw a lot of monster films too. I have made many monsters throughout the years. It seems that I have an endless capacity to renew myself within this theme.

I think I was born with a terror of snakes. Snakes have an inherent mystery for me, their rapidity, their lightning. I used to love trembling in front of them at the zoo. For me, they represent life itself, a primeval force. Through making them, I have transformed my fear into joy. I have learned through my art to tame the things that scare me.

NiKi de Saint Phalle

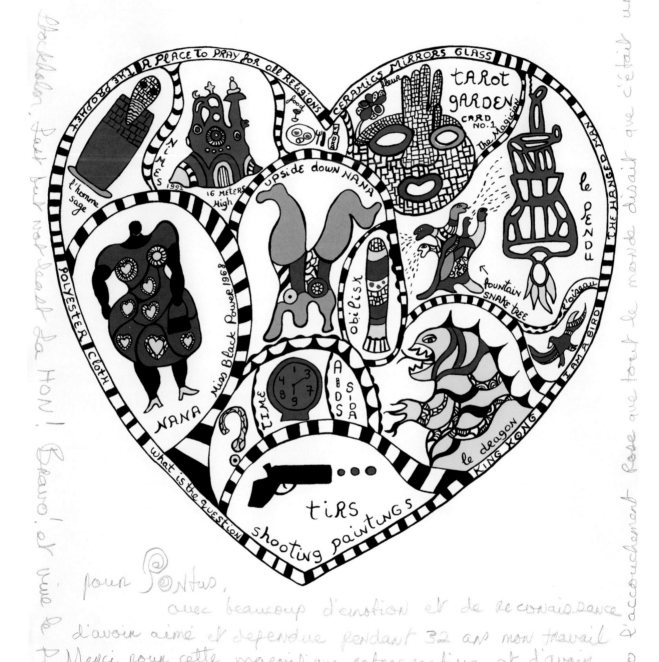

Kunst- und Ausstellungshalle der Bundesrepublik Deutschland, Bonn
19.06. - 01.11.1992

Niki by Niki

I am a special case. An Outsider.

Most of my sculptures have a timeless quality, reminiscences of ancient civilizations and dreams. My work and life are like a fairy tale full of quests, evil dragons, hidden treasures, devouring mothers, witches, the bird of paradise, the good mother, glimpses of paradise, and descents into hell.

The same themes recur again and again, in different forms, colors, and materials. Myths and symbols throughout history and culture have been periodically reinvented and re-created. I show, in a very modern way, that these myths and symbols are still alive. Take the Nanas—they are very much the sculptures of today, yet we cannot help thinking of the Venus of Willendorf when we look at some of them. Tell me, am I a reincarnation from some ancient time? I am convinced that I have had several lives, and in one of those lives, I was burnt as a witch. In another life, I was certainly involved in sacred rites in Mexico, and why was it my destiny to make the *Tarot Garden*? Was I involved with the cards in the fourteenth century, or was I linked to the Kabala?

It is not an accident that I am making this garden in Italy. There is a reason. My hand is guided. I follow a path that has been chosen for me. My work is readable to the general public because there is something familiar, something haunting, that arrests them. It is their own past, their unconscious dreams, that they see in my work. Sometimes it is a lost vision of a forgotten paradise or hell. Some dream remembered from some other time made present today.

I see myself as a devouring mother who has devoured all sorts of varied influences from Giotto, early Siennese paintings, Douanier Rousseau, Mexican and Indian temples, to Bosch and Arcimboldo, to Picasso, and they have been eaten and absorbed and the child that is born from that feast is invariably a Niki.

One of the reasons very little has been written on my work is that I am difficult to categorize. Am I a twentieth century artist or an archaic sculptor? What is the essential period of my work? Is it the early oil paintings where all the future avenues are revealed? Is it the shooting New Realist period with altars and assemblages? Or is it the romantic, tormented period of the white hearts, the brides, the women giving birth? I think this particular period—the one that has been overlooked for me is very important.

For Pontus, / With much emotion and gratitude for loving and defending my work for 32 years. / Thank you for this magnificent retrospective and for rescuing *King Kong*, *Black Rosy*, all the studies of *King Kong*, and the *Fantastic Paradise* and for buying, for $1,000, *Pink Birth* which the whole world said was a horror, for loving and including my first painting and reliefs and organizing the first official shooting at the museum in Stockholm. Last but not least, the HON! Bravo! And hooray for the future. / love Nikita

Or is it the Nanas, for which I became famous? The Nanas, which put everyone in a good mood. The Nanas, which are the opposite side of the coin to the white reliefs. The Nanas, some of whose forms come from the most ancient antiquity. In others, we can see the influence of Picasso or Léger and be reminded of Matisse by the colors. Yet they too also remain Nanas.

Then comes the Devouring Mothers series, which is extremely ironic and makes a rather violent social commentary. These works are unpopular, as they remind us of our nightmares of being devoured by the evil witch. These sculptures for me are among those I prefer, though sometimes they can scare me too.

Many artists have been inspired by their love affairs. It seems that my work has also been inspired by the roles women have had to play in life. What is behind these roles? These myths? The Bride, the Whore, the Women Giving Birth, the Devouring Mothers.

One important factor in my work is the passion with which I experiment with different materials, oils, plaster, guns, chicken wire, cloth, wool, *objets trouvés*, toys, clay, polyester, and my new big loves—glass, mirrors, and ceramics.

It seems as though I am always in movement, always in some new research, sometimes moving too fast and not developing certain periods long enough.

For instance, the almost plant-like skinnies and lamps, which are like drawings in the air. I feel I could have and should have gone much further with them.

But there is no time, I am working on the big project of my life, the *Tarot Garden*.

I feel an urgency in everything I do, as though I am always pressed for time, afraid that it is running out, afraid I will not have finished what I was meant to do.

What is this obsession I have with the monumental? Does it come from my lifelong admiration of Egyptian art, or is it my urgent necessity and destiny to show that a woman can work on a monumental scale?

What about my architecture? What kind of crazy architecture is that?

My *Tarot Garden* is in the classic tradition of fantastic gardens and certainly the most ambitious one since Gaudí's Park Güell.

I would like to give myself a piece of advice. Take it easy. Relax a bit more. Take those walks you want to take every day with your dogs. Read a bit more. Relax! I can't do that. WORK WORK WORK. It's my obsession and my destiny.

P.S. I forgot about my graphic work. All of my ideas come from my drawings. Lousy little scribbles on generally bad paper for essential ideas. Drawing, drawing, as soon as I have a pen in hand, the anxiety goes.

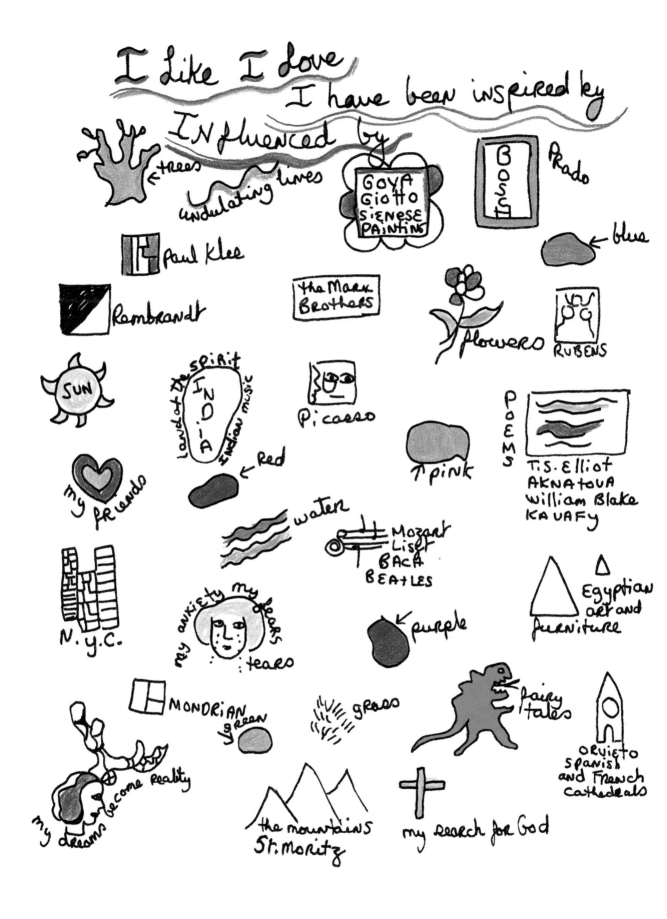

I Like I love
I have been inspired by
INFluenced by

←trees

undulating lines

GOYA
Giotto
SiENESE
PAINTING

BOSCH

PRado

←blue

Paul Klee

Rembrandt

the Marx Brothers

Flowers

RUBENS

SUN

Land of the spirit
INDIA
Indian music

Picasso

POEMS
T.S. Elliot
AKNATOVA
William Blake
KAVAFY

←Red

↑pink

my friends

water

Mozart
Liset
BACH
BEATLES

N.Y.C.

my anxiety my fears
:tears

←purple

△
Egyptian art and
Furniture

MONDRIAN
↓green

grass

Fairy tales

ORVIETO
SPANISH
and FRENCH
cathedrals

my dreams become reality

the mountains
St. Moritz

my search for God

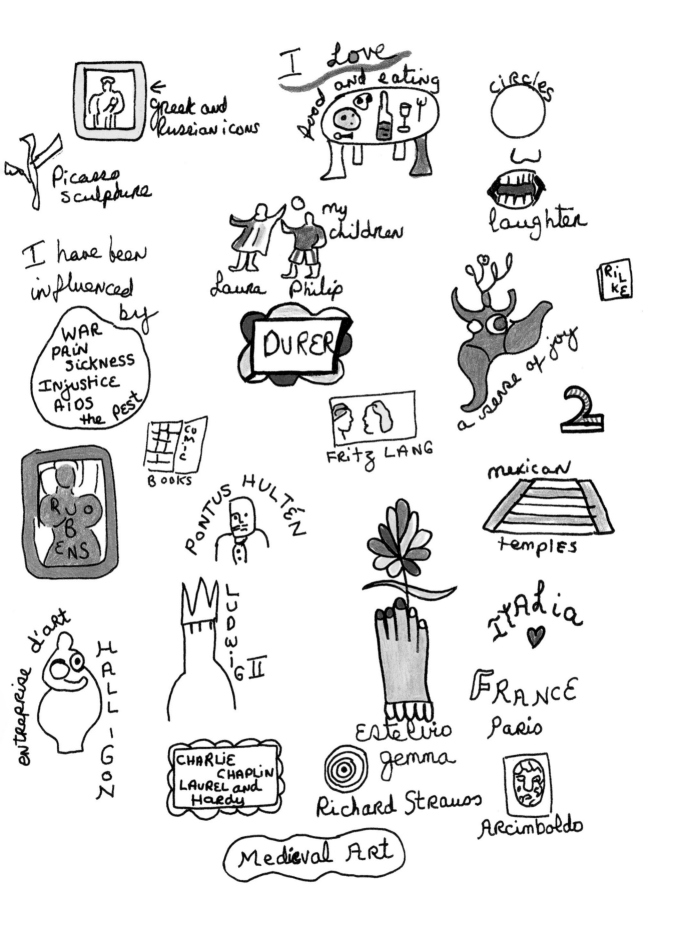

Greek and Russian icons

Picasso sculpture

I Love bread and eating

circles

laughter

my children

Laura Philip

I have been influenced by

WAR
PAIN
sickness
INjustice
AIDS
the Pest

DURER

RILKE

a sense of joy

2

FRITZ LANG

mexican temples

COMIC BOOKS

RUBENS

PONTUS HULTÉN

LUDWIG II

ITALIA ♥

FRANCE
Paris

entreprise d'art HALL-I-GON

CHARLIE CHAPLIN
LAUREL and HARDY

Estelrio
gemma

Richard Strauss

ARcimboldo

Medieval ARt

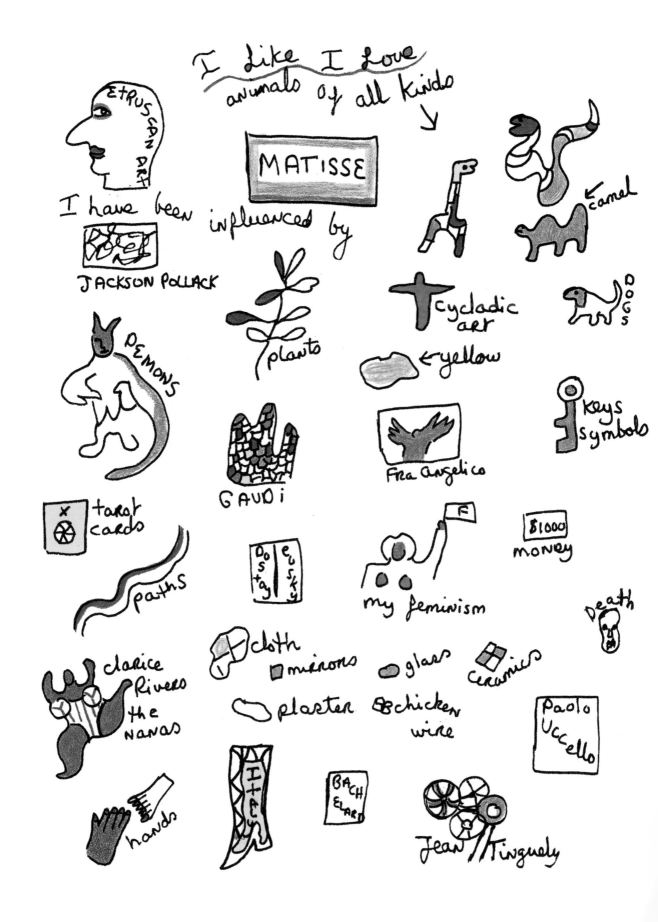

I like I Love
animals of all kinds

ETRUSCAN ART

MATISSE

camel

I have been influenced by

JACKSON POLLACK

Cycladic art

DOGS

plants

yellow

DEMONS

keys symbols

GAUDi

Fra Angelico

tarot cards

$1000 money

paths

Dostoevsky

my feminism

death

clarice Rivers the NANAS

cloth
mirrors
glass
ceramics

plaster chicken wire

Paolo Uccello

hands

ideas

BACH ELARD

Jean Tinguely

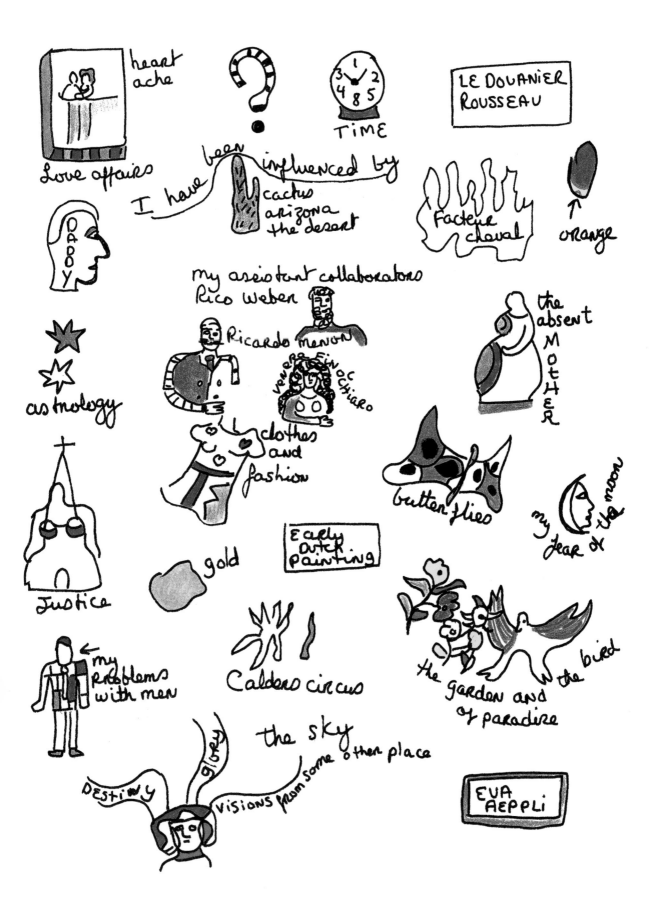

heart ache

?

TIME

LE DOUANIER ROUSSEAU

Love affairs

I have been influenced by

cactus arizona the desert

Facteur Cheval

orange

DADDY

my assistant collaborators
Rico Weber

Ricardo Menon

venera Finochiaro

clothes and fashion

the absent MOTHER

astrology

butter flies

my year of the moon

Justice

gold

EARLY DUTCH PAINTING

the garden and the bird of paradise

my problems with men

Caldero circus

DESTINY GLORY the sky

visions from some other place

EVA AEPPLI

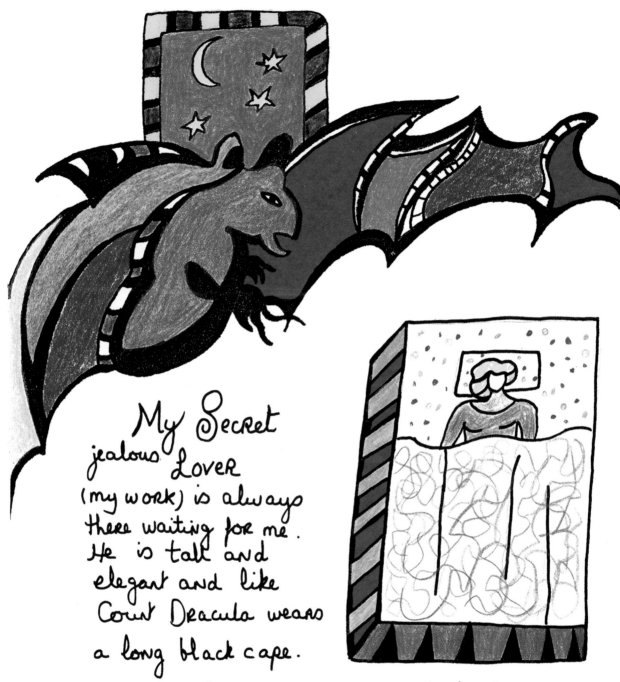

My Secret
jealous Lover
(my work) is always
there waiting for me.
He is tall and
elegant and like
Count Dracula wears
a long black cape.

He whispers in my ear that there is not
much time left for what I am meant to do.
He is jealous of every moment
I spend away from him. He is even
jealous of my locked bedroom door.

Sometimes at night he flys
through the open window of my room
in the form of a huge bat.

I shiver as he takes me in
his wings. I struggle for an instant
in my long white night dress.
His teeth sink into my soul.

I AM HIS

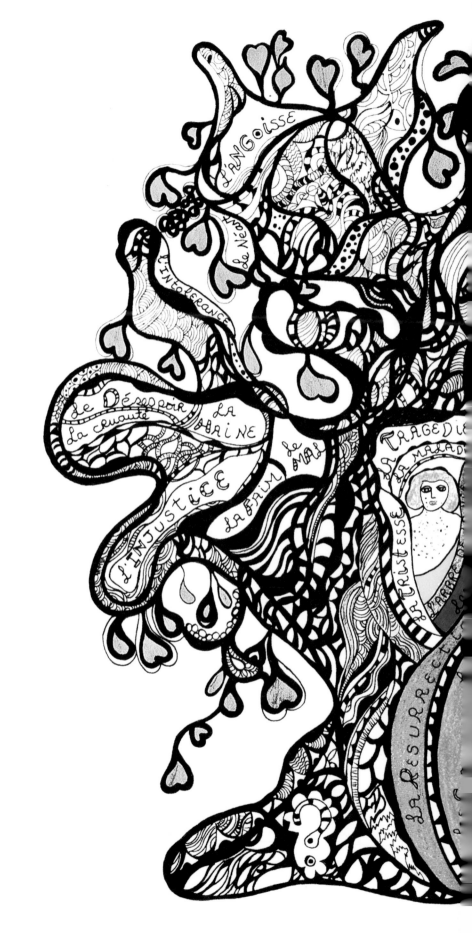

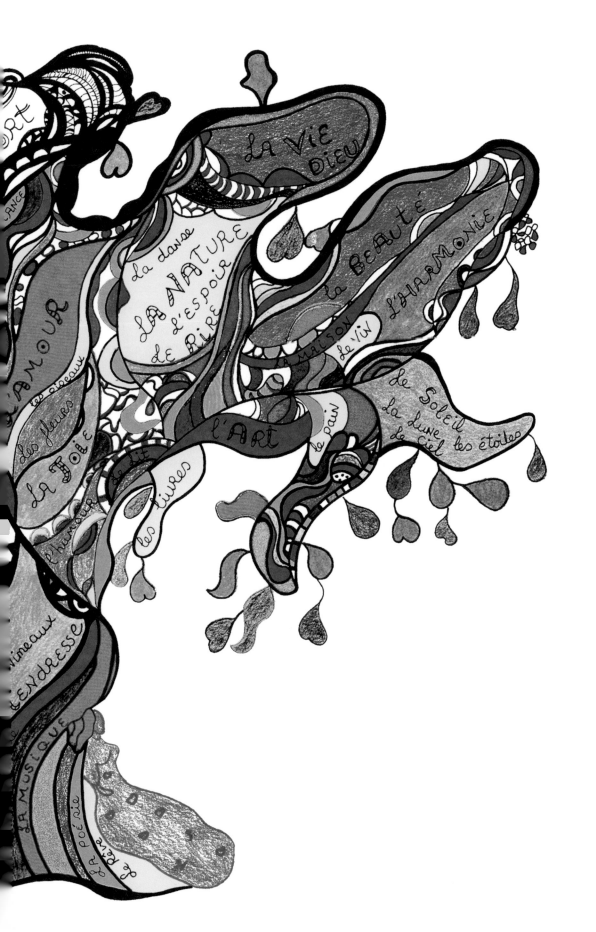

Jean gives an impression of electric energy. As soon as he walks into a room, he fills the space entirely. His eagle eye instantly sees everything that is there. He notices the slightest feature of change in tone or hesitation. He likes to seduce and is full of charm. His almost obstinate seductive powers have obtained for him many things that would have been impossible for others. His genius is there in his physical presence as well, and is felt in his original and paradoxical way of speaking. One of Jean's strengths lies in the fact that he's not afraid of making a fool of himself. He always expresses himself freely, in his work as well as his life.

Jean is a unique and fascinating man. His vitality tires everyone out, including himself. He can be too hard on others because he judges them by his own strength—poor them! He has a very hypnotic gaze and knows how to use it. He's got all this, plus a fundamentally tormented and contradictory character, which can be funny at the same time. If he sees a Marx Brothers film, it makes him sad. Show him a tragedy, and it puts him in a good mood. Astrologically, his double Gemini makes him impossible to pin down. Jean loves children, a man's world, and women of strong character. He has no patience with weakness and indecision. The important women in his life have been, if possible, a bit crazier than him, which he told me gave him a certain sense of stability—at last! Jean is a great catalyst. He knew when to lock up Eva Aeppli with only a bottle of cheap red wine until she finished the painting she was having so much difficulty with. Always provocative, he knows how to goad me into surpassing myself. I've realized my own strength by measuring myself against him. He has been my love, my work partner, and also my rival. Several women have played major roles in Jean's life. He met Eva Aeppli when he was seventeen at the Basel art school in Switzerland. Her uncompromising poetic nature, her artistic madness, her lucidity, and her charm made her a decisive partner. Together, they left Switzerland to go and live in Paris.

Jean often uses anger as a way of getting what he wants. Too late I learned that these rages of his were often the performances of a great actor! He'd do anything to get what he wanted from you—he'd use that fatal charm, any clever ploy, generosity, sensitivity, plus his sense of humor, all gift-wrapped with a pretty bow.

Jean has never forgotten his proletarian origins. Even today he often goes to his openings in dirty overalls. There's another reason for that too—he's told me that, dressed in this way, he's had enormous success with women. Riches and fame

haven't changed his way of life, except for a Ferrari or two, which he regards as kinetic sculpture. He doesn't have a dishwasher, and most of the time he shops and cooks himself. He lives in Switzerland in an old inn where everything is a bit disorderly—poetic chaos. He still hasn't got heating in his big studio, not because he can't afford it, but because he doesn't care about being cold.

Jean financed the Head,* his secret and monumental sculpture, himself. He was helped here by friends who bought work from him, especially to further this project. He has also saved my *Tarot Garden* when I was on the brink of disaster and has helped and sustained other artists. No one would have been willing to finance such mad projects as ours, so we had to find our own way. This autonomy has given us a special freedom—freedom of time—to hesitate, start again, and work at our own rate without any deadlines, an old-fashioned luxury that hardly exists anymore.

Neither Jean nor I have been unconscious of the power game, but on the other hand, we are both totally devoted to our work and our destinies. Jean has been a brilliant manager of his own artistic career—he's done it himself. He has even refused to sell his work to certain people, and in his own crazy way, he's always been right in the end. He can juggle, insult, and convince when necessary. He's a master at all this.

Jean's anxiety and fear of the dark and the unconscious are exorcised by him through the invention of his funny/tragic, always moving machines. Sorcerer and victim of his own spells, he lives like the racing cars he loves so much—at 250 m.p.h. He burns himself up. His hold on people is enormous; it's exhausting for others to live with him. With his boundless energy, he knows no rest.

Brought up a Catholic by nuns, he was under the thrall of the mystery and magic of the Mass. His large triptych altars, among my favorite works, are proof of the religious sentiment that has never left him.

These last years have been difficult for Jean. He has played Russian roulette with death. He has worked with frenzy, surpassing himself in innovation, as though there were no tomorrow. As always, he gains something from each situation and uses it to renew his creativity.

The Head is the gigantic, extravagant sculpture which he has built secretly in the forest of Fontainebleau for more than a decade (and without permission) with the help of his faithful assistant/collaborator Sepp Imhof. For the last few years the Head has lain dormant in the woods, like Sleeping Beauty. Now, the spring of 1987, she is waking up. Everything is beginning again.

The official title of this work by Tinguely is Le Cyclop.

I like the fact that I am able to say
something on a very immediate level.
So much of art today has become
tied up with ideas, with philosophy,
with the abstract, and a lot of people
feel excluded from it because of the
impoverishment of the image.
Nobody is excluded from my work.

Two years ago, Professor Silvio Barandun, a close friend and immunologist, asked me, as a public service, to make a book on AIDS.

He foresaw the catastrophe that was about to explode and realized that one of the main problems would be to pass on the scientific data to young people in a seductive way that would encourage them to read and assimilate the information.

I became very involved in this project. It was not an easy thing to do. We rewrote it many times. While working on the book, a close friend and collaborator became sick. Since then, other friends have died of AIDS.

What is AIDS? A disease? Yes. Is it more than that? Yes. It touches each one of us in what is most intimate, most secret, our sexuality.

Is AIDS a divine punishment on us because we are wrecking the universe? The air we breathe is rotten, trees are dying, animals are in peril, water is full of poison. Faulty nuclear plants and chemical leaks are putting life in peril.

AIDS is just another peril of the twentieth century.

We must not fall back into a state of puritanism. We must fight the disease.

At the same time, the world must show humanity and lucidity in dealing with the problem. We must not be afraid. Fear is the tool of fanatics.

We must not turn against homosexuals, sex, Blacks, drug addicts, and as usual, the Jews. This is a time for temperance.

The tremendous scientific energy, money, and compassion that is being used to combat AIDS will win the battle. We must not let the fanatics win again.

Man is a highly inventive creature and must find ways of saving the world and the human race. It is our only chance.

Governments must see that this is the only way for all of us to survive instead of selling arms to fuel a final catastrophe.

AIDS

lives mainly in

BLOOD and SPERM

and can be found also in saliva, genital and intestinal secretions and even in tears. Outside of the body it may survive for some time (particularily in NEEDLES)

YOU CAN'T CATCH IT FROM

A DOG

← a flower

a mosquito or a fly ↙

a cat

from a canary

YOU CAN'T CATCH
it FROM

spoon

plates food

fork

knife

glasses

10$ MONEY

combs

books

door knobs

your hairdresser

USE A RUBBER

← what do you think of these?

It may not be your cup of tea but it will save lives.

TEENAGERS
BE CAREFUL AT PARTIES
with drink and drugs.
(or you may forget your resolution)

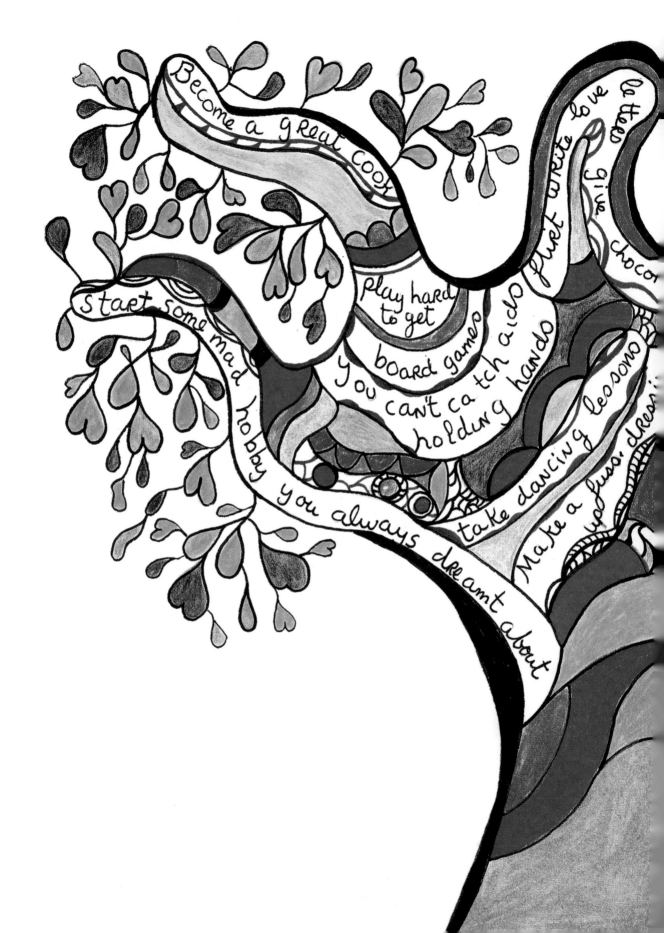

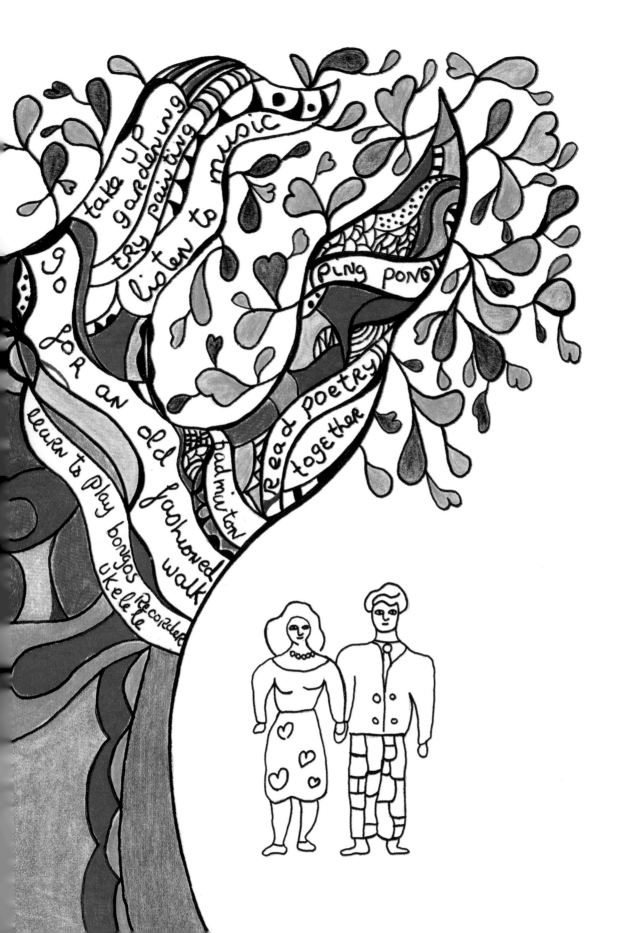

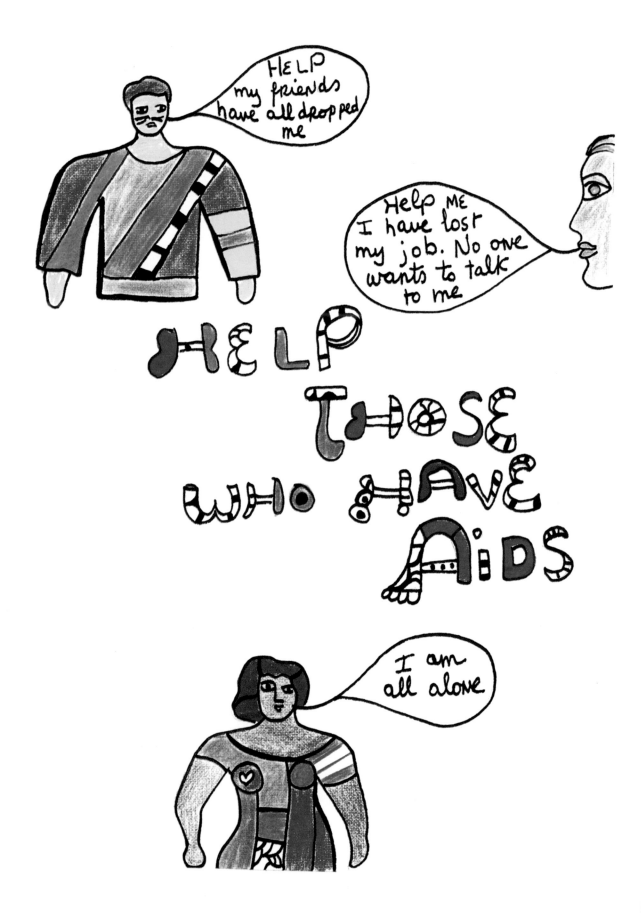

there are thousands
of people
DYING
with AIDS
ALONE
because of
I GNORANCE
AND
FEAR

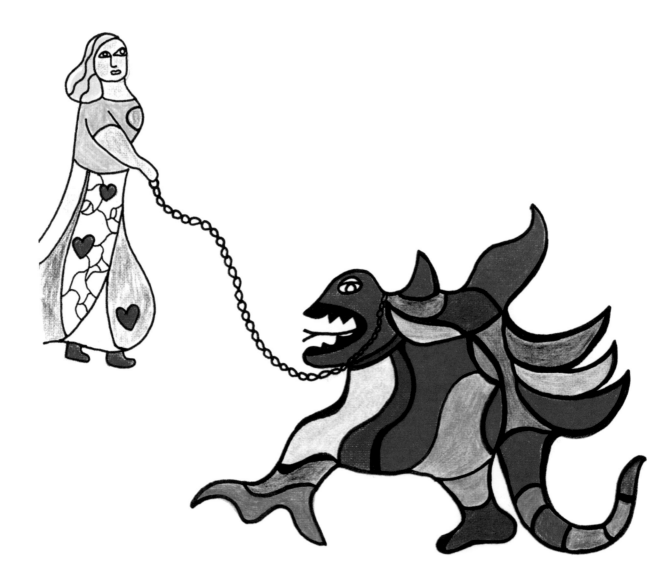

The WORST part of all SERious disease is the ANXiety it causes in those who are sick and to those who love them. WE MUST OVERCOME OUR FEAR

BIRDS

I have always been crazy about birds ever since I can remember. My dream was to have one of my own. This I managed to have when I was six. I refused to learn to read until my father had the brilliant idea of offering me a bird as soon as I could read. This worked like a miracle. I learned to read almost instantaneously.

Unfortuneatdy all my birds have had an unhappy

2

ending and that is why I
don't own any today. I
still remember the Spring
night when I was 12 years old and
I left my bird in its cage
in the garden and some
mean animal came and ate
him. There were only some
bones left in the morning.
I felt like a murderess.
Later Harry and I had
a couple of birds when we
were living in Mallorca
One was a clown always
doing crazy things to amuse
his beloved. One day we found

3

we found the clown dead.
Three days later his companion
died of grief.
Birds have been a constant
theme in my work. Immortal
birds. Sad birds. Triumphant
Birds.
When my father died in
1967 of a heart attack I
made a portrait of him in
his coffin. Next to him
a red bird was crucified
on a golden cross.
Whenever I change styles
the bird is always there
in a new form. In the
skinnys sculptures there are birds. In

4

the Stravinsky fountain
there are two. In the
tarot garden a huge joyous bird is
used as the symbol of the
sun card no. XIX.
This spring of 1988 I
have made a relief in ceramics
and glass of a bird resurrecting
from the sea. In my new
series on what we are doing
to nature I am making a
bird in flight one
of whose wings have been
shot.
Birds are
messengers from our world

5

to the next. My guardian
angel is a bird.

Pauvre Ricardino

ont un mysteRe mys
faire un exchange
je t'embra

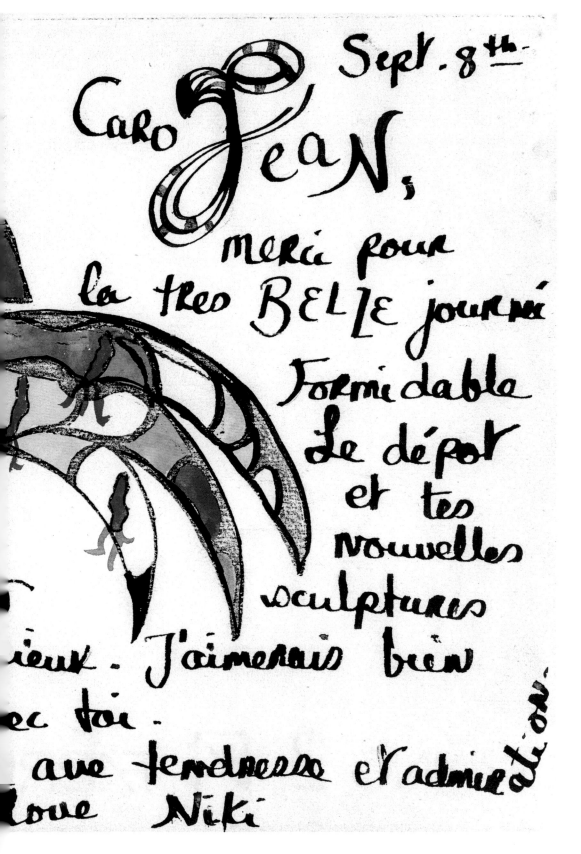

Sept. 8th.

Caro JeaN,

merci pour
la tres BELLE journée
Formidable
Le dépot
et tes
nouvelles
sculptures
ieux. J'aimerais bien
ec toi.
ave tendresse et admiration.
love Niki

Poor Ricardo / Dear Jean, / Thank you for the very beautiful day / Wonderful / The warehouse and your new sculptures have a mysterious mystery. I would love to make an exchange with you. I send you kisses with tenderness and admiration. / love Niki

As a child, I would not cry. I still have great difficulty. It's too bad. Because tears are wonderful. They cleanse the soul, tears. I held them in, and I think they harmed my body. They became little rocks inside, and they choked me and gave me asthma... all those tears I could not shed. I was going to be strong... would not show them when I was hurt. Tears. I love drawing tears.

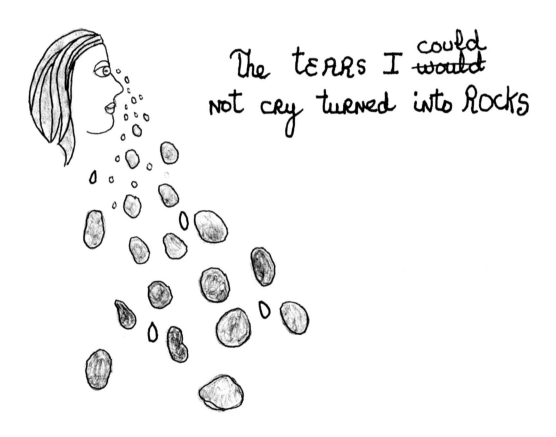

The tears I could ~~would~~ not cry turned into Rocks

Everything had to be hidden for you Mother
I would show. I WOULD SHOW
EVERything. My heart, my emotions.
Green, blue, Red, yellow, all colors.
I would show fear, anger, laughter
tenderness in my work. IN my
life I found it more difficult.
 I wish you were still around
Mother. I would love to take you
by the hand and show you the TAROT
GARREN. you might not have such a
bad opinion of me today. Who knows?
 Thank you Mother. what a boring
life I would have had without you,
 I Miss you.
 ♥ love
 Niki ♥

Mother was very intuitive. Before any of us got sick, she would have a recurring dream of a small child in her arms. Sometimes she would postpone a trip if she had that dream, or would hasten home if she were gone. For all her rigidity in bringing us up, she obviously cared a lot.

Mother had an elegant sense of decorating our apartment in New York. The long hall which led to the living room had an entire side covered in mirrors, as did a whole wall of the living room. Walking down the mirrored hall, one could see the reflections of furniture, the colors of the flowers in the vases, and who might be sitting on the sofa.

I remember looking endlessly into those mirrors. I liked the melting confusion of my perceptions. It made the room seem bigger than it really was.

Do you remember Mother's catty-cornered transparent glass and mirrored piece of 1930s furniture in our dining room? It was filled with crystal decanters which contained colored waters—red, yellow, green. The colors were very bright and were reflected in the mirrors. I was intoxicated by these pure magic colors. It was difficult for me to resist drinking them. I wanted to become the color. One day, Mother's colored reflections would reappear in the *Tarot Garden*.

A very dear Jean / A wonderful 1989 full of health, new discovery, water, mystery and spring. I send you kisses / your Nikita

cher très cher JEAN

une BONNE et BElle année 1989

avec santé et Belle découverte, de l'eau,
du mystère et le printemps. je t'embrasse ta Nikita

June 1990

Dearest MARELLA, Chère,

→ le magicien

the MAGICIEN

le JARDIN DES

CARD NO. 1

The TAROT garden

MiROIRS, VERRE, CERAMIQUE

ART

Dearest Marella,*

Whoever would have guessed that meeting you and liking you in 1950 when you were the assistant of Blumenfeld the photographer was the secret beginning of the TAROT GARDEN.

We lost sight of each other and twenty years later met again high up in the Engadine mountains. There our friendship renewed itself. I was recuperating from lungs damaged from working with plastics.

How well I remember our long winter walks amidst the pine trees. Do you remember our five o'clock Russian teas in front of the fire while we took turns reading the poems of Cavafy and Akhmatova?

It was there, one day, while walking towards the glacier that I told you about my LIFELONG DREAM of building a garden that would be a dialogue between sculpture and nature. A place to dream in. A garden of joy and fantasy.

I wanted to build it in ITALY, and I asked you to find someone in TUSCANY who would let me build my sculpture garden on their property. (At my expense, of course!) By BUILDING on someone's property, my work would be protected against vandalism.

You told me that your brothers, Carlo and Nicola Caracciolo, were enthusiastic about the project. A few weeks later, I arrived at the Roma Termini station with my bulky maquette. Carlo was there to drive me to the beautiful Tuscan countryside of Garavicchio. Your brothers were enthusiastic, and the die was cast!

THE BIGGEST ARTISTIC ADVENTURE OF MY LIFE HAD BEGUN.

I would spend most of the next ten years, beginning in 1980, entirely devoted to the realization of the Garden. If I had not concretized my dreams into sculptures, I might have become possessed by them and ended up in a psychiatric hospital—a victim of my own inner visions.

At last, my lifelong desire to live inside a sculpture would come true. An undulating round space without any right angles to threaten and attack me.

You took wonderful photos, Marella, when you came to visit me in Garavicchio in 1981 while JEAN TINGUELY, Rico Weber, and Sepp Imhof were welding the metal structure that was to be my home. Jean would take in his hands the model I made, absorb it in his ELECTRIC SOUL, then we'd hear him shout as he pointed to the sky, "Seppi, weld there!" How I loved watching this process. My house appeared almost overnight like a huge mushroom rising after a good rain, the iron frame a much larger duplicate of my model. Jean had taken no measurements—he built with his eye only.

*Marella Agnelli, Italian noblewoman and art collector.

185

He seemed like SUPERMAN to me, and likewise, I was WONDERWOMAN for having the nerve to embark on such a mad adventure. Our mutual admiration stimulated each other. We were in competition to amaze one another.

After the iron structure was finished, wire mesh was attached to the frame to catch the cement, which was sprayed on by noisy machines. The Sphinx became gray and melancholy in her cement dress. I knew that she needed a new costume, and I was going to give her one that would be spectacular. Little by little, she was covered with colored glass that I had ordered especially from Venice. Mainly, however, her apparel was made of molded ceramics and mirrors.

I had made my first NANA house in 1967. It was a doll's house for adults—just big enough to sit and dream in.

I WANTED TO INVENT A NEW MOTHER, A MOTHER GODDESS, AND IN THESE FORMS BE REBORN.

A breast. I would sleep in a breast. My kitchen would be in the other breast.

I found myself far from my origins, far from my family and friends, in a new culture besieged by a lot of technical and financial problems. These problems enlarged my vision of things.

I had to learn to direct the local workers, the electricians, and the masons, who were involved in the making of the sculpture. This was not my usual working relationship with artists; these were my partners.

The workers knew nothing about modern art. The women we hired had all been cleaning ladies. It took many years before they would feel a part of this adventure, and it took a while for me to establish a real contact with them. In the beginning, when Jean welded the steel frames for my forms, the workers would watch me go into ecstasy in front of the welded iron, and they would wonder what was going on. Today, however, they are very proud of being a part of the Garden and are uniquely skilled artisans.

To avoid the macho problem (the first few years, I only had men working for me, no women showed up), I instinctively became the MOTHER. Italians are used to taking orders from Mother. I prepared coffee for them and tea for me. Today, almost all of them have become tea drinkers. We took our morning break in the stomach of the Sphinx.

I had no privacy because the workers were continually finding excuses to PENETRATE the Mother. There was only one huge space inside the Sphinx with an alcove for my bed. There was no space for me to hide, and I felt devoured by my own Mother and my children, the workers.

The Mother sculpture emanates a FATAL ATTRACTION. The Sphinx Mother has an extraordinary power not only on me, but on all who enter. Everyone who comes inside wants to stay.

Twenty years earlier, I had left my children for my art. Here I was mothering my adopted children, the workers, and living inside a Mother sculpture I had created! It was during these years, while living inside of the Mother, that I got close again to my own children, Laura and Philip.

The accommodation inside the Empress was rather primitive when I first began living there in 1982. I used all my money to make additional sculptures for the Garden. I enjoyed living like a monk, but it wasn't always pleasant. There was a big hole in the ground where I used to keep my food, and I cooked on a tiny little gas heater. Each hot night, like a child's nightmare, I would wake up surrounded by hundreds of insects from the marsh. I spent hours trying to KILL them with books or shoes. Their bloody cadavers DISGUSTED me. Sometimes I watched the legs of these dying little spiders while they were AGONIZING. I was SCARED that one day they would devour the Empress and me.

I was RESCUED by my Argentinian friend, Sylvia. Terrified by these nocturnal visitors, she decided to leave right away, but not before giving me a check destined to save me from these horrible beasts. That same day I ordered screen doors. It hadn't occurred to me before, something so simple! The following summer, Sylvia came back. She said the heat was unbearable inside this sculpture which was made of cement over an iron frame. The cement absorbed all the heat. Shortly after, Sylvia sent me a big electric ventilator which is still on my ceiling.

My first years in the Empress were marked by PAIN. When I started working on the *Tarot Garden* I was struck with rheumatoid arthritis, an extremely painful disease. For reasons that are incomprehensible to me today, for two years I didn't want to see a traditional doctor. I was going to conquer the pain. I didn't even take an aspirin. I liked the idea of healers, and I was convinced that, with my WILLPOWER, I would cure myself. The experience of pain became very important.

I started limping. I could hardly hold anything in my hands. Jean invented a system which permitted me to open the water taps without any pressure. At night I would wake up screaming. Jean calls this period of my life "CALVARY."

If I could CONQUER this unbearable pain, I would be stronger, stronger than DEATH. This great lady, death, who fascinates and frightens me. She doesn't exist.

Do I exist? If I suffer so much, I exist.

Hell. The attraction of hell. The beauty of horror. My hands started to become deformed. I watched the disease progress each day. I couldn't sculpt anymore. Jean cried when he looked at my hands. I lost twenty pounds. I became the transparent shadow of myself. I wanted to live at any price. The cost didn't matter. But live. Suffering is also living.

My intelligence remained, along with my imagination and my eyes. I would learn how to direct others, since I no longer was able to work myself.

One day I found myself in a hospital, vanquished by pain. I couldn't walk anymore. The pain had proven stronger than me. At last I'd found my master.

I accepted the cocktail of drugs that the doctors prescribed for me.

The next few years I was STONED most of the time with heavy medications, but I was able to continue working on my Garden. The Garden profited from my health problems because it made me stay put; I didn't take any trips. I was soldered to the sculpture more than ever.

The drugs, especially the cortisone, changed my character, I was very nervous. Usually I have an even character. My new SPEEDY personality made me look after a million details, which was good for the Garden. However, it wasn't a very happy time for my close collaborators.

I refused to go anywhere. I was stuck there. One New Year's Eve, one of the workers, Estelvio, came to get me to celebrate the New Year with his family. He didn't like the idea of me being there all alone. I was touched by his gesture, but I was incapable of leaving the Sphinx. These were years of great SOLITUDE.

At the beginning of the '80s, Carlo and Nicola, my friends and owners of the land on which the *Tarot Garden* was built, were worried about my safety, as some notorious bandits had come to the area. They spoke about this to Jean Tinguely, who immediately had his assistant, Sepp Imhof, come and make some iron doors with an easy, mechanical way of opening. So during the day, the Sphinx was open, hospitable. At night, it became a bunker, a fortress. I didn't like locking myself up like that; I wasn't scared. But out of respect for Jean's effort, I always shut the iron doors.

Inside my nocturnal prison, I listened to music very late into the night. The acoustics of the Sphinx are extraordinary. The music pierced my heart here as it hasn't anywhere else. I often thought of the cathedrals, my first architectural love.

I had to earn the money to finance this vast adventure. I continually found myself in the difficult situation of having enough money for only one or two months to pay the workers. I never mentioned this to them. Why worry them?

I BECAME JEALOUS OF MY MASTER, GAUDÍ. He was lucky to have his duke support him in making a miraculous park. I, a woman, was making the largest sculpture garden since Gaudí. Maybe this is why I met so much resistance.

Once, a woman in the nearest village asked Venera, the ceramist, "Do you work for that crazy French woman who spends all her money making the hill more and more beautiful?"

Constantin Mulgrave, a writer I lived with from 1976 to 1980, had secretly saved enough money, which he gave to me, to start the Garden. Also, the Gimpel Gallery sold my sculpture models of the tarot cards which helped contribute towards some expenses.

When things were very tough, Jean came to my rescue. He bought from me, at

gallery prices, sculptures of mine that he really liked. One day, he bought me a huge ceramic oven.

A few years ago, Marella, you bought some of my sculpture models of the tarot from JGM Galerie in Paris and that money also went into the Garden.

Recently, Harry Mathews gave me some money to plant bushes, trees, and flowers to embellish the Garden.

The money problems obliged me to find new resources inside myself. I got the idea to make some vases and furniture. My decorative art was successful and sold well in the art galleries.

I was asked to create a perfume that would be contained in a sculpture of mine. I decided to make the container a sculpture of two snakes. Remember, Marella, when for several months you carried around the scent of the last two to be tested? I chose the one you liked best. The perfume paid for one-third of the Garden!

The final cost of my Garden would be between four and five million dollars.

TO BE MY OWN BENEFACTOR HAD MANY ADVANTAGES. I was master of my own ship. I didn't have to cater to patrons. I could work at my pace, in my way, which wasn't always logical. Sometimes I would start two or three sculptures at once. I could start again, change my mind, there were no dates. This was complete freedom.

Today, I believe THESE DIFFICULTIES WERE NECESSARY. Every fairy tale contains a long quest before you find the treasure. The treasure here has been the privilege of making the Garden, and my UNSHAKEABLE FAITH in the necessity to build it. There are twenty-two cards in the tarot and the Sphinx is one of them. Eighteen of the twenty-two cards are now completed.

A nuclear plant was being built at the same time as the Garden and directly opposite it. I ardently wished for it to stop. Two years ago, the Italian people had the right to choose whether or not they wanted to have nuclear plants in their country. They voted against it. Was this the result of the magic power of the tarot?

One thing that helped me enormously during these years was my great love for Italy. It is now my second home.

During this time, Ricardo Menon, my assistant-collaborator, cook, chauffeur, welder (he did everything!), stayed by my side. He had an incredible intuition about when I was in danger, and he'd look after me with the jealousy of a tiger. His love and devotion gave me the courage to finish the Garden.

Ricardo was young and handsome. He had enough charm to seduce the Angel Gabriel. He left Paris, which he adored, to come and work with me in the middle of an ex-swamp. This wasn't easy for him. NEVER, during those terrible years of my arthritis, when my friends no longer liked to come and see me (who wants to see someone you admire a cripple?), did he ABANDON me. Ricardo often brought his friends to visit. He even carried me in his arms, to my bathtub, when I couldn't walk.

Ricardo, who was the healthiest man in the world, was carried away two years ago by AIDS. In the chapel of Temperance, one of the tarot cards, on the altar of the Black Madonna, there is a photo of Ricardo. Very often I go there; I STILL FEEL HIS PROTECTION.

In 1983, I asked Ricardo to find a ceramist to assist me. I wanted to take risks in this medium. Three days later, Venera Finocchiaro made her appearance, and she would prove to be indispensable. Venera was ready to start a color one hundred times to get it just the way I wanted, and some days she worked sixteen hours at our five ovens. She worked with PASSION AND LOVE for the Garden and for me. Venera brought great technical knowledge with her and was able to resolve complex problems that ceramists are never faced with. Giorgio, her fiancé, calls the *Tarot Garden* her second love.

In the beginning, Venera used to sleep downstairs in the Sphinx on the sofa while Ricardo slept in the Tower of Babel (another structure in the Garden that could be lived in—and another tarot card). Ricardo, Venera, and I used to spend quite a few evenings playing canasta, poker, or gin rummy; we laughed a lot. On crisp autumn days, we burned wood in the fireplace, which was covered with mirrors. Sometimes I would read their tarot cards for them.

I felt part of the space. I couldn't leave her, this mother regained. There were two big portholes in the stomach of my Mother, and I used to spend hours looking from the inside of the Mother's stomach to the outside world. I spent long moments watching the wind play with the leaves of the olive trees. WHAT A LUXURY TO BE INSIDE MY MOTHER AND BE ABLE TO LOOK OUTSIDE!

In the magic space, I lost all notion of time, and the limitations of normal life were abolished. I felt comforted and transported. Here, everything was possible. But there was a dark side also.

I would feel every second of the night tick by, and during my long bouts of insomnia, the idea came to me that God really loved me and chose me to make this Garden.

Sometimes I had visions of thousands of shiny, little black devils with horrible wings. Disgusting, revolting devils coming out of all my orifices; could I get rid of them? I would open the doors of the Sphinx in the middle of the night, and they would fly away. The demons would be gone for now.

Last year, I felt an imperative desire to be alone with my Mother, the Sphinx.

I chased away all my children, the workers. I wouldn't let them in anymore, I wouldn't prepare tea or coffee for them. I bought them a coffee machine.

I FINALLY HAD TO HAVE MOTHER ALL TO MYSELF. When I did, IT WAS UNBEARABLE.

I had to leave my Mother! Or was it she who decided to EXPULSE ME?

In 1988, I left my Mother, the Sphinx, in peace and not with violence (the way I left my family when I was eighteen). Reborn? How many times can one be reborn?

Jean was afraid that if I left the Sphinx, I would stop working on the Garden, and he also felt that I was close to a nervous breakdown. I was living on tranquilizers. He suggested a very ingenious solution: build a studio beneath the ground. He felt I needed a large studio in a normal rectangular space to work in. Actually, it resembles a New York loft—in the middle of Tuscany.

There was a big hole under the Sphinx, and one side of the studio would be in glass, and the rest would be covered with earth. My roof was my Garden.

I'm practically a mole. I now live in a structure three-quarters under ground.

I became calm for a short time. However, in my artistic haste, I forgot to get a building permit. The BUREAUCRACY is now after me. This is a bigger NIGHTMARE than the IRRATIONALITY of the Mother.

Marella, I am really worried. They are threatening to shut the entire Garden. Let's pray it will all turn out well.

A Big Kiss
From Your Niki

I have been a wild, wild weed.
Done everything. It's possible
in art to be a rebel and to
experiment. Now I am much more
concerned with bringing joy.

Bursting Paintings

I like challenges. / It's said that oil painting is dead. NO! I make it explode and live. / An electric photo cell turns on my paintings / Without an audience the paintings don't move. / They need the other's gaze to start moving. To live! / They explode from figurative to abstract paintings. / From order to chaos. / Bursting paintings, grandchildren of the shooting paintings / They explode / BOOM! / After the explosion there is a revelation. / My art isn't a reflection of the world as it is / But rather what I would like it to be.

TABLEAUX Éclatés

j'aime les défis.

Ont dit que la peinture à huile est morte. NON! Je la fait ÉXPLOSER et ViVRE.

une photo cellule électrique met en marche mes tableaux

Sans spectateurs les tableaux ne bouge pas.

Du figuratif ils explose en tableaux abstrait au chaos.

Ils ont besoin du Regard de l'autre pour se mettre en mouvement ViVRE!

Tableaux Éclatés, Petits enfants des tableaux -tir ils explosent. BOUM! Deriere l'explosion il y a une Revelation.

Mon art n'est pas la Reflexion du monde tel qu'il est

Mais plutot de celui que j'aimerais qu'il soit.

Niki de Saint Phalle

A Swiss banker told me
they are so rich because
people prefer not making a will

so the
money goes
to the bank

$$\boxed{100999}$$

why GREED?
we cant take it with us
we could be so happy doing worth while

Hell is
E
ope
your
tu
an
u

Heaven
is
the next
world

it wu

9 out of ten doctor
are crooks

9 out of ten lawyers
ar crooks

but it worth tryin
to be a good Ma
because Honest Mo
has worked out hi
is worth 100000

WHY MUST FLOWERS DIE? EVERTHING my EYes

Just

cockroach

THERE IS A NEW MYSTERION WORLD awaiting us.

our daily bread

bread

Power was invented
to hook fools
a drug
as potent
as heroin

WINE

VANity

James

ones

N see will DIE. EVEN you EVEN ME.
Don't worry Niki. It will be BETTER.

my love what s

I will buy a beautiful
black dRESS and mouRN oVER you

And then I will build a fantastic
monument for your to

l I do y you die?

ill cry for many months

IN HOMAGE TO MY LOVE

YOU ARE MY BIRD FOREVER

And then I will forget you

DEATH and RESURRECTION

When Jean Tinguely died I went home to the city where I had been brought up - New York I needed to be alone with my grief.

I walked the city block after block with no destination in mind, cluching my hand bag so it wouldn't be stolen.

When I wasn't roaming the streets, I'd sit by the big bay window overlooking the East River (in the apartment lent me by my first husband Harry Mathews) I'd watch fascinated for hours, the enormous variety of tug boats moving in front of me. The East River became the River Styx. Sometimes I imagined each boat carrying Jean's mortal body in a golden coffin taking him to his new mysterious life. I thought also of all the close young friends who had died over the last few years of Aids.

Being in the city, my city, I started to think about the life around me. The vibrant city life, visually exploding, rushing, energies Bursting. Other thoughts took hold of me. How the world was fragmenting into Racism, Religious isms and hates.

Out of this dark journey came light. I had a vision of a painting EXPLODING, then coming together. REJOINED.

I HAD TO DO IT.

I asked the best technicians I knew. They said the idea was too complex, probably impossible.

My obsessive stubborn self PERSISTED.

I WOULD NOT GIVE UP, and Eureka!!! I found a way - an electrical engineer Juan Carlos Etcheverry and my assistant Marcelo Zitelli helped me to make my vision a reality.

The first tableau éclaté or Bursting painting was of the God Ganesh, a popular hindu God of good Luck, new beginnings and success in overcoming obstacles.

With this work and others that followed I began to reassemble the shattered pieces of my soul and psyche.

My body was another story. I was often dangerously sick. I nomaded around, dragging my oxygen tank, trying to get some good weather. A climate where I could breathe and move without pain. I wandered into Seville and there. I came in contact with "Vanitas paintings" of the 17th century. These somber fascinating images of death (not devoid of black humour) stuck in my mind and suited my mood and I began drawing a series of Vanitas tableaux éclatés. I plunged into this world.

I felt doomed and felt sure I would soon join my numerous friends in the next unknown world waiting for us. The Vanitas Reflected how I was feeling with skulls bursting open to reveal the SUN.

I went to see Dr. Seely in New York and told him

life wasn't worth living dragging an oxygen bottle around. He advised me to go to San Diego.

It was my LAST CARD. If this didn't work I would join the hemlock society.

To Breathe or not to breathe had become the question.

RESURRECTION iN LA JoLLA!

Health, joy and curiosity for life came back with a BANG.

I was Rejuvenated by the open spaces, the desert, the ocean, leaving my past life, starting over.

New Muses arrived. In my 20's I painted for 8 years without formal training. I had developed a way to paint that allowed me to achieve the effects I wanted. Today I wanted to paint in a new way that I could not achieve on my own. I nearly joined a painting class under an assumed name when my friend Marina Karella came to the rescue. She became my "professor". She taught me, melting, glazing blending of colors to give the feeling of space and light that has overwhelmed me living in California

Its never too late to learn! What next?

My work has changed. The Vanitas vanished and dream like scenes in the desert and ocean took their places. From a concious work (the vanitas) I moved to the land of the unconcious. I intuitively tried to Recapture the Mirage like feeling and light that enveloped the sea and desert.

In Southern California I became a sponge, permeable to the sea, mystery, immensity of nature, trees, air, animals, earth, sand, people.

The Vanitas reflected a certain disallusion in the human race. Nature Restored my faith. I've left the Oxygen bottle behind.

Now I walk, breathe and feel Life is Vital once again.

5 These MEN loved me, excited my mind, INSPIRED me, but I Never entirely REVEALED myself to them. I REMAINED an ENIGMA.

MY WORK CAME FIRST. my PROTECTION. Independance CHÈRE INNERJOY BEYOND what they could PROVIDE. MY MEN (these beasts) WERE my MUSES. The suffering they inflicted and the VENGEANCE I took Nourished MY ART for many years. I THANK THEM.

I'll forgive you anything because you make me laugh. I.W. addicted to humour.

I had a weird dream last night you were a gorilla

I often work

CALIFOR

HELP!

You? Me?

who is the bear? who is the seal?

Me? you?

URGENT Call me right away or I'll Kill you

Silly ME

thank you for the flowers

Thank God I am NO longer attracted to these types of MEN. DELIVERANCE At Last!

Now I Know I'd PREFER someone who took aLONG TIME UNDRESSING ME....

DÉSOLÉE SALAUD ORDURE me je Vengerais you rem

6 MY REVENGE ON these ABANDONME I ended Relationships I was Ruthless. Goo

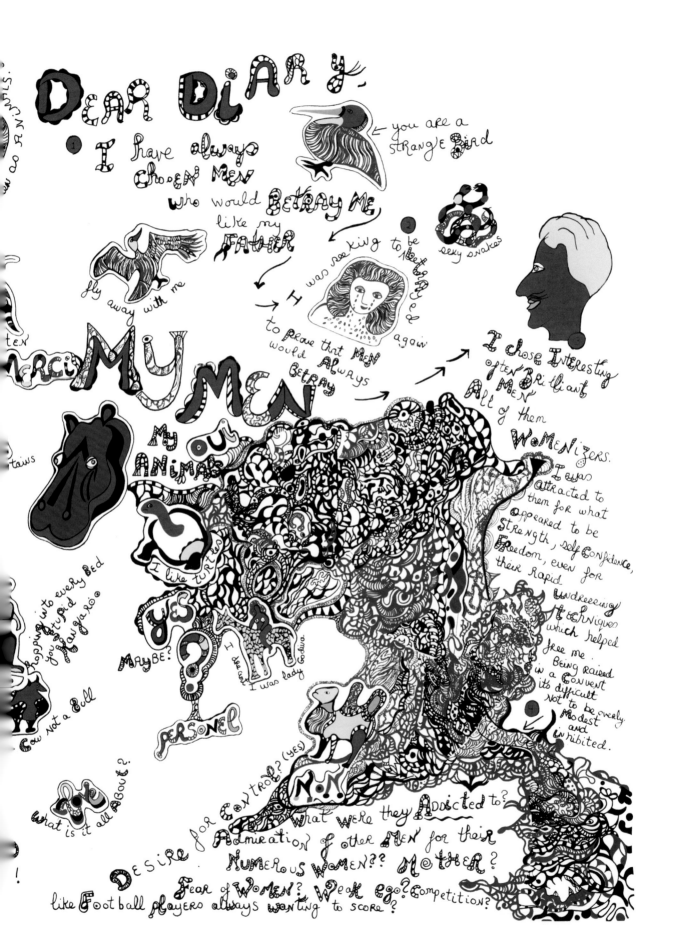

There is an odd Mixture here. The incredible trees, glorious Nature, and underlying everything THIS VIOLENCE! WHY are there so many CRAZIES here in Paradise?

Dear DIA... spent a long... today telling him about... PARA...

Watching TV News. One HORROR story after another... Does violence breed violence?? No act of generosity is ever shown.

RAPES INCEST GREED CHILD MURDERERS Priests and Bishops accused of SEX CRIMES VIOLENCE TERROR CHILD abuse

I'm terrified by News on T.V. Sensationalism SHOCK value SLEAZE GORE Perverse excitement

Last night in bed in Ted's flat I saw a SHADOW pass the window. SCARY! My HEART STARTED to pound! WAS it the PACIFIC BEACH RAPIST?? He's already violated 46 WOMEN! and they haven't... No, it was only a SKUNK!

HELP! AU SECOURS

a bear of desire

Why must Humanity?... I love season Compari Soda

yes

9 8 7 6

November 95 La Jolla

TEMPERANCE
CARD No. XVI

TEMPERANCE is about ENERGY flowing
with love and tolerance.

What do people
mean by "Politically Correct"? ?
They talk about it
all the time. (brain washing)

It seems to me that nothing
that is Political is Correct
and Nothing Correct is Political.

I would like to make a Sculpture
Representing TEMPERANCE on a campus.
RANCE is not FANATIC. No RULES.
NCEPT of UNIVERSALITY
not in the head

HEARTFELT

that suppresses individuality and puts pressure on people to THINK and act in the sameway. (NOT FOR ME!)

I saw A FAT woman on the beach today and she i

MINDED ME OF A GREAT PAGAN GODESS

BLACK
IS DIFFERENT.

I have made MANY
BLACK FIGURES
in my work.
Black Venus, Black Madonna,
BLACK MEN, BLACK NANAS.
It has always been an important
color for me.
 Today, walking on the beach
 I watched a small black child
5 or 6 years old playing with his father.
 He was SO CUTE It was
a REVELATION.
 Black is ALSO ME NOW
with my great grandson Djamal. This is NEW
and I like it.
 Djamal is FRENCH, American Vietnamese,
Greek, Belgian Irish, ENglish, African,
Scottish, Russian, Italian, Jewish, Cuban.
 = AMERICAN
Black is also Me Now.

Dear Diary

Philip my son and his wife Elizabeth want me to be alone for the Holidays. WHAT A WILD CHRISTMAS!

CHRISTMAS TREE

We love you

Trudy like a bolt of lightning became all our lives. The world needs more Trudy's. Don't leave us. I need you. You bring of us a gaiety and childlike quality that enriches all our lives. The world needs more Trudy's. Don't leave us. I need you. You bring

Tru
others
a bit
a little
Sh
Trudy and
until 3 in the
accuses the other
little bit of that g

Chea

from New York to take me to her parents home. They didn't

The TISO family is INTERNATIONAL Elizabeth's father is of Italian origin seems Scottish and is American!

Elizabeth, her Mother Trudy her father John and her 2 good looking brothers were COOKING, SCREAMING, INSULTING one another - and enjoying every minute of it!

No PENT UP HOSTILITY in this family!

THE FOOD WAS too GOOD!

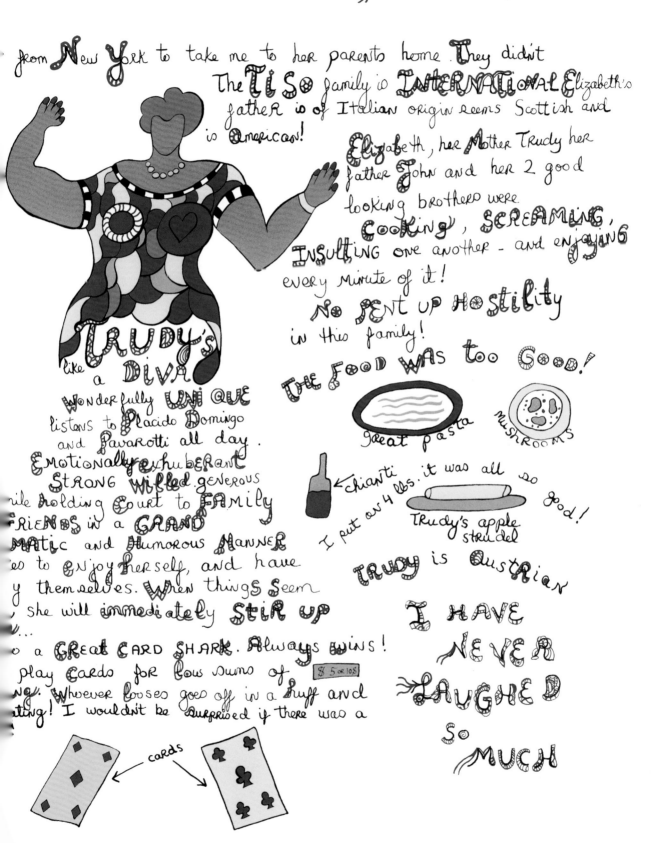

TRUDY'S like a DIVA.

Wonderfully UNIQUE listens to Placido Domingo and Pavarotti all day. Emotionally exhuberant STRONG willed. generous while holding court to FAMILY FRIENDS in a GRAND MATIC and Humorous Manner ...es to enjoy herself, and have y themselves. When things seem , she will immediately STIR UP u...

o a GREAT CARD SHARK. Always wins! play cards for low sums of $5 or 10$ ng. Whoever looses goes off in a huff and ...ting! I wouldn't be surprised if there was a

Great pasta

MUSHROOMS

Chianti I put on 4 lbs. it was all so good!

Trudy's apple strudel

TRUDY is AUSTRIAN

I HAVE NEVER LAUGHED SO MUCH

cards

The Goddess of Liberty

In her right hand
the FIRE of CHAOS
exploding, creative
purifying
the book? order?
I am convinced
she is connected to
the Spirit of the TAROT,
ROTA, TORA.
She HOLDS HER
BOOK (WORD) of INNER
SECRETS in her left HAND.
Will unrolling
(what INNER ORDER is about)
protect me from being
consumed by the EXCITING
and SCARY FIRE
of CHAOS??
Who is the GODDESS
of LIBERTY??
THE HIGH PRIESTESS?

SHE SHOWS ME HOW
. to IMAGINE
my life

ORDER AND CHAOS
are united by ETERNAL MOUVEMENT and TIME?

Dear Diary, March 94, La Jolla

what is Time?

Time PAST, Time PRESENT, Time FUTURE TIME UNKNOWN. ALL the other times I don't KNOW ABOUT. ?

ORDER/CHAOS (I AM CHAOS)?

WHICH CAME FIRST? do they Exist side by side??

I want to Control and Explain instead of just SURRENDERING to the Mystery

BANG! BANG!

All my CREATIVE MOMents come out of CHAOS.

EXPLODING PAINTINGS

FIREWORKS FLAMING RAINBOW

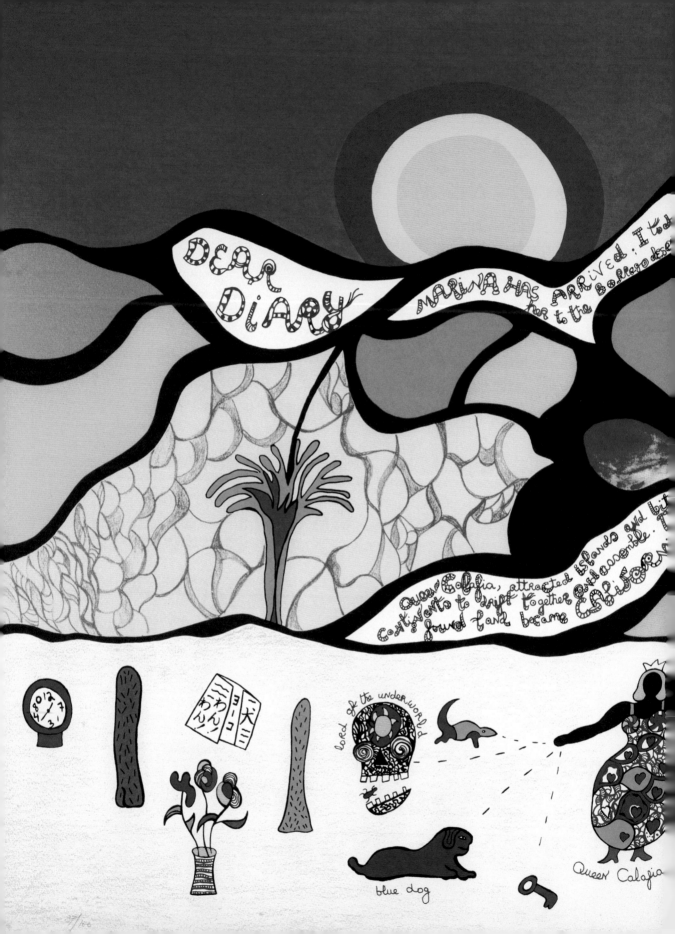

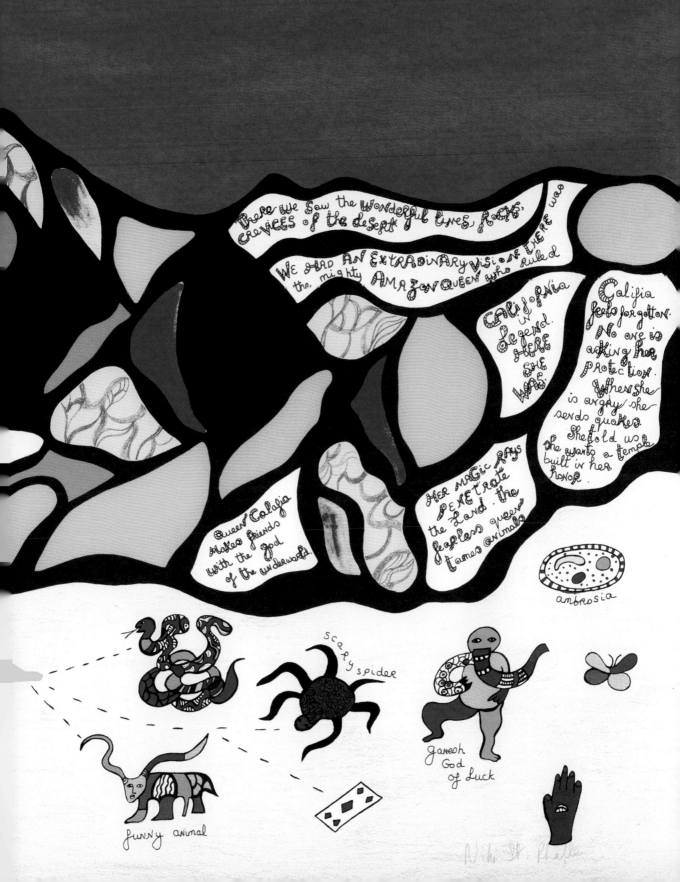

There we saw the wonderful lines, rocks, crevices of the desert

We had an extraordinary vision there was the mighty Amazon Queen who ruled

California in legend. Here she was.

Califia feels forgotten. No one is asking her protection. When she is angry she sends quakes. She told us she wants a temple built in her honor.

Queen Calafia makes friends with the god of the underworld.

Her magic rays penetrate the land. The fearless queen tames animals.

ambrosia

scary spider

Ganesh God of Luck

funny animal

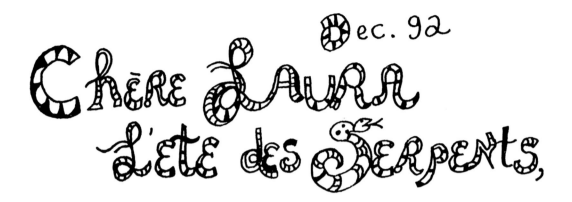

Chère Laura
L'été des Serpents,

Dear Laura
Summer of Snakes,

Every summer, my parents rented a country house a few hours from New York City in New England. Each time, we stayed in a different region. It was 1942. My parents had rented a nice white wooden house with lots of land around it.

The grass was tall. It smelled good. A dense, seductive calm enveloped my walk through the fields. I liked looking at the sky and the clouds, especially at twilight.

A big gray rock blocked my way and was too big for me to ignore. Intertwined at the top, two opulent black snakes (copperheads), whose venom was deadly, were moving slowly. I stopped, terrorized. I dared neither move nor breathe at that point. Fascinated, I saw death for the first time up close.

Was it death or the dance of life? I must have stayed there for a long time in front of the snakes, fascinated. I had become a snake.

The following week, we cut the grass and put poison in the fields around the house to deal with the snakes. Was I exterminated along with the snakes?

One evening, I pulled back the sheets on my bed in the small room where I slept alone. In the sheets lay the black corpse of a snake. I knew perfectly well who had put it there. It was John, my eldest brother. He was shorter than me, and he didn't forgive me for it.

My cousin Charles-Henri, who was twenty-years-old, was in the next room. My cry attracted him. He thought I had been stung. He took the serpent's body and threw it out the window.

I begged him to let me sleep beside him, soothed, I spent the night in his arms. The next day, my parents were shocked to learn that I had slept with my cousin.

Morality was everywhere in our house: crushing like a heat wave.

That same summer, my father—he was thirty-five years old—slipped his hand into my panties like those horrid men in the cinemas ogling little girls.

I was eleven, and I looked like I was thirteen. One afternoon, my father wanted to look for his fishing rod, which was in a small wooden hut where the garden tools were kept. I went with him... Suddenly, my father's hands began to explore my body in a way that was completely new for me.

SHAME, PLEASURE, ANGUISH, and FEAR wrenched my chest. My father said, "Don't move." I obeyed like an automaton. Then with violence and kicks, I freed myself from him and ran into the field of cut grass until I was exhausted.

There were several such scenes this same summer. My father had over me the terrible power of adults over children. No matter how much I struggled, he was stronger than me. My love for him turned into contempt.

He had shattered my trust in human beings.

What was he looking for? This, too, is not easy. Pleasure was something he could find elsewhere.

NO! It's the taboo and the temptation of absolute power over another being that exerted a dizzying fascination on him.

There is, in the human heart, a desire to destroy everything. To destroy is to affirm that one exists against all odds.

My father loved me, but neither this love, nor the ultra-Catholic religion of his childhood, nor morality, nor my mother, nothing was strong enough to prevent him from breaking the TABOO.

Was he fed up with being a respectable citizen? Did he want to join the murderers?

All men are rapists. Look at the history of war. The soldier's reward is always rape. This has been happening since time immemorial.

For the young girl, rape is death.

There is only one solution: the law. The law to protect those who cannot protect themselves.

Fear of prison for rapists of little girls.

At eleven, I felt expelled from society. This beloved father became an object of hatred. The world had shown me its hypocrisy. I understood that everything I was taught was false.

I had to rebuild myself outside the family context, beyond society.

The Summer of Snakes was when my father, this banker, this aristocrat, had put his cock in my mouth.

My father died in 1967, felled at sixty by a heart attack.

The sudden death of my father, without our having reconciled, was a huge shock to me.

I decided to make a film to try to understand what my relationship with him had been. I started the film in 1972 with the help of the filmmaker Peter Whitehead.

I gave free rein to my fantasies, and a mad anger arises from this film. Through the images, I trample on my father, I humiliate him with all my might, and I kill him.

To my great surprise, this film, far from calming me, triggered a nervous breakdown. I hadn't had the courage to make this film while my father was alive, and the violence of my feelings against him and men had overwhelmed me.

Jean Tinguely, my family, and almost all the press were outraged by this film. Only my mother, some rare critics, and Jacques Lacan stood up for me.

I had asked my mother not to see *Daddy*, claiming that it was a paranoid fantasy invoked to deepen my art.

Not long after the film came out, I had lunch in New York with my mother in one of these tiny French restaurants she was fond of when she said to me in a very calm tone, "I know everything. I opened the letter that Dr. Cossa sent your father, and he confessed everything to me. I wanted to throw myself out the window."

She said to me further, "If my father had done that to me, I would never have spoken a word to him again." From this day on, there was a secret conspiracy between my mother and me.

She followed my advice and never saw the film.

Tormented for years by this rape, I consulted many psychiatrists: men, alas!

What they brought out above all, to my deep dismay, was the ambivalence of the little girl, who might have caused the situation. Psychiatrists, therefore, since they did not recognize the crime of which I had been the victim, unconsciously took my father's side. According to them, no man could be blamed for not having been able to resist the perverse seduction of a young girl. It was up to her not to provoke her father, who was the victim of a tragic moment of weakness.

It's exactly as if, in examining the behavior of the racists in the Ku Klux Klan, we deduce that Black people had exaggerated in order to lead brave white people into racism!

This rape made me forever united with all those whom society and the law exclude and crush.

Since I had not yet managed to externalize my rage, my own body became the target of my desire for revenge.

Solitude. We are very alone with such a secret. I got used to surviving and living with it.

The number of raped women who end up committing suicide or who are forced to return to the psychiatric asylum is monstrous.

There are survivors. Among the writers, there is a long list of women who kept going. Virginia Woolf, on the contrary, succeeded in a body of literary work, but she did not ultimately escape suicide.

We know today, thanks to considerable work, that the vast majority of rapists

were raped themselves by a father, a brother, or a stranger: had this been the case with my own father? I may never know for certain. Unhappy humanity! We repeat the crime inflicted on us indefinitely.

At these thoughts, the rage in me gives way to pity for all human beings.

If men are (often) rapists, rapists are also men. Rape is not essentially a sexual act. It is a crime against the spirit.

My father supported society as it was. He adhered to his morality, but something in him dreamed of wrecking everything in order to find himself. Alas! Men often lack imagination; very few dare to cross the line that separates them from themselves. They cannot conceive that at every moment another life, full of possibilities, beyond respectability and conformism, is available to them. The most gifted and the most proud remain unconvinced about this lack of imagination. My father, secretly, had to suffocate in his life, but he lacked the courage of genuine outrage. The little girl I was will be the only victim of his lamentable rebellion.

This rape suffered at eleven years old condemned me to a deep isolation for a long time. Who could I have told? I learned to live with it and to survive with my secret. This forced solitude created in me the space necessary to write my first poems and to develop my interior life, which would later make me an artist.

I kiss you, dear Laura, with much tenderness and regret at not being able to speak to you about all this while you were a teenager. Why is it so difficult to speak?

I love you
Maman Niki

P.S. Prison is not the solution!
P.P.S. One day I will make a book to teach children how to protect themselves.

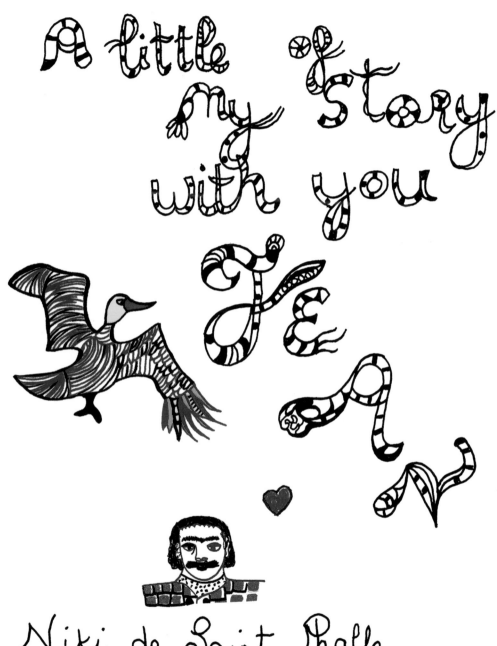

A little of my Story with you JEAN

Niki de Saint Phalle

Jean, I met you in 1956. I was twenty-five and you were thirty-one. When I saw your first machines, I was with my first husband, Harry Mathews. In the studio that you shared with Eva Aeppli, there was suspended a long mobile relief in black and white. There was a little hammer which hit a machine, and there were numerous little wheels which turned and trembled. I had never seen anything like it, and I was crazy about it. Harry and I didn't have much money, but we decided to buy it. You were very happy.

How many times did we go together on pilgrimage to Barcelona to see Gaudí, my master? The first time I discovered Gaudí, I felt hit by a lightning bolt. It was that day in 1955 that I met my destiny. I trembled all over and felt that I too was meant to create a garden of joy for people to enjoy one day.

We also visited the marvelous Bomarzo monsters in Italy. It was together in 1962 that we discovered the Watts Towers.

You helped me enter the "normal" art world of exhibitions, the cultural world. Later, you would put all of your ability and energy at my disposal to make the iron structures of my monumental projects, respecting my models exactly.

When I met you, you were totally into modern art, Malevich, the Dadaists. It's you who introduced me to Marcel Duchamp.

What I brought to you was a dream that fitted your hand like a glove: "outsider" art. Your desire to make something immense, fantastic, outside of the art world was my contribution to you.

In 1961 and 1962, I made altars. Many years later, you would also make altars, totally different. It was like a game of ping-pong between us, always keeping each other on our toes. I wanted you to be my hero, and you responded to that. You liked the very strong, tough woman in me, which pushed me further. Ours was a very fertile marriage of the spirit. But the most important thing you brought to me, Jean, was your confidence in my work. You believed in my dreams. You recognized them to be a reality. One day you said to me, "Technique, Niki, is nothing. The dream is everything."

Between you and me was forged a solid friendship, founded on our mutual passion for our work.

When we first started living together in 1960, you saw me as an aristocrat, the enemy. You were the working-class man. That's why you loved going to the movies in the afternoon when everyone else was working. Most of the time, however, this didn't matter at all, as we were doing our "Bonnie and Clyde" art team, making bombs, exploding machines, and shooting up art.

To see me spending so many hours at work dissuaded you from going to the bars and passing so much time picking up girls. You started drawing too for long hours, and you loved it. Eva Aeppli called me "Snow White and her dwarves." She couldn't understand how I could spend so many evenings with you, Rico, and Seppi without being bored.

I remember the exploding birthday cakes you and Rico used to prepare. There was shaving cream that looked like whipped cream that always ended up on the walls. Inside, the cake was filled with little fire crackers. Nobody understood our relationship, certainly not us.

Our very diverse educations and upbringings made our living together difficult. Each morning you would read the sports page out loud for news about all the race-car drivers. You liked to turn the TV on in bed, while I liked to read late into the night. Many of my favorite authors I could not share with you because you liked history, not poetry or novels. For me, history is a long recital of man's insanity.

Somewhere in a Magic Space, we met. Where neither your background nor mine existed. It was a meeting of pure electricity.

We couldn't sit down together without creating something new, conjuring up dreams. We knew how to play, and we knew how to play together. I think of all the projects we had fun dreaming up. Did we realize half of them?

Remember the big cascade of Nanas you wanted to make, with water swirling around? You wanted the Trevi Fountain to look small in comparison. You were macho and not at all macho. Contradiction was your name.

Remember when you exchanged a sculpture with Marc Bohan of Dior for clothes for me? If there was a small tear on my dress or if a button fell off, I couldn't care less. But you would go right out to Madame Martino's, the local store, and buy thread and sew it back on. You learned to sew in the Swiss army.

Remember, Jean, you told me you felt I was elusive? You couldn't catch me. Is that why you always came back?

I didn't know how to deal with your rages very well. They would come suddenly, unexpectedly, like Mother's. The moon gone crazy. So I resorted to my childhood tricks. I learned to switch off totally. Not say a word.

I remember the beautiful bouquets you made for me. You often hid one or two plastic flowers in them. Sometimes you would bring a little bouquet of violets. You never came with empty hands.

My friends all found you sexy. Alas. I wonder if you ever counted the women you had?

You were a sexy tough guy, with a cigarette dangling from your mouth. You looked like a young, dark Jean Gabin.

It was in 1960 that we fell in love with each other. For me, I think it was the day when you put out your cigarette in the butter. It amazed me. For you, I think it was when you realized you didn't like your friend Daniel Spoerri flirting with me.

Jean, in 1960, you arrived in New York on the *Queen Mary* with machines to make your first American show at the Staempfli Gallery.

You were already known for your *Méta-matics*, drawing machines, which

enchanted Duchamp, John Cage, and Raymond Queneau, and which also angered the Abstract Expressionists.

You seduced the cultural world of the Museum of Modern Art in New York, which was rather conservative, and managed to impose in a few weeks your imperious dream. You wanted to make an *Homage to New York*, an insane machine, beautiful and auto-destructive, which would consume itself and commit suicide in the courtyard of the Museum of Modern Art in a spectacle which lasted thirty minutes.

Today, more than thirty years later, I still ask myself how it was possible to have had them accept such a folly. Bravo, Jean!

A few days before the machine was to explode, one of the directors of the museum, Peter Selz, came and asked you, "Promise me you won't make it destroy the museum too." You gave your word of honor, but everyone in the museum was trembling, and at the same time they were under the spell of your crazy genius. They didn't dare ask to do a security control or ask too many questions.

When we went to America, we had fun. I was your ambassador. Poets and writers were our friends, and you liked each other. Kenneth Koch even wrote a play for you, *The Tinguely Machine Mystery*.

You loved many American artists. You were friends with and an admirer of Rauschenberg, Jasper Johns, Ed Kienholz, Larry Rivers, and Frank Stella. We collaborated several times with Bob Rauschenberg. The first time was at the American embassy in 1961, in a John Cage concert (David Tudor spent almost all the evening under the piano). On the stage, you made a striptease machine, which lost all its feathers and diverse parts. Rauschenberg painted a painting onstage, which he did not allow the public to see. Jasper Johns presented a big target made of flowers. I did a shooting painting, only David was too nervous that I might shoot him by mistake, and so we hired a professional marksman. The majority of the public left before the end of the show. Only a few remained. These cultural exchanges were very exciting for all of us.

I remember we were in New York together in the autumn of 1962, when Pop art exploded like a bomb. I remember how excited we were. We immediately loved Lichtenstein, Rosenquist, Oldenburg, Jim Dine, and Segal. You liked Warhol's work very much, but he gave you the creeps. He made you uncomfortable, and you asked me not to become too friendly with him. You felt that Pop art was a truly American phenomenon, and you liked the Dadaist side of it.

When the most important gallery at that moment, Leo Castelli, asked you to make a show at his gallery, you were very pleased. Many of the artists you admired were in that gallery. You immediately accepted. Fifteen days before the opening, Leo said to you, "I can do everything for you in America, but only on one condition. Move to New York and become an American."

You immediately took your machines and left the gallery.

Only an immigrant like Leo Castelli could think like that. Leo wanted to bring to his new country, which he adored, the artists he loved the most. I understand this desire well, being the daughter of an immigrant myself.

Jean, you never refused to participate in any of my projects, even the craziest ones. When I made the film *A Dream Longer Than the Night*, I asked you to invent a war that would make fun of men and their phallic obsession with arms. You and Luginbühl* went to a great deal of trouble and made a marvelous parody of a combat. I asked you both to play the generals, which amused both of you to no end.

Contrast is one of the secrets of our collaboration. I made my colors stronger so the strength of the darkness of your iron would come out. Another reason our collaboration was to last so long, and how it continued to renew itself, was that I often changed the subject matter. I was as obsessed with change as you were with movement.

You always asked me to start our collaborations. I would prepare for you lots of little maquettes in clay, and when there were enough, I'd tell you, "Come and do your shopping." You came and chose.

I liked to experiment with different materials. This interested you very much. I would go from one material to another, to see what secret it could reveal to me. Like the god Vulcan, you remained faithful to iron, but also to found objects. You always said, "I am an assemblager."

Alexander Iolas had started his autumn season in 1962 with a show of Yves Klein's. Yves had died suddenly, at the age of thirty-two from a heart attack, to our great sorrow.

Iolas always followed his instincts. In the summer of '62, he saw at the Galerie Rive Droite an altar in gold which I had made. He decided immediately to give me a show that same autumn in New York. My show followed that of Yves Klein. We had a shooting stand in the gallery where people actually shot at my Tyrannosaurus reliefs. It was insane, delirious, and a great success. Iolas immediately seized the occasion of the breach between you and Castelli's gallery to propose that you have a show in his gallery right away. You accepted. My show was leaving the Iolas Gallery while your pieces were arriving. All my pieces were white (it was the period of *The Bride*, women giving birth, assemblage). Your works were all black; they contrasted so much with mine. Our eyes met. This exchange was the decisive moment in which the seeds of our future collaborations were born.

*Bernhard Luginbühl, Swiss sculptor.

We both insisted with Iolas that he show *Roxy*, a giant work by Ed Kienholz, which we loved. No other gallery in New York would show him because Ed was a Californian, and there was a cultural war going on in that period between California and New York. Iolas was always receptive to the artists that other artists brought him. He trusted artists' instincts.

During the '60s we often went to New York. We used to stay at the Chelsea Hotel, or with our great friends, Clarice and Larry Rivers, in Southampton, where we spent long months together.

Alexander Iolas was our dealer for years. He was quite a phenomenon. He was a genius, intuitive, perverse, funny, and had a real passion for his profession as an art dealer. He would shut himself up in the gallery two days before a show, alone with the works. He would sleep on the floor and couldn't leave until the hanging was exactly as he wanted it.

We learned a lot from him. It was he who got us into making catalogues. He said, "It's the only thing that remains of a show." He didn't count the pennies. He said, "It will cost what it will cost." He showed us catalogues of Max Ernst and Magritte that he had made. It did not take long for him to convince us.

He loved our drawings, yours and mine. And since we were often broke, he bought all our drawings and collected all my silk screens, especially the ones with writing on them. You scared him a bit, like everyone else. But he wasn't Greek and wily for nothing. He knew how to handle you and make you laugh, or fascinate you like a snake.

Iolas had a look which did not please everybody. He had diamond and emerald rings on each finger, and his shoes had wide heels. In winter, he would wear long mink coats that trailed on the ground. He owned 2,000 watches. Jean, you told me one day, when you were going through customs with him, you saw beneath his transparent Egyptian shirt a large belt that was made of solid gold.

Once, when going to his gallery to get my monthly check, I saw he had little bits of string tied on all his fingers, instead of his diamond and emerald rings. I asked him, "What's going on?"

He answered, "I had to separate myself from my rings. I put them in hock. Niki, I must reduce your contract by half."

"All right, Iolas, and when things go better for you, you can raise it again."

When I told this to you, you were enraged. You said to me, "How could you be so stupid, didn't you understand the rings were just a ploy?"

Another time, when you were starting the Head, you were looking for funds to continue to finance this project. Iolas was about to pay me for the sale of my first big sculpture. When I told him I was going to give you this money for the Head, he said to me, "Come back tomorrow, I'll have it."

The next day, he gave me an elegant black leather case filled with money, which represented the sum of $10,000—all attached with pink ribbons. Bénédicte Pesle* whispered to me, "Don't let yourself be had, Niki! Refuse, and count the bills. It's the big trick of dealers to encourage artists to like money. Bills are more seductive than a check." I did count them and some were missing, but I did not refuse the gift. It was too tempting. Proudly, I gave it to you, Jean, who did not refuse it either.

Hon was our first big collaboration, with Pontus Hultén and Per Olof Ultvedt at the Moderna Museet in Stockholm. This is where we first met Rico Weber, in 1966. He was washing dishes for the museum restaurant. We needed volunteers to help us. Rico, already an artist, a Swiss hippie with long hair and a beard, entered into our life.

After *Hon*, Rico became our first assistant for many long years.

It was a remarkable feat, to be able to be an assistant of two artists as diverse as you and I. Rico always kept his autonomy. He would come for periods when we needed him. It was Rico, Jean, with whom you welded the *Fantastic Paradise*; and it was with Rico who mainly welded the *Golem* for me. Rico worked with us until 1976. It was then that he decided to concentrate only on his own art. This did not please you. I, on the contrary, encouraged him. Rico is today a very unique artist, and his work does not resemble either yours or mine.

For the World's Fair in Montreal, Canada, in 1967, the Minister of Cultural Affairs contacted us, along with other artists, to make a sculpture garden on the top of the French Pavilion. We immediately seized on the occasion to present a collaboration to take up the whole roof, thus eliminating all the other artists. We baptized it the *Fantastic Paradise*. It was a love combat between my Nanas, my animals, and your machines.

When our maquette was finished, you asked me to go present it by myself to Robert Bordas, president of the French Pavilion. You knew I was a good fighter. Faced with his reticence, I immediately attacked, "Do you know what the Americans are going to do there? A Buckminster Fuller dome! With Rauschenberg, Jasper Johns, Stella, and all the best American artists. And you, the French, will be ridiculous, as usual. For once, take a risk, take a risk with us!"

The secretary who was taking shorthand suddenly asked, "Should I write all this?"

"Yes, write everything!" said the president.

Finally, he agreed, but we had to pay for everything. They didn't have any money. Their budget was empty. Luckily, Germain Viatte came to our rescue. He proposed that the National Museum of Modern Art in Paris would buy works of yours and mine,

Bénédicte Pesle, director of the Iolas Gallery in Paris and a supporter of American avant-garde artists in Europe.

which would correspond to the cost of making the pieces. We accepted, so it was actually us who financed the *Fantastic Paradise*. As this was our first budget, we got it all wrong and had to pay the difference. It took a couple of years to pay off the debts.

It was at the time I was working on the Montreal World Fair that I seriously burned my lungs while cutting polystyrene with a heated electric wire. The day my work was finished, I fell to the floor and had to be hospitalized.

Jean, you had to leave for Montreal with Rico for the installation. When I was better and rejoined you at the French Pavilion on the roof, it was freezing cold. I heard you screaming, "It's me, the captain of the roof!"

Robert Bordas looked delighted to see me arrive just at that moment. He said to me, "Madame, Jean Tinguely has become crazy. He wants the whole roof for your pieces. The cardinal of Montreal came yesterday to visit the roof, and he was very shocked by your work. He wanted us to take everything off. I propose to give you both half the roof, do you agree?" I replied, "Monsieur le Président, I've just come out of the hospital. I was very sick. It is very cold. If you don't give us all of the roof, I shall immediately start a hunger strike." Robert Bordas, always elegant, kissed my hand and said, "Madame, the roof is yours."

Many years later, Robert Bordas would tell me that he telegraphed President Georges Pompidou of France that night: "What should I do with these ruffians?" Georges Pompidou telegraphed him back: "Let them have the whole roof."

Jean, you always loved collaborating. Our collaboration lasted over thirty years. When Jacques Chirac, who was mayor of Paris in 1982, and Pierre Boulez, the composer, went to see you, they asked you to make a fountain for them in front of the Centre Pompidou with Miró. You refused.

You said, "I'll do it with Niki, or I won't do it at all."

I was very honored that you preferred to work with me. It was through the making of the *Stravinsky Fountain* that you and I became close friends with Madame Claude Pompidou, who wholeheartedly supported us.

Jean, you had a multitude of other projects. One I remember was in 1963—you designed a tower. You wanted to make a cultural tower in Paris. You made many drawings and contacted engineers and the architect Claude Parent. You also wanted to make a huge phantom train which would go through a park, and a cultural station with Luginbühl. Alas, the finances were not found.

We also thought about making a traveling cultural circus, mixing animals and art. We asked Spoerri and other artists to join us. You and I were fanatic fans of provincial circuses. We imagined ourselves in our caravan, going from city to city.

Then Eva Aeppli and Sam Mercer rented a house in Saint-Vrain, in the park of my cousin Charles René de Mortemart. The park was beautiful. We asked him to let us construct a monster on his land. He was enthusiastic, but his wife Moira was

scared. It was too bad, because the place was magnificent. Later, he turned it into a zoo, and someone was eaten by a lion. We were disappointed, but not discouraged, and we went to find another place.

It was in the woods of Milly-la-Forêt that we found our site. The land was cheap. We could afford it.

We consulted the mayor of Milly, Mr. Clovis, who also happened to transport our sculptures. We told him about our project and our fear of regulations and formal permissions. He had the courage to say, "Yes, in the village of Cocteau, do as you wish. I will shut my eyes."

The land we wanted to build on was not zoned for construction. That was why it was so cheap. So we bought the land together, fifty-fifty.

And then you began to pose yourself some questions. At that time, you were reading Max Stirner's *The Ego and Its Own*. You wanted me to read it too. (I remember carrying it around a long time… and it was very heavy, but I didn't end up reading that much of it.)

You were also influenced by the Austrian philosopher Wittgenstein. You told me about his life. He was the richest man in town. He decided that he didn't want to be rich anymore and thought a long time about what he should do with his money. He decided to give it to the next-richest man of the city, because he didn't want to disturb the lives of the poor. He then went penniless and installed himself in Sweden as a gardener.

This book impressed you a lot. You decided that we should give the land that we had just bought to build the Head on to the richest people we knew. We didn't want the Head to belong to us. We immediately thought of our friends, John and Dominique de Menil. They accepted, and much later, when we asked them, they gave it as a present to the French state. You insisted that I sign the act of donation to the French state with you.

Our first idea was to make a monster and to call it the "Monster of Milly." We thought about it a lot, and finally the idea of the Head won. You were full of enthusiasm. You loved working in nature. We would often grill our meals in the forest and eat there. Luginbühl and Spoerri came often. There was a great feeling of excitement. It was a good time. You started making some money, but not too much. You were in the prime of your life.

In 1972, you decided that the Head must be stable and solid, if it was to be visited. You decided to hire a professional welder, because you and Rico were artists and not professional welders. You put an advertisement in a specialized paper, and that's how you met Seppi Imhof. He was a welder at Von Roll, a steelwork factory in Switzerland. Seppi must have fallen from the sky when he joined us. He arrived on another planet. He wanted to stop work at five at night, like in a factory. You had a

hard time understanding his very peculiar local Swiss accent. It took quite a while for him to adapt to us and us to him. He thought we were all ready for the asylum.

It is thanks to Seppi's great technical skills and devotion that you were able to make the Head as you wanted. One day, Colette Le Cléac'h asked him what he was doing. He answered, "I am an artist's slave." He wasn't wrong.

Seppi brought you his technique, but you never allowed him, or any of your other assistants, to use their initiative. No one had the right to add to or suggest anything. There were memorable scenes about this subject. You liked to help young artists, but not in your domain. No one could touch your holy iron. Once, though, you let Seppi assemble a bit of the Head which was an homage to Schwitters, but of course you chose all the pieces he was to assemble.

Later, Seppi opened a small gallery called Friday Gallery at Solothurn in Switzerland. It was his way of participating in the art world in an autonomous manner.

A few years before you died, you asked me to make one of your favorite pieces, *Bird in Love*, at five and a half meters high. Seppi also loved this work of mine. He had already asked me if he could use it on the back of a deck of cards, and he made a very pretty edition of them to sell in his gallery.

You were impatient to install the *Bird in Love*, but it was the month of August, and as each year, Seppi took his vacation then. Not once did you manage to make him change his vacation time. So you were rather annoyed, and you wanted to teach him a lesson. So you decided to install the *Bird in Love* without him. On his return, Seppi was stunned to see the sculpture in place and went up to the top of the scaffolding to verify if it had been done well. Seppi, usually agile as a cat, fell and severely fractured his back. Jean, you were extremely unhappy about this. What a terrible coincidence. Later, I'd give Seppi a small version of the *Bird in Love* to try and reconcile him with the piece he had once liked so well.

It was the time of free love in 1973. The pill was going strong. You were living half-time with me, and half the time with Micheline. When Micheline became pregnant, you gallantly offered to make me a child too. I declined.

I ran away with the first beautiful man who came by (he was presented by my great friend Marina Karella). He was twenty years younger than me. He was a poet, English, and he had long golden hair. He used to recite Shakespeare's sonnets to me (which sounded much better than Grand Prix racing). Your friends found it unbearable to see me with him. They said it was dishonorable to you. Spoerri one day insulted him by calling him "just a gigolo." He was living poorly by choice and did have quite a few holes in his clothes, which I never mended. Even if I had been keeping him, so what? He came from an old aristocratic English family that didn't have money problems.

Around the age of fifty, when your friends Luginbühl and Hofkunst grew mustaches, you grew one, too. Little by little, it became your mask. You told me, "I can

hide behind it. Between my bushy eyebrows and my big mustache and my longish hair, I can hide my mouth and eyes, which give me away." The hair masked a very serious look, a shyness, a toughness, and a great sensitivity.

We had fights, too. Once I made a dome in the *Tarot Garden* where I planned to place the Hermit. Jean, you screamed, "You'll never be able to make anything from that. Forget it!" I did not tear the dome down. Patience is sometimes one of my virtues. I waited.

Several years later, your bypass surgery went wrong. You were in a coma for several weeks. I needed a church to pray in. Brought up Catholic, I went to a church. It was so ugly, I ran out. Finally, I chanced upon a small Russian Orthodox church in Geneva. Lots of candles and icons and great charm. I lit all the candles each day. One icon particularly struck me. I prayed to this icon, "If you save him, I'll make a chapel in your honor." Miraculously, you recovered. The dome became her chapel in the *Tarot Garden*. I made a Black Madonna icon in ceramic inside. On top of the dome, I placed the Angel of Temperance. It's a jewel in the Garden. And who loved it the most? Jean, you of course. You cried when you saw it.

I use to like to sleep alone with open doors inside the Sphinx in the *Tarot Garden*. You had an obsession that I was going to be kidnapped by the Mafia. You gave me exact instructions on how to survive if this were to happen… You told me to tell them that I was very sick, and without my medicine I would die. You also told me you would pay the ransom, no matter how high it was. With the new protections that you designed and had Seppi build, the Sphinx became a bunker.

After you were so sick, Jean, you said I saved you by talking to you all the time when you were in a coma. You wanted to take me to a bank, place me on a scale, and give me my weight in gold to help fund the *Tarot Garden*, to thank me. If I had accepted, I would have pleased you, and it would have simplified a lot of things for me later on. Why did I refuse? Deep down all those Benedictine nuns were inside of me. All that righteous upbringing took hold. I did not find the alchemical mix of gold and love to augur well.

Jean, you and I never really separated. An invisible thread held us together for over thirty years.

I knew you wanted to die. You did not want to live with your diminishing physical strength. You did not take your medications, or when you did, you would take the whole box.

There was nothing I could do or say to help. You were in purgatory. You did not like it. Sometimes, you would call me from your car and tell me at what impossible speed you were driving, and that you were going to take your hands off the wheel.

It was with the people closest to you that you were the most obnoxious, as well as the most tender. You were not a double Gemini for nothing!

The more I think about us as human beings, the more I am convinced that we contain everything: Goodness, Creativity, Stupidity, the Devil, and God. We contain all these elements, and we choose what we are and what we will be. With your death, I had to make many difficult decisions. You often said to me, "My work will not survive me." That is why you left me your moral rights. You knew I would do everything possible to save your work.

Your funeral, Jean, which you had totally organized, was like a king's funeral. You ordered the music, the Mass, and the pipers from Basel. Prince Michael of Greece had never seen a more royal funeral.

Now, I felt this grandiose funeral only represented a part of you. The part of you that appeared after your bypass, when your personality changed. Before your operation, you used to listen, and you were secretive. After, you began to talk a great deal. It was almost as though another person had joined you.

I thought it would be a good idea to create an incident in the middle of the cathedral. First, we must cover the sad-looking coffin in mirrors. Then inside, place some motors that would alternately make some strange screeching noises to scare everyone.

I got out my pencil, and Rico, Marcelo, Seppi, and I drew the possibilities of how to quietly open the coffin and have one of Eva's bony hands appear or have the coffin turn right around, very fast.

Pontus Hultén assisted at this conversation, which went on for hours. He knew I meant it, but he didn't want it to happen. So very cunningly, Pontus asked lots of technical questions, while he kept filling our glasses with vodka. When he felt there was no longer enough time to execute the plan, he quietly put the drawings in his pocket. That was the end of that.

You had wanted to become the king of Switzerland in your last years, and you did.

Before 1986, the moment when the art market went crazy with speculation and all the prices went skyrocketing, you weren't particularly interested in money. Your only luxury was your obsession with Grand Prix racing and fast cars. Later, you let yourself be impressed by the power of money and by the media. That's why I thought that the anarchist incident in the cathedral was closer to the real Jean. You suffered enormously during those last years, even though it never impaired your creativity.

You asked me not to come to your openings, as you preferred being seen with a young girl on your arm. My love for you, Jean, transformed itself from a passionate relationship into a more compassionate one. You always knew you could count on me, and I on you.

The great love of your life was your work. The same was and is true for me. It was there, dedicated to our goddess, that we forged an extraordinary relationship.

"Annabel Lee," Edgar Allan Poe's poem, comes to mind:

And neither the angels in Heaven above
 Nor the demons down under the sea
Can ever dissever my soul from the soul
 Of the beautiful Annabel Lee

Jean, you were a great artist and an imperfect man.

When you became the "clown," you felt more at ease telling your very amusing tales, to which your fertile mind always gave a certain unexpected twist, and behind your mustache, you were not afraid to be ridiculous.

I miss how chivalrous you were to me. You always treated me like a queen with a certain deference. We were a good match. I liked your macho side. You liked the feminist side in me. I liked (I needed) to take risks as much as you. I lived for a vision and so did you, and the excitement between us was infectious and fertile.

I miss you. I miss you walking into a room and electrifying it.

How many times did you give me *The Prince* by Machiavelli to read? I found it boring and never finished it. I should have listened to you, because since your death, the culture vultures have been having a field day. I did not do my homework properly. It's all there in the Bible, the New Testament, and Shakespeare. Judas and Brutus are people we meet on the long journey of life, and we must learn how to deal with them. The world is a tough place, and it is necessary to learn to defend what one believes in. Nothing grand gets done without leaving a few scars.

Living with you could be extremely difficult, as you had a sense of your own space, but did not realize this for others. It's a privilege to have shared this relationship with you, with its many ups and downs.

Alas, in your later years, like certain great men, you fell victim to your own myth. You loved the media, while at the same time despising them.

In spite of your cynical and very funny remarks, you remained a passionate ruffian, romantic and anxious. You were my hero for a very long time, and when you weren't anymore, I still loved you. I miss you. I always made you feel you could come home when you wanted. I created a certain psychological stability for you. A safe place.

My continuing year after year with my *Tarot Garden* was profoundly important and moving to you. It helped keep up your faith and commitment to your own work. You, as well as me, belong to those privileged artists for whom creation is a game. Many artists suffer when they work. I have often been reproached that I'm not a real artist because I have passionate fun working, and because I amuse other people with my work. We wanted to communicate with people and our work to be for the people.

After your funeral, there was a small gathering of people at the Hahnlosers' home. Paul Sacher* came up to me and clinked glasses. He said to me that if I would give enough sculptures, he and Hoffmann-La Roche would create a museum for your work.

Spontaneously, I said yes. Afterwards, I thought about it, why Switzerland? First of all, Jean, you were Swiss, and then, a lot of your creative fires came out of rebelling against your country.

Jean, you would never have been the artist you became if you had not left your native land to experience the greater world. But it was Switzerland that always held you in a strange way, called to you, and right or wrong, brought you back.

You were linked with a tender friendship to Maja Sacher. You wrote her beautiful letters for years and years, which are now published in a book. I also loved Maja. We would visit her in Italy, St. Moritz, Basel. We were friends with the whole family, Vera, Lukas, and their children. After Maja's death, you often saw Paul Sacher and the two of you became very close, as did Paul and I, after your death.

Paul told me the two of you had planned a future museum, not far from Paul's house, Schönenberg. The survival of your work was an obsession for me. By keeping your work alive, I was keeping you alive. Your pieces need to be maintained and repaired. Hoffmann-La Roche were soon to have their centennial, and Fritz Gerber was willing to finance the project, which was perfectly in accordance with the tradition of Hoffmann-La Roche to support the art and artists. He had already bought difficult and important sculptures from you for Hoffmann-La Roche.

In 1988, you bought an enormous factory called the Verrerie under both our names. You wanted it as a working space and also as a space to enable yourself and other artists to store and exhibit their work. The last year of your life, you started installing two exhibition spaces. The first was the *Bird in Love* in five and a half meters that you commissioned from me. The next room was filled with an extraordinary group of Eva Aeppli's sculptures.

I asked you several times to make a foundation out of the Verrerie. I even sent our lawyer to see you. You refused, saying, "It's better to leave a door open, something better might turn up."

Luginbühl, Spoerri, and Eva were all originally against the idea of the Basel museum. They wanted the Verrerie, but there was nobody who would have taken over the responsibilities and the financial support to run such a museum. I did not want to enter into a Tower of Babel.

Paul Sacher, a Swiss conductor and arts patron. His wife, Maja, was a Swiss art collector and philanthropist with family ties to the Hoffmann-La Roche pharmaceutical company.

Before I finally agreed to support the Basel museum project, I asked two people whose judgment I valued and who were close to you: Pontus Hultén and Ebi Kornfeld. They both agreed it would be the ideal solution and right choice for your work.

I always felt you outshone all your contemporaries. Your energy and incredible creativity were consistent in everything you attempted, from the smallest drawing to a huge outrageous machine. Each was unmistakably a Tinguely.

That Hoffmann-La Roche, which also includes a very important research laboratory, made a museum for you was curiously appropriate. Your mind was always inquiring, searching, and asking questions about man and his relation to life and to art. Your way was similar to basic scientific thinking and research.

Mario Botta has designed an incredibly beautiful museum for you. It is made to the measure and merit of your work, with a view to the new century about to come.

Now thousands of people will be able to see and share in the power of your crazy and beautiful vision.

I am pleased and happy to contribute and honor you, Jean, a man I have loved and worked with so closely, by contributing over fifty important sculptures and more than double that in gouaches and drawings for the museum.

Through the work on the museum, I have become close friends with Mario and his wife, Mary.

Now the time has come for me, Jean, to think about myself. Mario and I are finalizing a grand exciting project, *Noah's Ark*, for Jerusalem. I am starting a wild project in California, with new techniques, new challenges.

Jean, I am sure you are watching me, happy that I am taking new risks, continuing with the same enthusiasm.

I am conscious of time—not just our
time, but eternal time. I want to use
the time left to me, for ME. I want to be
a bird and fly wherever I please. I am
ready for new adventures of the spirit.
I want to experiment. I want to write.

WE WANT / WE DEMAND / For the twenty-first century / The freedom to eat one's fill · The freedom
to remember · The freedom to leave · The freedom to play · The freedom to learn · The freedom
to choose · The freedom to say no · The freedom to choose your god · The freedom to develop these
talents · The freedom to govern your body · Freedom of speech · Freedom of knowledge · Freedom
within private spaces · The freedom to be oneself · The freedom to converse · Freedom of movement
· Freedom for nature · The freedom to create · The freedom to live and die without pain · The freedom
to love · The freedom to grow up without violence · The freedom to live outside the system / My
freedom ends when the freedom of others begins / THE TREE OF LIBERTY

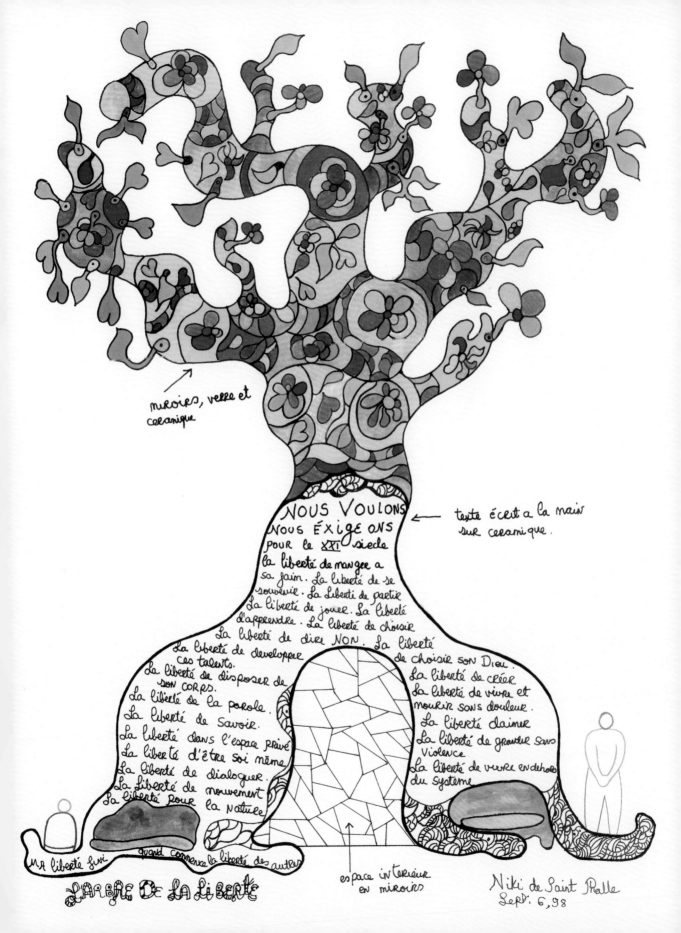

miroirs, verre et
ceramique

texte écrit a la main
sur ceramique.

NOUS VOULONS
NOUS ÉXIGEONS
POUR le XXI siecle
la liberté de manger a
sa faim. La liberté de se
souvenir. La Liberté de partir.
La liberté de jouer. La liberté
d'apprendre. La liberté de choisir
La liberté de dire NON. La liberté

La liberté de developper de choisir son Dieu.
ces talents. La liberté de créer
La liberté de disposer de La liberté de vivre et
son CORPS. mourir sans douleur.
La liberté de la parole. La liberté d'aimer
La liberté de savoir. La liberté de grandir sans
La liberté dans l'espace privé violence
La liberté d'être soi même. La liberté de vivre en dehors
La liberté de dialoguer. du systeme
La liberté de mouvement
La liberté pour la Nature

MA liberté finit quand commence la liberté des autres

L'ARBRE DE LA LIBERTÉ

espace interieur
en miroirs

Niki de Saint Phalle
Sept. 6,98

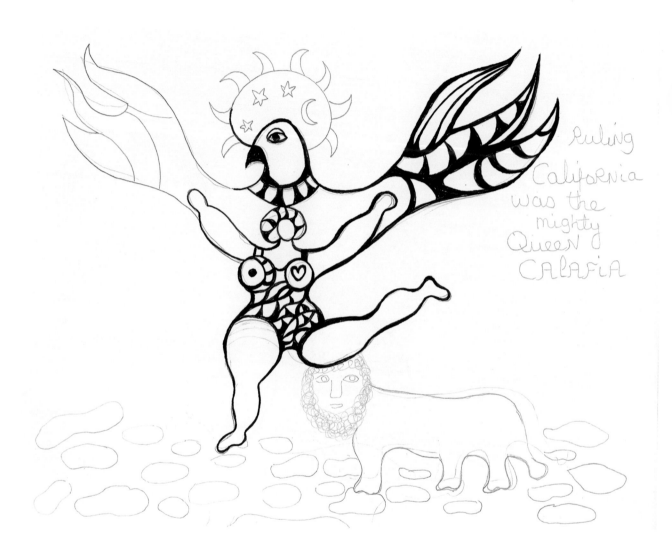

ruling
California
was the
mighty
Queen of
CALAFIA

IMAGINARY BOX

What saved me during those difficult adolescent years was an imaginary, secret magic box, which I kept under the bed. No one but me could see this box. When I was alone, I would open it up, and all kinds of extraordinary colored fish, genies, and wild sweet-smelling flowers would come tumbling out.

In this box, which was my very own, I kept poetry and dreams of grandeur. The box was my spiritual home. The beginning of a life of my own where "they" (our parents) could not intrude. In the box, I put my soul.

I started having conversations with my box. As I could not relate in a profound way to my family, I started communicating with myself. From this came a lifelong need for solitude. It is there in that solitude, alone, that my ideas for work come. Solitude is the artist's friend.

My magic box is still under my bed. I open it every day. My structure, my backbone, my skeleton are in that box. Sometimes it is filled with sand, and I become five years old again and make castles and dream palaces.

My box makes up for the adult world, which I have learned with difficulty to deal with, and which I am not too crazy about. The box has kept me from becoming a cynic and disillusioned. It is Pandora's box. After all the evil escapes, what remains in it is HOPE.

➡

Thursday, 4 May 1995

The summer I was fifteen, I saw the film *The Idiot* with Gérard Philipe. Maybe it was my crush on Gérard Philipe that led me to start reading Dostoyevsky like crazy. I became totally absorbed with the tormented Russian soul—passionate, extreme, grand. In *Crime and Punishment*, I was fascinated with the consumptive heroine. That same year, I also read *La Dame aux camélias* and saw the film version with Garbo. I identified even more with this wicked, seductive heroine dying of consumption. Garbo looked gorgeous with TB, languid and beautifully sad as she coughed and held a little hankie to her lips.

Tragedy, illness, madness—that was my cup of tea. Did I think I was Madame Butterfly? Joan of Arc? Yes. All the tragic heroines in fiction and history had immense appeal for me. Except for Anna Karenina, I never liked Tolstoy. My young psyche fell for the illusion that illness and suffering were attended by exceptionally dramatic and glamorous circumstances. Why didn't I identify with Groucho Marx? In my next life, I would love to be a female Groucho Marx without the mustache.

Did I see illness as romantic? Certainly. I don't see it that way anymore. Pain and sickness have been my constant companions for many years. The description of consumption I read and saw as a young girl was of course a lie. TB is a revolting disease. For a short time, when I was in my twenties, I had a touch of TB in my left lung. It's revolting to have—spitting, hacking, coughing, disgusting stuff coming out of my mouth. UGH! Why do we lie about disease? It's either romanticized or vilified. Cancer was at first always considered somehow bad, wrong, sinful. Today, it's AIDS.

Monday, 8 May 1995

My anxiety was not external. My exterior looked cool, aloof, and very easily hid my emotions. Inside, my heart could be banging away, while outside I was calmly smiling. I went to see all these therapists in an attempt to quell the raging fires of emotion inside me. I hoped to feel more united with myself, to be less passionately aroused by my feelings, and to be internally as cool as I looked.

I read about someone who'd cured themselves of rheumatoid arthritis by watching funny films and laughing. I got Rico and Ricardo to join me in laughing sessions. We made hysterical tapes together. When alone, I listened to them and laughed.

At this time, I was living at the *Tarot Garden*, inside of a female-formed home I had built there, called the Sphinx. Perhaps it was too much for my family and the working crew when I began to laugh out loud. They'd flee when they heard me cackling, maybe thinking I was some kind of witch. Anyway, this laughing therapy was great for my asthmatic bronchitis. It also tightened up my stomach muscles. I was

very proud of this and allowed my little granddaughter to jump on it, it was so firm. I continued this therapy for years, carrying my tapes with me wherever I went. Sometimes in hotels, there'd be an occasional banging on the wall if I got too extreme.

If somebody told me that I'd feel better by hanging upside down from the ceiling reciting Shakespeare, I probably would have done it. I would try anything to have the same peace of mind in all areas my life which I only have when working. These therapies sounded bizarre to my French friends, but having been raised in New York, I thought maybe it would work. The French are terrified to appear abnormal in any way. Americans, I think, have the advantage of being curious about themselves and to think that therapy is for normal people. The French are brought up to CONCEAL emotion, the Americans to REVEAL emotion. In general, the French do not go to shrinks (unless they have a nervous breakdown), but they do take more tranquilizers and drink more wine than in any other country. If there is something wrong, the French are loathe to admit it.

The next therapy was not a person, but a country. I fell in love with Italy. Being in Italy for more than ten years, I observed their commedia dell'arte sense of life—wild expressions of love and hate, screaming, laughing, rolling on the ground with rage, tempers enraged, passions aflame. It relaxed me quite a bit, and I started screaming myself, emoting, and talking with my hands. I gave up my cool mask in Italy, becoming more real. I was less aware of the contradictions in my personality, which I had been brought up not to show. I didn't need to be in perfect control. I looked at the Italians, and I'd just let go. Nevertheless, it was hard being in pain nearly all the time with arthritis. What helped me was to identify myself with card no. 2 of the tarot pack, the High Priestess, to see pain as part of an initiation to go through to complete my task. I had a feeling of special destiny, of having been chosen. It aided my spirit and enabled me to take on a Herculean task. Was it a delusion? If so, it was one that worked. It took me outside of myself. It raised me above the pain and made me stronger. Though I envisioned myself as the Priestess, the crew saw me as Mother, the Mama.

Wednesday, 10 May 1995

I have been on cortisone for thirteen years. I hate this drug that I am dependent on. The cortisone makes me look and feel ugly. My face gets round, like a moon face. My character changes, I become nervous, speedy, and am disturbed by things I normally don't give a damn about.

During the last three years, since the death of Jean Tinguely, I have had to considerably augment the dosage of cortisone, since both asthma and rheumatoid arthritis got worse. Auto-hypnosis was not sufficiently effective for me at this time. I found myself living in a world of problems and grief, and wished I was dead. ANOTHER PART OF THE FOREST...

I encountered a multitude of thorny problems, like a many-headed monster, following Jean's death. Because of my grief, I panicked from not knowing how to cope with his complex affairs and got terribly sick. I spent over two years sitting up in bed at night, unable to breathe, not suspecting that panic could create this condition. The only thing I felt positive about was that I had done the right thing. I willingly had given most of my inheritance from Jean (sculptures, drawings, gouaches, and prints) to a museum that was being built for Jean Tinguely in Basel.

I was confused by the whole scene and signed papers in a trusting, childlike way. I could not believe anyone would want to make trouble for me or attempt to eliminate my input in issues concerning Jean's art. Or that people I liked and trusted could try to take away the power and trust Jean had left me. Little did I know that after a major artist dies, there are attempts to alter the reality of the artist's life into a false image. I did not suspect that treacherous maze full of hidden traps that I was entering into or why. Slowly, I began to see the strange scenarios, unreal plots, and bizarre subplots like on the TV shows *Dallas* and *Dynasty*. What was happening to my life? I felt like a visitor to another planet.

Only very recently have I fully understood why the people involved (whom I know had a real and genuine affection for me) began behaving the way they did. I was an accomplished artist and a strong woman in my own right before Jean's death. That was threatening enough. Further, I had been empowered by Jean's leaving me his moral rights. On top of these, there was the "mythic" art couple of Jean and Niki that some people wanted to keep alive and make my principle reality.

Centuries before, they'd burn those they called witches and those that had the audacity to identify with the High Priestess. Now, they had to use more subtle weapons. Even though I was aware of this on an intuitive level, I was trapped by my grief and illness and my affection for the people involved.

A year prior to my first retrospective at the Centre Pompidou in 1980, Larry Rivers told me, "Your young writer friend had better be able to get his book published before your show, Niki, or he's gong to leave you." I asked Larry why. He replied, "Men's egos. We can't be with a woman who is famous if we aren't. It's threatening." Larry was right.

Most men won't openly admit this like my good friend Larry. I had observed this before with Jean, when I had a show of Nanas in London at the Hanover Gallery in 1966.

It was an incredible evening. All of London trotted out in great costumes. There was an all-female band, and it was an incredible opening, with people waiting outside to get in. I sat in a corner on the floor, in a beautiful black dress made especially for me by Marc Bohan of Dior. I was good-looking and I knew it (I have always been vain and still am, for me and those I like). I would read the tarot cards to whomever wanted to listen. There were quite a few hip Londoners around me. I was thirty-six years old. At the end of the evening, Jean told me he wouldn't come to my openings anymore. He

couldn't take it. Several years later, Jean would change his mind and would come.

It was soon after that Jean met Micheline. Even though we resembled each other physically, she had an advantage over me. She was twenty-five and didn't offer Jean any competition. Armed with other women and no longer living with me, Jean could enjoy our relationship again. He felt safer.

I also had an affair at this time, with Rainer. He was a German theater director, nine years younger than me. Like Jean, he could not take coming to my openings. So for a couple of years, I always went alone to my exhibits. Is that when I started getting claustrophobic at openings? Not very surprising if success meant losing my guy.

The next man in my life was a French physician-scientist, Étienne B. He was the opposite. He was comfortable going to openings with me. But often he would be charming someone else, and made sure I saw it. Jean had mixed feelings about Étienne—admiration/jealousy. They were similar in their physicality towards women. Iolas, my crazy wonderful dealer, called him "the sexy doctor." Jean did a few things to torment Étienne which I remember too well, but won't tell. When my friend became famous, it was Jean who sent me clippings and articles about him.

Meanwhile, I was becoming close friends with Micheline (women are smarter than men). She would phone me when Jean left her and say, "He's just left, so I know he'll be there in about five hours." This was the time it took him to drive at 120+ miles per hour from Switzerland to Soisy. Jean hoped that by never informing his two official women of his comings and goings, he could control us (somewhat). Jean never knew.

Women have had to put up with so many centuries of Men's Egos. Why can't they bear a little beginning of a woman's budding and blossoming without feeling threatened? Are they so FRAGILE? I think the answer is YES. If I had realized this earlier, would I have played my hand differently?

The Wild Woman is the scariest kind of woman to most men. I am a Wild Woman. A loner who has left the pack and gone off on her own. STOP HER! She must be stopped because she is in touch with things we don't understand. Now, at last, I understand the complicated scenarios. I am stronger.

Tuesday, 23 May 1995

My depression often took the form of diseases. PANIC was disguised in asthma attacks and in insomnia that resisted sleeping pills. FEAR. I was afraid of people, pain, DEATH. Despite a belief in eternal life, I had great difficulty watching and assisting people much younger than me die. Watching them, I took on their suffering and pain. It did neither them nor me any good. I found myself, time and time again, visiting my friends dying of AIDS, though it produced in me deeply disturbing psychosomatic reactions. I felt it was my duty as a friend and as a human being. Other friends joined

me in sustaining the morale of our desperately sick friends. During these extremely difficult three years, I also saw a great deal of solidarity and caring from my family and friends.

Friday, 26 May 1995

I realized a few days ago that when Ricardo died, it was the beginning of a long depression. I gave up a lot of things. Not consciously, but little by little flowers disappeared from my home. My house had been like a garden. I gave up the laughing therapy I'd been involved with for five years. I gave up my crazy clothes and dressed in a more conventional way. I gave away my collection of crazy hats. I gave up reading tarot cards. I gave up having boyfriends. I was simply crucifying myself, identifying with my young friends who had died from AIDS.

A certain childish, wildly enthusiastic streak in me disappeared in my life, but remained in my work. My relations with people, the world, my public image, success, all became fraught with anxiety. I lost the joy of daily living. Before, everything was exciting. Each cup of tea was different. I was also feeling Jean's approaching death and his desire to die. I was helpless to enthuse him about life and work, the way I had for so many years. It made me sad. When he came to visit me in the *Tarot Garden*, I would always ask myself, is this the last time?

I used to notice and be enraptured by privileged moments of sound, when sound seemed to possess me and transport me to another space. I listened to music of all kinds a great deal. Then, less and less. Music did not reach me anymore, only occasionally. Reading and my work remained. Music, music, what happened to you?

I felt it was so unfair for these young people to die before me. They had a right to live. Maybe it was my way of grieving, to give up, one by one, elements which made life more vital to me. I am thinking this for the first time. That is one of the reasons why I like to write. Writing for me is an instrument to think or unravel something I did not know—unraveling the spider's web. My hands print, my hands write.

Tuesday, 30 May 1995

I know what I SEE, but what do you SEE? Is your sight fixed near your body, or do you look at things that are further away? Can you remember what you see? I can't. How do you perceive colors? Flowers? Do you melt into what you see, or is there an interior voice in your head, like me, which prevents you from being totally united with your vision?

The vision of a painter is particularly fascinating to me. They say that El Greco had an optical defect which allowed him to see everything elongated; that Van Gogh

translated directly his insanity into the manner in which he applied paint. All this is speculation. We are in a domain where we know little.

Many artist friends have told me that they work from an exterior vision of the world which they then internalize, and which in their work becomes concretized. For me, the process is the opposite. It is impossible for me to retain the laws of perspective, no matter how hard I try. I made the decision very young to work with my handicap. Often handicaps that are accepted become trump cards. It was in my case. I have utilized my incapacity to use perspective in my graphic work, integrating it in my work process.

One would think I would be unable to become a painter and artist. It seems natural for painters to have a knowledge of perspective. Any traditional art school would have refused me as a student, and I never went. Yet, my handicap has enormously enriched my work and kept me an "outsider" to the mainstream of art.

Caruso had a minor injury to his vocal cords following a car accident. This forced him to correct his voice when he sang. Before this accident, he had a beautiful voice, but thanks to this change, he had a voice of a genius. Beethoven was deaf, but this did not stop him from continuing his work, because he was listening with his inner ear. I could not represent what I saw in front of my eyes, so I was obligated to express what I felt inside, my interior vision. My way of becoming a painter was to reveal sentiments, contradictions, joys, sorrows. I was forced to find a pictorial language which was really my own, as I was not able to use the usual exterior sources. Jean Tinguely was always fascinated by what I saw. He said, "You don't see like others." I replied, "In a certain way, I think I'm blind." Jean was amazed when I would make a lion with six feet. He said it looked more like a lion than a real lion. Sometimes I asked him to add a touch of realism to my drawings, but he always refused.

Wednesday, 21 June 1995

Rheumatoid arthritis hit me like a thunderbolt at the moment when I was about to start the great work of my life, the *Tarot Garden*. The first attack came in my right hand the day after my first big retrospective at the Centre Pompidou in 1980. Was this an accident, a coincidence? At the *Tarot Garden*, my hands and wrists would swell…

I was normally quite strong physically. I used to haul things around. I had good muscles. Suddenly here, at the *Tarot Garden*, my hands—my most precious tools— were losing their strength. I could hardly bear the pain, the suffering, and the loss of strength in my hands. It forced me into having a distance from my work. In a certain way, this big handicap enabled me to learn to direct a crew of people much better. I had to be able to communicate to them what I could no longer do: take off a little bit here, add a little bit there… No, not quite like that… Like this, like that… I could still take a pencil and draw in the clay all the designs on the molds of the Sphinx and elsewhere,

but I was extremely handicapped, in great pain, and stoned most of the time by a mixture of cortisone and codeine. If I think back on it, the long downward spiral started then. How can you not be depressed when you have major pain? I remember thinking that even if I can't walk, if I have to finish the Garden in a wheelchair, I will continue to the end. I think that my rage at my handicap and my identification with the High Priestess provoked me into doing work that was larger than I had initially intended. I couldn't bear for anyone to touch me, so lovers were out. I was totally focused on the Garden. To travel was painful, because every time I'd take a plane, the rheumatoid would flare up. To live was painful.

Will the rheumatoid arthritis disappear like a thief, the way it appeared, when I've finished my task at the *Tarot Garden*? Was art for me a quest towards God to liberate what was invisible? In my Chinese astrological sign, I am the solitary horse.

Sometimes I feel if I am not wild, I don't exist. When I become esthetic, my magic disappears. It has to be heartfelt.

Thursday, 22 June 1995

New York City, 1982. Jacqueline Cochran* was launching my perfume. I really needed to have success with the perfume because the financing of the *Tarot Garden* depended on it. I had to go on a promotional tour and look gorgeous, glamorous while being stoned on codeine for my pain. Marc Bohan of Dior created special snake dresses and glorious snake hats to help me pull this off.

Ricardo and I spent months at a time in New York, where I was designing the scarves, posters, packaging, and bracelets to accompany and help sell the perfume. The company gave us a studio where I could work and eat. It had two bedrooms for Ricardo and me. At breakfast one morning, I found a beautiful young German at the table. He didn't speak any French. I asked Ricardo, "Where did you meet this guy?" He said in the street. I told him, "Are you insane? This is New York. We might have been murdered. Promise me you'll never do it again." He promised, but—well, Ricardo was Ricardo AND...

I had to go around the States to BIG stores to promote the perfume in the snake chair I had made. The company lent us its private plane, and to pass the time, Ricardo and I played gin rummy. In my perfume contract, I was allowed to have a limousine when necessary. Ricardo fell in love with big stretch black ones. I had never been in one before. Ricardo would order one every day, wear dark glasses, and go to the supermarket to buy our food. It was quite something to see him get out of that big stretch with his many rings. He loved gold and was always well-dressed in a casual way—blue jeans, very smart shirts. Ricardo had a beautiful black mustache. In fact,

**Jacqueline Cochran, a pioneering American aviator and cosmetics executive.*

he was very hairy except for the top of his head, which was bald. His shirt was always a little bit open to reveal his very hairy chest. He even had some hair on his hands.

Anyway, when the perfume company got the bill, $8,000, for one month of stretch limos, they WERE ANGRY. They wanted me to pay the bill. I said I couldn't, I didn't have the money. They told us no more stretch limos, and only limos when it's raining. I still remember Ricardo sipping a whiskey in a stretch.

Friday, 23 June 1995

BODY REMEMBERS.

Always trying to cope. Must be strong. Not allowing myself to be weak. Pride can be a strength but also auto-destructive. High goals are inspiring to oneself and others, but a little kindness to oneself isn't bad either.

Sunday, 5 November 1995

One of the questions I keep asking myself is, were my diseases necessary for me to build the *Tarot Garden*? Does one have to go through catastrophe to arrive at vision? I honestly don't know. I think that each person who has a unique vision, in a certain way, does go through a very close encounter with Death, either through himself or the shock of sudden death in others. Or insanity. Everything that makes a person come into contact with Death directly can nourish his sensibility, if one is willing to accept it. Perhaps to create something incredible, one has to have gone through the extremes.

I think at the heart of the abilities I have is discipline. Discipline, I think, is one of the strongest forces in my life. With enthusiasm and discipline, I have continued to be curious, active, and creative. I've seen many others with more talent than I have who waste their talents because the motivation or the discipline isn't there. Talent is not number one. Dr. Kemp told me he hadn't put me on [Paxil] earlier because he was afraid it might hurt my creativity. I haven't noticed. I work just as hard, and now I know how to relax. I miss the visual effects I had the first three months on the drug. I no longer feel visually stoned. It was an enriching experience because I saw more clearly outside myself, everything sharper and better defined. I still see clearly, only I've gotten used to it, alas!

Many people I know think suffering is an essential part of themselves. I never felt this way, and I spent years going to therapists to get rid of the misery. I always felt that the Garden of Eden was right next to Hell. Just a step away.

➡️

 to life
 bring
I brought to ~~my work~~

my desires and ᵐʸfeelings ᵐʸcontradictions
longings forgotten memories
 shadows visions from some
other place. I ~~made a dark~~
 ~~secret~~ ~~tunnel~~ ~~like~~ I ~~worked~~
~~worked~~ ~~in the~~ ~~darkness~~ in a secret dark ~~tunnel~~
always looking for the sun
 hiding from the moon
worshiping the stars. where are you?

driven
I am Real ~~fearless~~ ~~I am~~ I am don't exist
Destiny Receptive mean
 enthusiastic I am bad fake dark
young sensual delight stupid I am rain
 gay I am
~~serious~~ I laugh frivolous old
I am funny egocentric shame
 I Love love cruel sterile afraid
for me joyous I am love I am deadly serious
wise child like I am naive
 generous I am sick I'm hungry
 tormented
 I doubt I'm heavy
I am well
 ~~sincere~~ I am unjust
passionate forgiving I am violent I am cold

I BRING to LIFE my
desires my feelings my contradictions
longings forgotten memories
shadows - visions from some
other place. I work in a
dark secret tunnel always
looking for the sun hiding
from the moon worshiping
the stars. WHERE ARE YOU?

everything starts with drawing for me

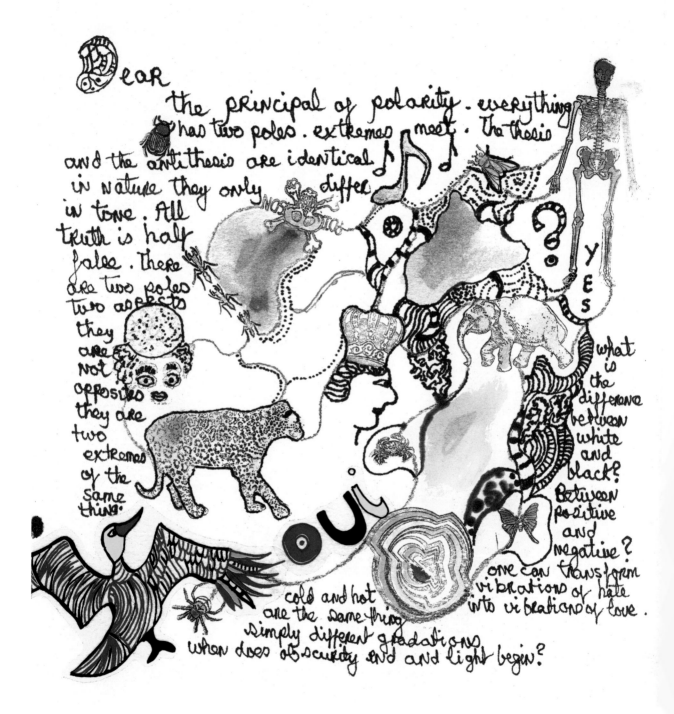

Dear

the principal of polarity. everything
has two poles. extremes meet. The thesis
and the antithesis are identical
in nature they only differ
in tone. All
truth is half
false. There
are two poles
two aspects
they
are
not
opposites
they are
two
extremes
of the
same
thing.

YES

what
is
the
difference
between
white
and
black?
Between
positive
and
negative?
one can transform
vibrations of hate
into vibrations of love.

cold and hot
are the same thing
simply different gradations
when does obscurity end and light begin?

oui

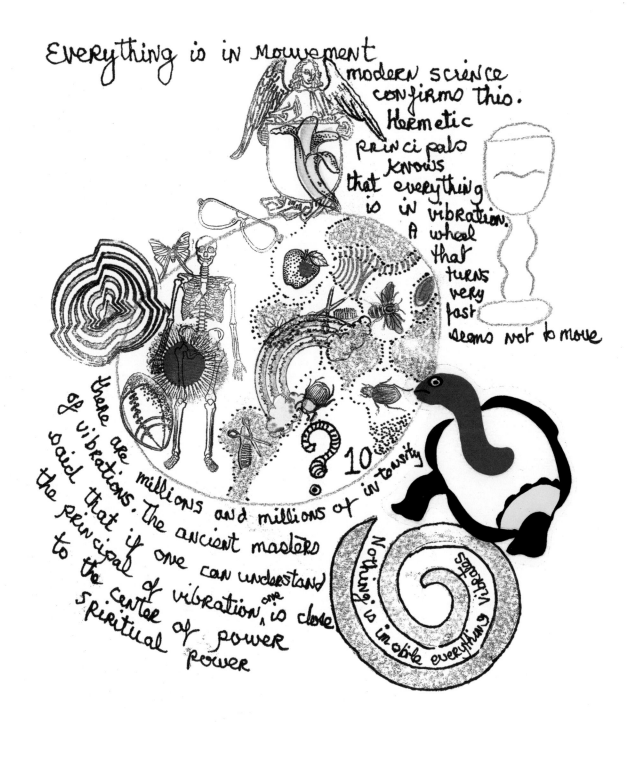

Everything is in movement modern science confirms this. Hermetic principals knows that everything is in vibration. A wheel that turns very fast seems not to move

there are millions and millions of of vibrations. The ancient masters said that if one can understand the principal of vibration, one is close to the center of power spiritual power

10

in toutity

Nothing is imobile everything vibrates

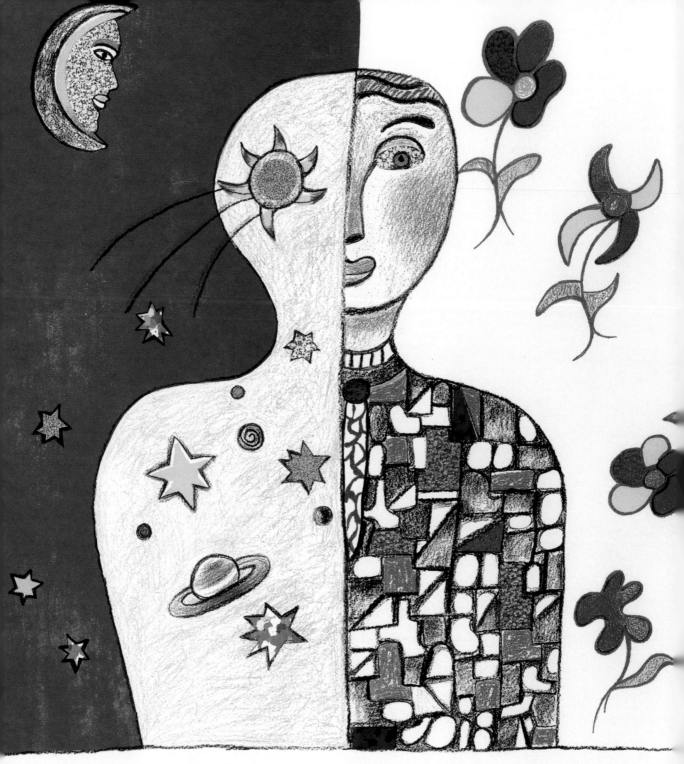

LA MORT N'EXISTE PAS
LIFE IS ETERNAL

Niki de St. Phalle

Afterword

Categories don't apply to Niki de Saint Phalle's work. They never have. A newspaper item in the late 1940s carrying the headline "Glamour Deb Pitches in at French Hospital" reports, "Like many girls her age, Niki doesn't like being called a teenager. 'Makes everyone seem so uniform,' she explained, 'when what we should be striving for is individuality.'" Hugh Weiss, who mentored her in Paris in the 1950s, disliked her early collages, as did the dealer René Drouin. In the balance hung a show at Drouin's gallery—he wouldn't exhibit work he felt was not up to snuff—but she wasn't swayed. "If I have a really strong feeling about something I can't give it up," she wrote of the episode, "no matter what other people think." In 1961, after participating in one of Saint Phalle's Tirs, or shooting paintings, the critic Pierre Restany invited her to join the Nouveaux Réalistes, a group of artists—all men, including Jean Tinguely, Yves Klein, Arman, and Daniel Spoerri—united by "a general orientation, a state of mind, a special phenomenology of expression," according to Restany. It was an uneasy fit. He declared the group hostile to figuration, and they disapproved of Saint Phalle's return to it that same year. (Though Restany was a supporter of her work, he is also a cautionary tale of paternalistic good intentions. In 1969, he lumped Saint Phalle, Marisol, Yayoi Kusama, and Evelyne Axell together under the repellent heading "womanpower's art.") Saint Phalle also refused to participate in women-only exhibitions—refused, in other words, to be a subcategory of artist.

She didn't formally study art or art history, and her travels through France, Spain, and Italy in the '50s were a crash course in possibility, an individual education that was untethered from the history of a medium, from any single tradition, and from the academy. While living in the tiny Majorcan town of Deià, she made multiple trips to the Spanish mainland, where, among the work of Goya, El Greco, and Bosch, she discovered Antoni Gaudí's Park Güell in 1955, a sprawling and fantastical architectural project built into the side of a mountain over fourteen years. Gaudí modeled the forms of his structures on the curving and unruly lines found in nature and developed the broken-tile mosaic style *trencadís*, which Saint Phalle brought into her own art. Back in France a few years later, she visited the Palais Idéal, in Hauterives, an elaborate grotto-esque palace constructed over thirty-three years, beginning in 1879, by Ferdinand Cheval, a French postman who built the baroque stone structure and bestiary in a kind of fever dream. For Saint Phalle, Park Güell and the Palais Idéal provided the strongest and most lasting representations of what individualism could look like.

Pontus Hultén, a lifelong supporter of Saint Phalle's work, invited her, Tinguely, and Per Olof Ultvedt to collaborate on an in situ installation at the Moderna Museet in 1966. Thinking of the Palais Idéal, Saint Phalle suggested they construct "a giant cathedral"; Hultén proposed a giant Nana. The resulting installation-cum-Happening was called *Hon—en katedral* (She—A Cathedral). Saint Phalle painted the outside of it like a psychedelic Easter egg. Visitors entered the supine *Hon*, which was seventy-seven feet long and nearly thirty-three feet tall, through her vagina. Inside were a milk bar (in the right breast), a planetarium (in the left), a bottle crusher, a gallery of fake paintings, a moving assemblage at her heart, an aquarium, a slide, a theater screening the 1922 silent German comedy *Luffar-petter*, a roof terrace, a miked "lover's seat," and a payphone. *Hon* was "a temple, a church fête, fun, a return to the womb," Saint Phalle said. "She was also the praying mantis, the devourer." Saint Phalle thought that visitors weren't the same after entering *Hon*. After two months and some hundred thousand visitors, *Hon* was demolished in three days. They stopped the mechanism in her chest and took saws to her body. Only her head remains, an artifact in the museum's collection.

The *Tarot Garden*, Saint Phalle's fourteen-acre sculpture park in the Tuscan hills, is the culmination of these formative influences. Constructed from 1978 to 2002 with a devoted crew (including the local postman, who stopped by to help and never left), the garden is a communal cathedral realized according to a singular vision and force of will. No longer in the era of patronage, Saint Phalle became her own patron. In 1982, she launched Niki de Saint Phalle fragrances, at the invitation of the pioneering aviator and cosmetics executive Jacqueline Cochran, and designed a lavish bottle featuring two entwined snakes on the stopper. The revenue from sales of the perfumes funded a third of the garden's construction.

In 1962, she and Tinguely traveled to America. In the West, they visited Simon Rodia's steel and mosaic structures in South Central Los Angeles. Rodia's structures are known as the Watts Towers, but he called them "Nuestro Pueblo," or "Our Town." Did Saint Phalle also know them by their collective name? Much later, she would say that no one was excluded from her work. It's easy to see this impulse in her public projects, monumental works meant to be circumnavigated, entered, climbed, explored, works whose shimmering bodies are visual feasts—art consuming and being consumed. It's also true of her works on paper: imaginary scenes of love, heartbreak, and friendship that impersonate illustrated letters and private missives, sometimes written pseudonymously ("You are my love forever and ever and ever"); textual mini-histories that resemble letters never sent ("Dear Jean, I remember very well meeting you and Eva for the first time..."); image-based books that pose questions to an unidentified addressee ("What do you like most about me?"); and a host of works that peruse women's roles and emotions through images and bits of text. These works are intimate, in scale and tone. "I Rather Like You a Lot You Fool" and "My Love What Shall I Do If You Die?"—confessions, acknowledgments, declarations, desires that she reveals openly, makes accessible. "I wanted to show everything," she wrote to her mother, from whom she kept so much. She is never only speaking to herself. Her work is a diary, and she made it for all to see.

Saint Phalle's first show, a series of oil paintings, took place in 1956 at a café-gallery in St. Gallen, Switzerland. She signed these early works "Niki Mathews." As Niki de Saint Phalle, the Tirs were among her first exhibited works. When she made the Tirs, her expression of anger—a woman's expression of anger—was taboo. So too was "the open admission of the desire for power and control over one's life," as Carolyn Heilbrun, the pioneering academic feminist, writes. Saint Phalle saw herself entering the so-called world of men as "trespass," but she nevertheless openly sought access to and agency in that world. She overcame the feeling of trespass not by blending in but by affirming her voice. In her art, she made herself subject and author; she put herself into it, "as into the world and into history," Hélène Cixous writes. She didn't simply put her anger into the work: she put it on display, shooting her canvases publicly—performing the taboo. She was a woman behind the gun, not in front of it; the woman wielding power, not having it acted upon her.

For Kenneth Koch's play *The Construction of Boston*, directed by Merce Cunningham and performed in New York in 1962, she dressed as Napoléon Bonaparte and shot at a plaster Venus de Milo. Her lines from Koch's libretto include:

> In my hand I have a gun,
> And it is the only one
> That gives columns fluting!
> It's the only pistol which
> Makes an empty canvas twitch
> And become a painting!
> It's the only gun that fires
> Answers to the soul's desires—

Koch saw the duality of the Tirs, that her shootings yielded beautiful art and addressed her innermost longings. Tinguely was also at work on transformation. Some of his machines self-destructed: art that unmakes itself. Saint Phalle shot in order to bring life—unmaking was creation. What's more, she shared the joy of release—finding "answers to the soul's desires"—by sharing the gun and letting others shoot. She told John Ashbery that in making the Tirs she felt close to the spirit of the poet Lautréamont, who wrote, "Poetry should be made by all. Not by one."

In an appraisal of the violence of this early work, Saint Phalle declared, in 1968, "I used to think that there was a need to provoke, to attack religion, and the generals. And then I understood that there is nothing more shocking than joy." Is it shocking because it untethers us from its opposite, a spell to counteract adversity? Because it is a form of rebellion? Is it shocking, too, because we devalue it in art (perhaps especially when it comes from a woman)? If we accept art's expression of antagonistic human qualities,

why should we resist those that point to possibility and uplift? "If you suddenly and unexpectedly feel joy, / don't hesitate. Give in to it / …Don't be afraid / of its plenty. Joy is not made to be a crumb," the poet Mary Oliver writes. The buoyancy of the Nanas, the way these abundant figures rest so lightly on the ground, is an expression of joy, and yet they aren't pushovers. Saint Phalle once called them "happy joyous domineering women."

In her 1986 book *AIDS: You Can't Catch It Holding Hands*, she encourages love and compassion amid the plague, suffusing horror with hope (her playful condom designs became ten-foot rounded obelisks the next year), and never forgets companionship and sensuality. Until the virus is under control, she writes, we must learn to live with it. The monster, rampaging at the start of the book, is not expelled at the end but brought to heel. Saint Phalle recognized that joy springs out of tragedy. It lays beside its opposite always, each an extreme of the other, a radical reversal. Joy and sorrow are twinned in Keats's "Ode on Melancholy." The shrine of melancholy, he writes, lies within "the very temple of Delight," but only those who "can burst Joy's grape against his palate fine" can see it—a small explosion, a small death. The Tirs, engendered by anger, allowed Saint Phalle to die at her own hand and be reborn. She called them "a tabernacle for DEATH and RESURRECTION"; they were "a birth and a death at the same moment." A tabernacle, a shrine, a temple—sites of catharsis. "I have transformed my fear into joy," Saint Phalle writes in *Traces*. Think of the Nanas borne out of the Tirs, fully grown warriors of joy. Joy is communal too, "the underground union between us, you and me," the poet Ross Gay writes, "which is, among other things, the great fact of our life and the lives of everyone and thing we love going away." If we link our sorrows together, Gay proposes, we have joy—not a surrender, but an upwelling.

Many of Saint Phalle's most joyous artworks are the monumental parks and public sculptures that exist outside and beyond authoritative social institutions, in the physical and imaginative freedom of nature that, for Saint Phalle, encourages rather than restricts. (I think of the many trees in her drawings and of the complex of dualities in *L'arbre de la vie*, pages 158–59.) Her notion of shocking joy reminds me of what Cixous, writing in 1975, calls "luminous torrents"—a woman's overflow of desire, beauty, and imagination—and of the corresponding societal push to stay silent. Cixous writes, "Who, surprised and horrified by the fantastic tumult of her desires (for she was made to believe that a well-adjusted woman has a … divine composure), hasn't accused herself of being a monster? Who, feeling a funny desire stirring inside her (to sing, to write, to dare to speak, in short, to bring out something new), hasn't thought she was sick? Well, her shameful sickness is that she resists death, that she makes trouble." Being a woman is a resistance, an overthrow, a revolt. Isn't feminism a linking together of sorrows, a practice that transforms sorrow into joy?

Seventeen years before Cixous's essay, Adrienne Rich, pregnant with her third child, wrote, as though in conversation across the decades, "For it is really death I have been fearing, the crumbling to death of that scarcely-born physiognomy which my whole life has been a battle to give birth to—a recognizable, autonomous self, a creation in poetry and in life." Rich was a contemporary of Saint Phalle's, born a year earlier, though I don't believe they ever met. Still, Rich struggled to carve out a creative life within the domestic one at the same moment Saint Phalle did. Saint Phalle made trouble by leaving her family. Much has been made of her unwomanly "abandonment" of her children. How much of the story of this moment has been written by other people? How much changed and distorted? Saint Phalle disappeared for about six months, Harry Mathews told the art historian Jo Ortel, but the couple didn't reveal their split to the children for about a year and a half. The children regularly saw Saint Phalle throughout this period. She was ambitious for herself. She did not make her family the center of her life. Why does this need defending? Monsters are everywhere in Saint Phalle's work. They run roughshod, and they are tamed, sometimes slain but never expelled. They are, by turns, men, misfortune, trauma, disease, guilt. "Who is the monster," she wrote in her work, "you or me?"

Gilles de Rais, a fifteenth-century French baron who fought alongside Joan of Arc, is the subject of one of Saint Phalle's assemblages from her so-called white period of the early 1960s. She renders him as a large, pale face studded with tiny babies and swarming with spiders, a skeleton, and a coiled snake. His thin lips drawn, dissatisfied; one of his eyes a barred window, the other, milky. De Rais is Saint Phalle's forebear. In 1440, he was arrested and hanged for the torture and murder of more than a hundred children. In a video interview from 1964, Saint Phalle says of de Rais, "He took things to extremes, he was a real criminal, not a half-hearted one, he went all-out. I always admire people who go all-out…There was him, then me. The rest don't count." In interviews, particularly in the '60s, Saint Phalle is forceful. She has a lot to say and is adamant about not being misunderstood. She seems to want to prove herself, and she has a lot to prove. The break with traditional female values, with propriety and norms, must be swift and severe. (An astrological report on her work from 1962 reads, "You have a surgeon's soul—you must sever and cut away, then build again on the very ruins you have made.") In the video, she says next, "I want to go even deeper into the poetry of it, to try to express myself deep down. And by expressing myself with all my possibilities, I'm automatically expressing the situation of women in the world today." She says all this breathlessly, vehemently, and when she finishes, she looks spent.

Of her Devouring Mothers series—sculptures of corpulent, earth-bound women feasting on tiny children for tea—Saint Phalle said, "How could I be a mother? I was too young and scared. And I didn't know how, probably because Mother hadn't been hugged enough, hadn't been loved enough. So how could she express her love to me?…Then I started thinking, we are all devouring mothers. Mother devoured me, and I in turn thought I knew best for my children." She held herself to account. After her mother's death, her daughter, Laura, recalled, "It was quite dramatic to have her leave at such an early time, but throughout the years I came to understand, share and enjoy her need for creative power

and freedom. She was a terrific mother." Saint Phalle made up with her own mother in the early 1970s and was understood by her daughter, who recalls that at the end of Saint Phalle's life the family gathered around her in "the magic circle of forgiveness." It reminds me of what Rich writes at the end of her essay "Motherhood and Daughterhood": "Women are made taboo to women—not just sexually, but as comrades, cocreators, coinspiritors. In breaking this taboo, we are reuniting with our mothers; in reuniting with our mothers, we are breaking this taboo."

Saint Phalle enjoyed the company of women. She writes, for instance, of defining female friendships at Brearley and of finding both inspiration in the work of Eva Aeppli, Tinguely's first wife, and companionship, amid a community of men, in her person. Her lifelong friendships with women were not circumscribed by her relationships with men. In *Traces*, she writes, "My friendships were passionate, intense, important. They remain so today. I am better as a friend than a lover. Safer quarters." She broke out of the traditional role for women of her social and economic class, and though she didn't buck the gender dichotomy altogether, she recognized its fluidity. "Why shut oneself up in a role?" she said in 1974. "Man, woman, old, child, aren't we all that at once? You can make yourself very unhappy by cutting yourself off from your possibilities."

♣

Saint Phalle's father died in 1967. Five years later, she killed a father figure repeatedly in the film *Daddy*, directed by and written with Peter Whitehead. The provocative film, a formal mélange, is a fantasy of incest and revenge and makes complicit the daughter, the mother, and the father, who rapes his adolescent daughter. She is drawn to him even as she reviles him. The daughter appears at three different ages. In the first draft of the film, Saint Phalle played all three parts.

In the film's final moments, Saint Phalle shoots at her sculpture *La mort du patriarche* (The Death of the Patriarch), releasing plumes of white smoke and bursts of red paint. Finished, she lowers her gun and smiles at her work. It is a smile of total self-control and satisfaction. The camera pans over the Tir, honing in on its desecrated details—a plane, tanks, race cars, guns, soldiers, a tiny sculpture of a man holding a putto—as Saint Phalle says, in voice-over, "Goodbye, Daddy. I'm really sorry to see such a good man go. You just had to go, Daddy. But I don't want you to take this at all personally. Personally, I had nothing against you, Daddy. As daddies go, you were no more nor less of a fake than any other daddy. It's just that it's not your moment any longer, Daddy. It didn't work, Daddy. It just didn't work. Your slaves have finally freed themselves. And we intend to enjoy our freedom and our power, as you enjoyed yours." The camera drifts upward, across the ruined facade of a church and into the sky. "Mummy, mummy, I've got such marvelous news for you! At last, at last, Daddy is dead."

Asked in 1974 by the French magazine *Le Point* whether the film's Daddy resembles her own, Saint Phalle responded, "My father no longer exists. If he was still alive, I think he would have understood the film." The father of the film wasn't her father, she said, but the archetypal father. Her answer feels cagey, a half truth: the relationships in the film are too extreme to be convincing as archetypes. The interviewer then asks, "Your film is as daring as those of Warhol and Arrabal. Coming from a woman, won't it cause a scandal?" This question troubles me. How often is the reception or interpretation of women's art predicated on their sex? The implication is that if a man had made the same film, these issues would not apply, as if he said: "Your film is as daring as a man's, and yet..." The asterisk, the qualification. How can we know when this question hangs invisibly over a woman's work? What do you make of the question if you know that Saint Phalle's interlocutor is a woman? I read in it a kind of fearful searching, testing the waters: how much range can a woman claim before she is curbed? What if it turns out that range is endless? Saint Phalle's reply to this question is more revealing. "The scandal," she says, "is that women have been conditioned to be silent. To conceal their desires. To feign pleasure. To accept everything from the man." Joan of Arc, Georges Sand, Napoléon in drag—Saint Phalle wasn't going to be shut out. She insisted that her perspective matters.

When she was eleven, her father raped her. She desired control, a man's power, for herself, only to have it wrested away from her at an early age by her own father, a bleak reminder of the tradition of female powerlessness that she rejected as soon as she was able. In 1992, she composed the book that was published three years later as *Mon Secret*, an account of her rape, written as a letter to her daughter. Saint Phalle was sixty-one when she wrote it. It is the only account she ever offered. Her memoir *Traces* includes this time period, and she does not mention it there, though she alludes to it. "Why is it so difficult to speak?" she asks at the end of *Mon Secret*.

She may have had difficulty speaking directly about the incident, but she never had difficulty speaking. She spoke for decades, on this and other subjects, through the language of images. In 1979, she created new sculptures called Skinnies, which reduced her fulsome forms to outlines filled with air and light (she referred to them as "Air Totems"). Her lungs had been severely damaged by the polyester she used in her sculptures. She took walks in Tuscany, where she was beginning to plan the *Tarot Garden*, to get her breath back. The Skinnies are a manifestation of her thinking about art in the air of the countryside: subtractive sculptures whose emptiness is filled with the view beyond—trees, ground, sky. They are also continuous with her thinking all along. Of her earliest paintings, she wrote, "It seemed impossible to paint the earth without painting the sky. They were handmaidens; one could not go without the other."

Audre Lorde explained to Adrienne Rich how poems functioned for her as responses to direct questions—"and somewhere in that poem would be the feeling, the vital piece of information. It might be a line. It might be an image." The poem was her personal language, a translation, Rich offered, of something preverbal. Saint Phalle began making art of out an inner necessity. "I left the clinic a painter," she recalled of her hospitalization for depression in 1953. It's easy to turn the event into a kind of origin story of her lifelong

endeavor, as she herself has done. Yet lives, not to mention creativity, don't work quite so neatly. Both are better characterized by messiness, complexity, precariousness, and doubt. And yet it's true that once she left the asylum, life and art—her life and her art—were inextricable.

In the 1980s, she committed herself full time to the Garden. She moved into the Empress, an immense sphinx that housed a bedroom and kitchen, and lived there for seven years, during which she suffered a severe bout of rheumatoid arthritis. She was crippled, in the worst pain of her life. Art was her sanity and strength. ("The psyche and spirit do not share the instinct of the damaged body," Jeanette Winterson writes.) In 2002, Saint Phalle began designing a maze for the *Tarot Garden*. In her archive, I found a copy of "labyrinthologist" Randoll Coate's essay "Seven Golden Rules for Making a Maze." He concludes, "You will have given our world of harsh reality and mindless speed a timeless oasis, a leisurely paradise, the substance of a dream." The garden had officially opened on May 15, 1998, more than twenty years after she was given the tract of land, but she had never stopped thinking of ways to add to it. On May 21, 2002, Saint Phalle died. She was seventy-one. All new work on the garden ceased, according to her request.

<div align="right">—N. R.</div>

The majority of the art and writing in this book—a mix of unpublished and previously published material, finished work and drafts and sketches—is part of Saint Phalle's archive at the Niki Charitable Art Foundation (NCAF), in Santee, California. All artworks and reproductions © copyright and courtesy Niki Charitable Art Foundation, unless otherwise noted. Titled artworks are listed below, by page number.

2–3: *Double Tête*, 1999, marker on paper, 11" x 8 1/2".

18–19: "Dear Mother": Saint Phalle produced this letter, as well as "Cher Jean" (64–69), "Dear Pontus" (78–83), "Dear Clarice" (88–90), "Chére Marina" (122–124), and "Dearest Marella" (184–191), for the catalogue *Niki de Saint Phalle* (Verlag Gerd Hatje, 1992), which accompanied her exhibition at the Kunst- und Ausstellungshalle der Bundesrepublik Deutschland in Bonn, in 1992.

32–33: *Alphabet*, 1970, black marker, colored pencil, and pencil on paper, 12 5/8" x 28 3/8".

46–63: *My Love*, 1971, artist book published by the Moderna Museet, Stockholm, single-sided leporello in dust jacket, 7 2/5" × 7 2/5".

84: *Clarissa*, 1964, felt pen, colored pencil, graphite, gouache, and collage on paper, 25 3/5" x 20".

87: *Untitled (Hon)*, 1966, ink, crayon, gouache, watercolor, and tape on printed paper, 30 1/2" x 27 1/2". Courtesy Nohra Haime Gallery, New York. Photo: Kris Graves for MoMA PS1

91: *Watts Towers*, ca. 1966, collage, 10 3/5" x 8 1/5".

92–93: *Sweet Sexy Clarice*, 1968, serigraph with marker, 22 1/5" × 29". Photo: Moderna Museet / Stockholm

94–95: *Plan for Nana Town*, 1967, felt-tip marker and gouache on paper, 10 15/16" x 14 1/2". Collection Museum Tinguely, Basel. Donation Ad Peterson. Photo: Fredi Zumkehr

98–99: *You Are My Love Forever and Ever*, 1968, serigraph, 15 4/5" x 23 3/5".

100–101: *My Love We Won't*, 1968, serigraph, 19 1/2" x 24".

102: *Dear Diana*, 1968, serigraph, 19 2/5" × 24".

105: *What Do You Like the Most About Me?*, 1970, serigraph, 19 4/5" × 25 3/5".

106: *Carte of Emotions Land of Love*, ca. 1970, marker and ballpoint pen, 19" x 12 3/5".

112–113 (top): *Mother Is Dead*, 1968, serigraph, 23 3/5" x 48 3/5".

112–113 (bottom): *The Monster Dies / I Am the Beautiful White Bird*, 1968, serigraph, 23 3/5" x 42 2/5".

116–117: *I Would Like to Unlock the Closed Doors and Windows of My Mind*, 1974, felt-tip pen, colored crayon, ink, and collage elements on cardboard sheet, 8 3/5" x 11".

118–119: *Salut Caro Pontus* (with Jean Tinguely), 1975, ballpoint pen, felt-tip, stickers, feather, and collage on paper, 9 1/2" x 13 3/4". Museum Tinguely, Basel.

125: *Help [Eternal Life]*, 1983, pencil and black marker on Fabriano-Bütten, 9 1/2" x 13". Collection Sprengel Museum Hannover. Photo: Aline Herling, Michael Herling, Benedikt Werner.

126–127: *What Is Now Known Was Once Only Imagined*, 1979, offset print, 18" x 24".

130–131: *Dear Laura*, 1980, serigraph, 20 1/2" x 29".

133: *This Is My Right Hand*, 1974, marker, colored crayon, graphite, and ballpoint pen on paper, 11 3/4" x 9 7/16". Collection Sprengel Museum Hannover.

136–137: *Dear Clarice*, 1983, serigraph, 29" x 42".

140–145: Excerpts from *Tarot Cards in Sculpture*, 1985, published by Giuseppe Ponsio, Milan.

148: Exhibition poster, 1992, serigraph with pencil, 28 1/2" × 20 3/5". Photo: Moderna Museet / Stockholm

158–159: *L'arbre de la vie*, 1987, lithograph, 19" x 24 4/5".

164–175: Excerpts from *AIDS: You Can't Catch It Holding Hands*, 1986, published by Lapis Press, San Francisco. The book has also been translated into French, Japanese, German, and Italian.

193: Study for *Queen of the Desert*, 1993, collage and ink on paper, 17" x 11 5/16". Collection Sprengel Museum Hannover.

196–197: *My Love What Shall I Do If You Die?*, 1968, serigraph, 15 4/5" x 23 3/5".

202–203: *Californian Diary (My Men)*, 1994, serigraph, 31 1/2" x 47 1/4".

204–205: *Californian Diary (Telephone)*, 1994, serigraph, 31 1/2" x 47 1/4".

206–207: *Californian Diary (Tempérance)*, 1994, serigraph, 31 1/2" x 47 1/4".

208–209: *Californian Diary (Black Is Different)*, 1994, serigraph, 31 1/2" x 47 1/4".

210–211: *Californian Diary (Christmas)*, 1994, serigraph, 31 1/2" x 47 1/4".

212–213: *Californian Diary (Order and Chaos)*, 1994, serigraph, 31 1/2" x 47 1/4".

214–215: *Californian Diary (Queen Califia)*, 1994, serigraph, 31 1/2" x 47 1/4".

217–221: Excerpts from *Mon Secret*, 1994, published in French by La Différence, Paris.

239: *L'Arbre de la liberté*, 1998, inkjet printing on paper, 30 3/4" x 21". Photo: Moderna Museet / Stockholm

242–249: Excerpts from "Drug Journey," an unpublished manuscript composed in 1995.

254: *La mort n'existe pas / Life Is Eternal*, 2001, serigraph with stickers, 24 1/4" x 19".

FOR MAXINE

🐌

I am immensely grateful to the Niki Charitable Art Foundation, Bloum Cardenas, and Jana Shenefield. This book would not have been possible without their generosity and support. I'm also indebted to Lisa Pearson, for her faith, vision, and friendship.

A million thanks to Clare, for the books so long ago; Sam, Ross, and Scott, a fellowship; Margaret and John, for the time; and the writers and artists who sustain me, especially those who helped me give this book life.

Jeffrey, merci beaucoup!

This book is also for my family—Mom & Dad, Danielle, Doug, Grover, Ursula—without whom there is no joy.

🐌

What Is Now Known Was Once Only Imagined: An (Auto)biography of Niki de Saint Phalle
© 2022 Siglio Press, Nicole Rudick, and the Niki Charitable Art Foundation.
Foreword and afterword © 2022 Nicole Rudick.
All individual images and texts by Niki de Saint Phalle © Niki Charitable Art Foundation.

Book and cover design: Natalie Kraft
Front cover artwork: *L'Arbre de la vie* by Niki de Saint Phalle, 1987
First edition | ISBN: 978-1-938221-31-6 | Printed and bound in China

siglio uncommon books at the intersection of art & literature
PO BOX 111, Catskill, New York, 12414 p: 310-857-6935 www.sigliopress.com

Available to the trade through D.A.P./Artbook
75 Broad Street, Suite 630, New York, NY 10004
Tel: 212-627-1999 Fax: 212-627-9484